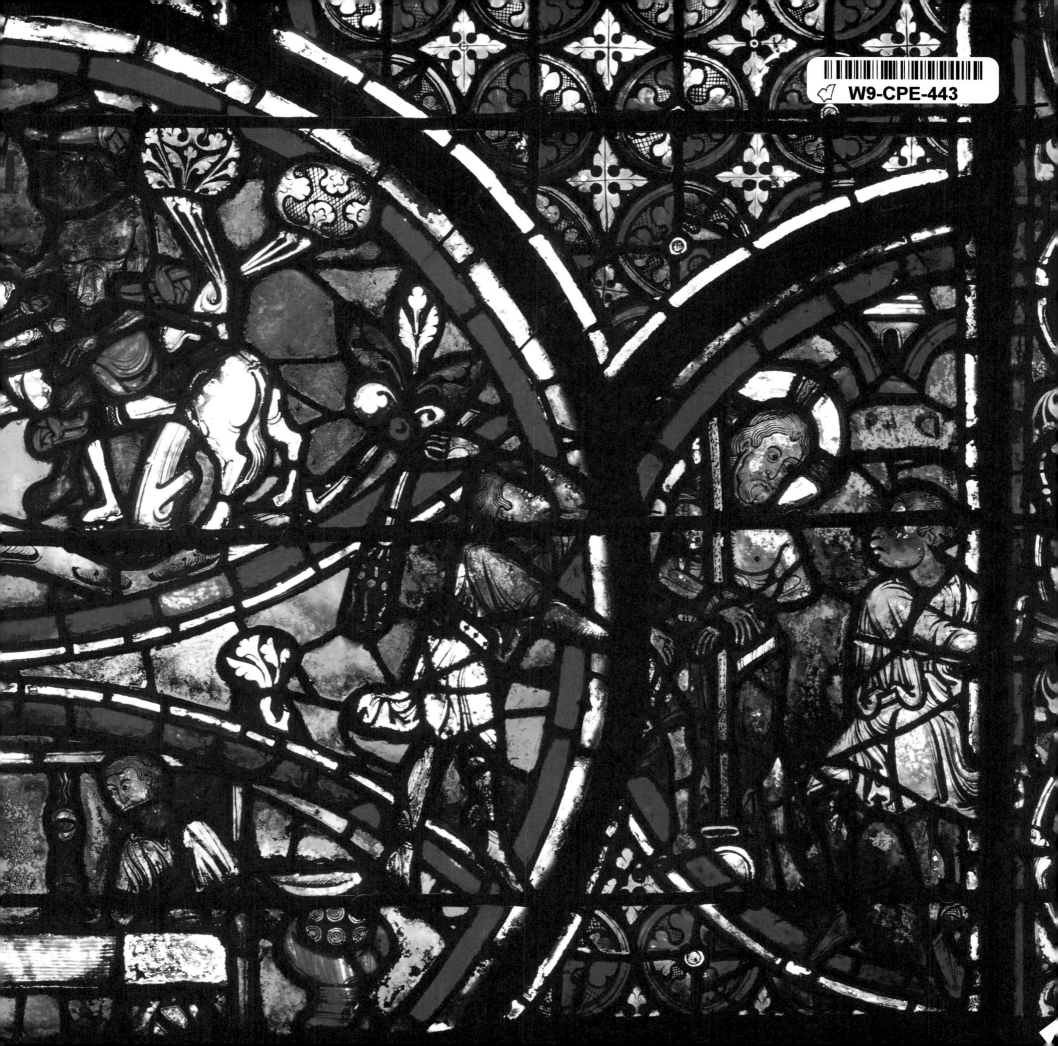

STAINED
GLASS

STAINED GLASS

JEWELS OF LIGHT

JOE PORCELLI

FRIEDMAN/FAIRFAX
PUBLISHERS

A FRIEDMAN/FAIRFAX BOOK

Library of Congress Cataloging-in-Publication Data

Porcelli, Joe
 Stained glass: jewels of light/
by Joe Porcelli.
 p. cm.
 Includes bibliographical references and index.
 ISBN 1-56799-550-0
 1. Glass painting and staining–History–19th century. 2. Glass
painting and staining–History–20th century. I. Title.
 NK5309.8.P67 1998
 748.59˚048–dc21
 97-17032

Editor: Celeste Sollod
Art Director: Jeff Batzli
Designer: Maria Mann
Photography Editor: Sarah Storey
Production Manager: Karen Matsu Greenberg

Color separations by Colourscan Overseas Co. Pte Ltd.
Printed in Italy by Poligrafiche Bolis s.p.a.

1 3 5 7 9 10 8 6 4 2

For bulk purchases and special sales, please contact:
Friedman/Fairfax Publishers
Attention: Sales Department
15 West 26th Street
New York, New York 10010
212/685-6610 FAX 212/685-1307

Visit our website:
http://www.metrobooks.com

Frontispiece: CHERUBS CAVORT IN A STAINED GLASS WINDOW AT THE BILTMORE
ESTATE IN NORTH CAROLINA.

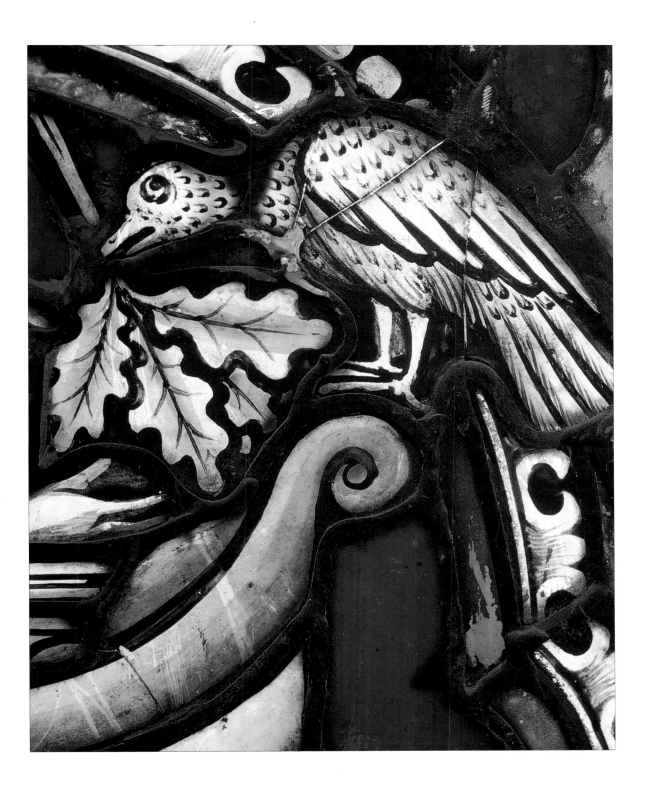

DEDICATION

Writing this book offered me a welcome opportunity to re-acquaint myself with many of the great works in glass I've encountered throughout my career. With that in mind, I'd like to dedicate this book to the many artists, designers and crafts-people who worked anonymously and sometimes in the shadows of others to bring these remarkable creations to light, and also to those currently working in the medium whose efforts promise to keep the future of stained glass ever bright.

ACKNOWLEDGMENTS

Thanks are in order to Celeste Sollod of the Michael Friedman Publishing Group for offering me the opportunity to do this book, and to photo editor Sarah Storey for the great job she did in locating the photos that grace these pages. I'd like to thank both of them for their professionalism, attention to detail, and their ability to keep me and this project on schedule. I'd also like to thank my family and the staff at Glass Craftsman Magazine for keeping things afloat while I was otherwise engaged.

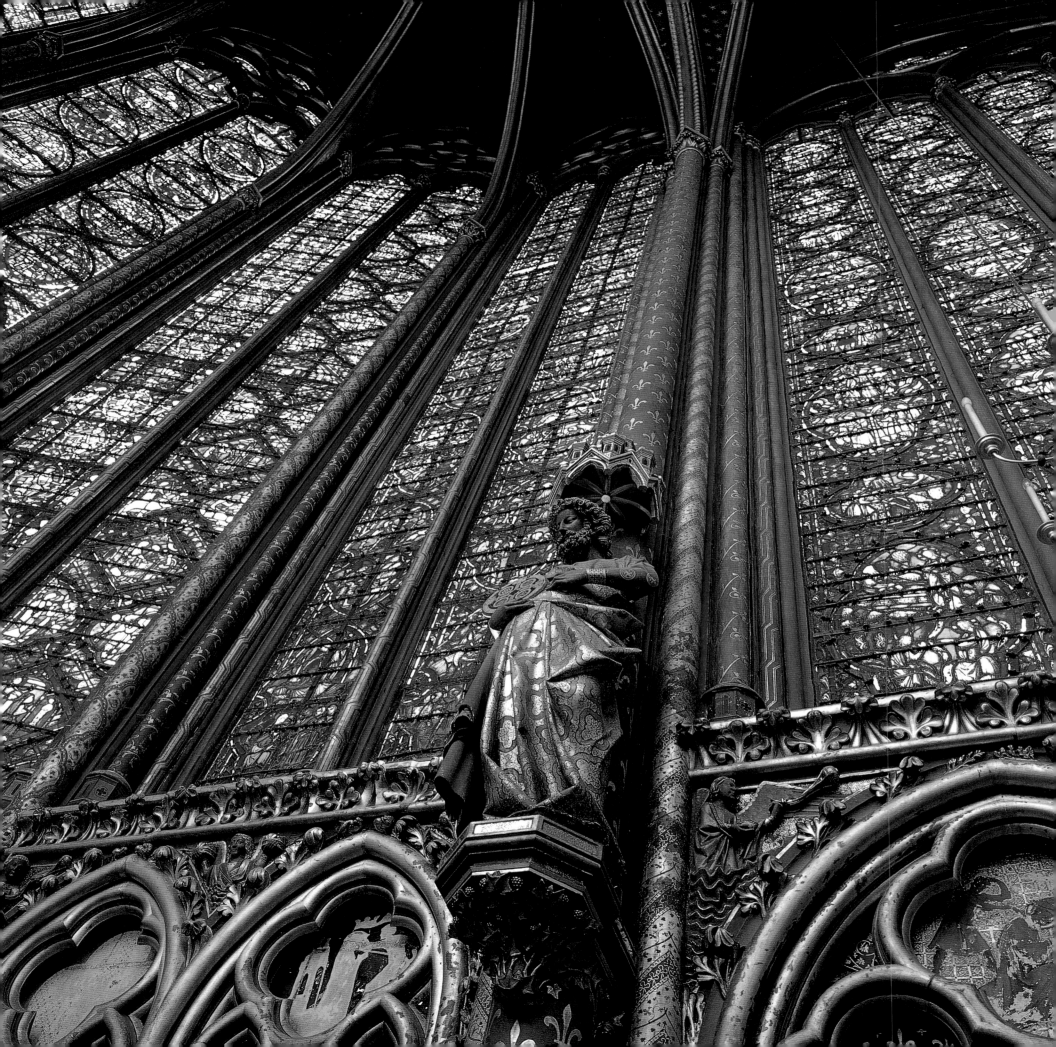

CONTENTS

THE MAGIC OF GLASS

You are about to encounter the wonder of glass, the way it enhances light, how it transforms any space it occupies into a radiant focal point, an endless source of delight and spectacle. You

"IT'S THE GLASS," SAID THE LATE GLASS ARTIST JIM SCHLITZ WHEN ASKED WHAT INSTILLS THE MAGIC INTO STAINED GLASS ARTWORK. SUCH MAGIC IS EVIDENT IN THIS VIEW OF THE STAINED GLASS IN THE THANKSGIVING SQUARE CHAPEL IN DALLAS, TEXAS.

will be amazed at how a material so common a part of our everyday lives can become something almost otherworldly, hypnotic in its beauty.

It is the wonder of glass that it needs only the slightest amount of light to come alive. A stained glass window performs its colorful magic whether the light is the product of a cloudy, overcast day or one brimming with glorious sunlight. The subdued light of a Tiffany-style leaded glass lamp graces any interior with a garden of color with even the slightest illumination. Beveled glass shimmers as a hint of prismatic light refracts on its angled surfaces. A free-standing piece of art glass, a blown glass vase or sculpture, reflects both natural and artificial light against its surfaces in an ever-changing symphony of sparkle and hue. Sandblasted and etched glass provide subtle elegance in an interior as their carved and frosted areas diffuse light.

Glass and light are inseparable companions. Whether the light is nature's own or artificial, glass and light are part of a natural marriage, a tender affair that dates back centuries. Join these two natural mates with the wonder of color and you have the ingredients for what has been called the "world's most beautiful art form"—glass.

Man's relationship with glass can be described as that of custodian, or referee,

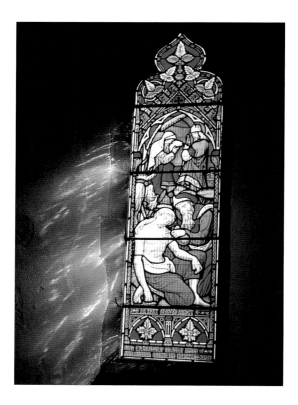

guiding and governing the activities of each of the ingredients in the interest of bringing out their best, and keeping one from overpowering the other, or letting the relationship get out of hand. It is man's participation in this romance that interests us here. Because of it we can enjoy a body of artwork that spans centuries, geographic boundaries, stylistic and sociological changes, and reli-

gious beliefs. His meddling with the elements of light, glass, and color is responsible for some of the most awe-inspiring creations the world has ever seen, from the thirteenth-century stained glass of the "Queen of Cathedrals" of Chartres, France, to the spectacle of Tiffany's 1923 "Autumn Landscape" window in New York's Metropolitan Museum of Art, to the latest creation of contemporary glass artist Judith Schaechter. All were inspired and realized by the possibilities of glass, light, and color.

When the power of glass was first realized, when it first met the imagination of the artisan, it set into motion a voyage of challenge and discovery unlike any other in the history of art. Colored glass could transform light, and, as a result, transform the whole of an interior space, an ability no other medium could boast. Developed in service to religious beliefs, as were many of the decorative arts, stained glass had the unique ability to present an image, in most cases a scene from a religious text, and add to that depiction the wonder of light. The connection between the

Opposite: THREE WINDOWS SPAN THE CENTURIES OF STAINED GLASS CREATION, EACH SHOWING HOW THE COMBINATION OF GLASS AND LIGHT CAN WORK ITS MAGIC. *Bottom Opposite:* THE STAINED GLASS IN WASHINGTON D.C.'S NATIONAL CATHEDRAL IS AMONG OF THE FINEST OF TRADITIONAL AMERICAN STAINED GLASS. *Middle Opposite:* STAINED GLASS TRANSFORMS LIGHT, REFLECTING ITS MAGIC ON AN INTERIOR SURFACE. *Top Opposite:* THE WINDOWS OF ENGLAND'S CANTERBURY CATHEDRAL, INSTALLED BETWEEN 1180 AND 1220, REMAIN A MONUMENT TO THE GLAZIER'S ART. *Right:* THE GREAT ROUND WINDOWS FOUND THROUGHOUT THE HISTORY OF STAINED GLASS ARE ALL REFERRED TO AS "ROSE" WINDOWS, AS THE CONCENTRIC RINGS OF THE WINDOW DESIGN WERE THOUGHT TO RESEMBLE THE RADIATING PETALS OF THE BLOOM. THE GREAT UPPER ROSE WINDOW OF FRANCE'S RHEIMS CATHEDRAL WAS CREATED IN THE THIRTEENTH CENTURY AND SURVIVED THE RAVAGES OF WORLD WAR I, THOUGH ITS COUNTERPART BELOW DID NOT FARE SO WELL. THE NEW GLASS IS A TWENTIETH-CENTURY WORK.

* споси*

gods, heaven, and light was not lost on early supporters of the art. The Abbot Suger, twelfth-century builder of the abbey church and stained glass of Saint Denis in Paris, a structure credited with initiating the Gothic style, is reported to have said upon entering his new church, "I see myself dwelling, as it were, in some strange region of the universe which neither exists entirely in the slime of the earth, nor entirely in the purity of Heaven; and that, by the grace of God, I can be transported from this inferior to that higher world." Dramatic, yes, but it suggests the power that Suger's new stained glass would continue to have over its viewers.

The same spark of imagination twelfth-century glass artists and craftsmen experienced when they looked up into the empty space of a cathedral's tracery, visualizing what could be, or needed to be done, with glass and light, is being experienced this very minute by artists and craftspeople in glass workshops and studios all over the world as they contemplate and orchestrate today's glass projects and tomorrow's masterpieces.

The relationship that began for the purpose of illuminating the great lessons of religious belief for the enlightenment of worshippers has become a vehicle for personal artistic statement in recent years, subject to the whims and genius of imagination and the unpredictable demands of art. As a result, we are enjoying one of the most dynamic and productive periods ever in the history of stained glass.

Stained glass windows big and small are still made in much the same way they've always been made. The concept of joining shapes of flat glass edge to edge in an attempt to create an image to fill a space or frame is a constant. Much like the art of mosaic, it is the technique and skill of the artisan filtering through this simple procedure that adds identity to the work. Although the styles and imagery portrayed in glass have changed over the centuries, the medium itself, and its inherent craft have not, with one indirect exception. As you will see throughout our viewers' journey past these many miracles of color and light, the spirit and character of the glass artist slowly emerged from the background of the craft guilds and studio traditions of Europe and England. For centuries, they remained hidden by the blinding light of so strong a medium. Today, the names of the glass artists in some instances shine as brightly as the medium itself.

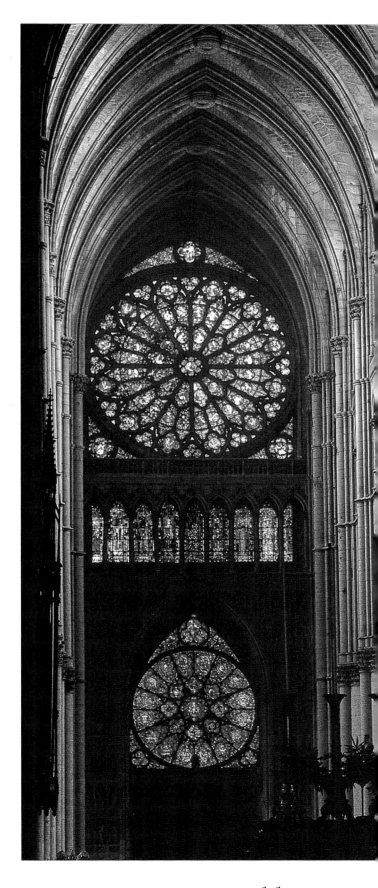

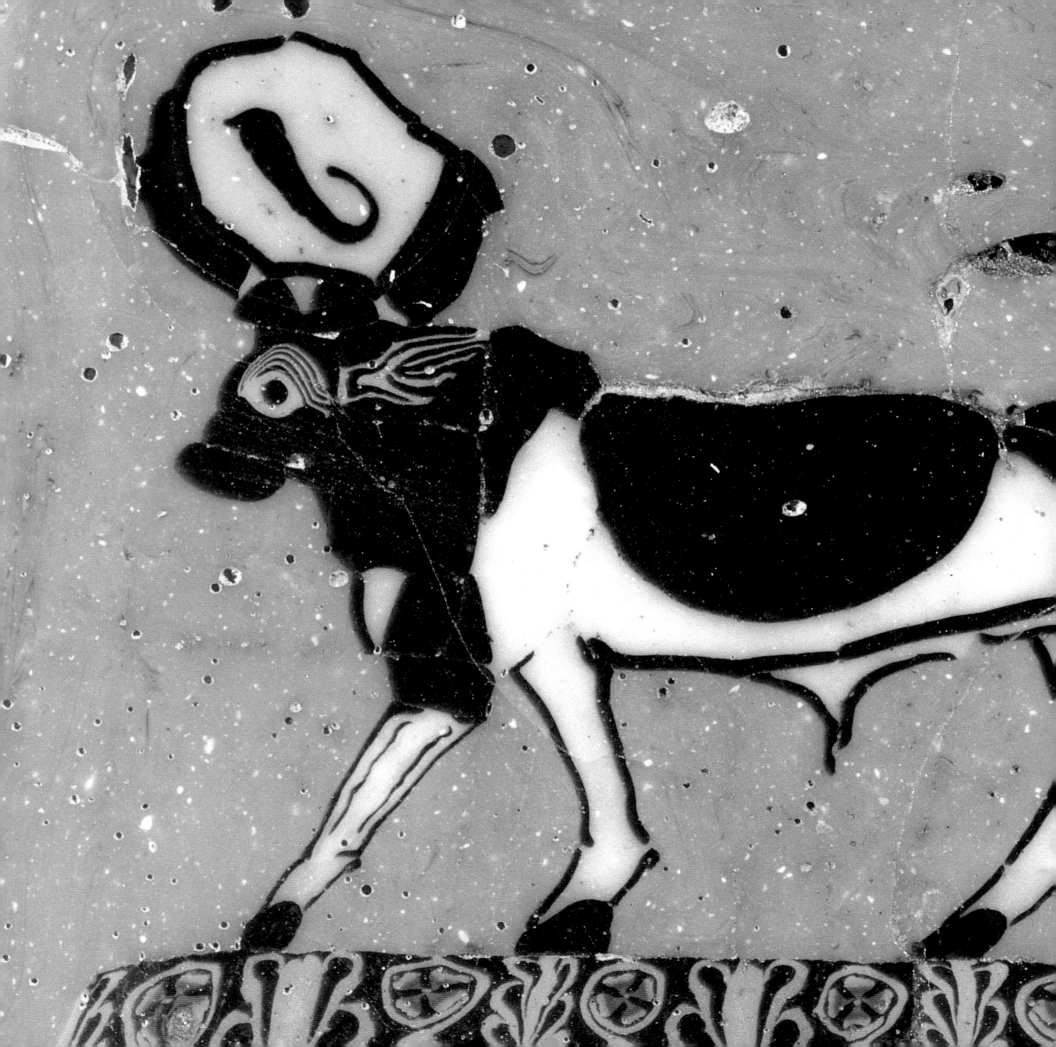

EARLY STAINED GLASS

Glass is one of the oldest materials known to man. Writing at the beginning of the Christian era, Pliny, the Roman historian, places the Phoenician discovery of glass at about 3000 B.C. If we are to believe his writings, glass was discovered by Phoenician sailors

THIS EGYPTIAN GLASS MOSAIC BUILT IN THE FIRST CENTURY B.C. PREDATES THE FIRST KNOWN WORKS IN STAINED GLASS BY ALMOST A THOUSAND YEARS. THE EARLY STAINED GLASS ARTISANS WOULD FIND INSPIRATION IN THESE EARLY FORMS OF DECORATIVE GLASS.

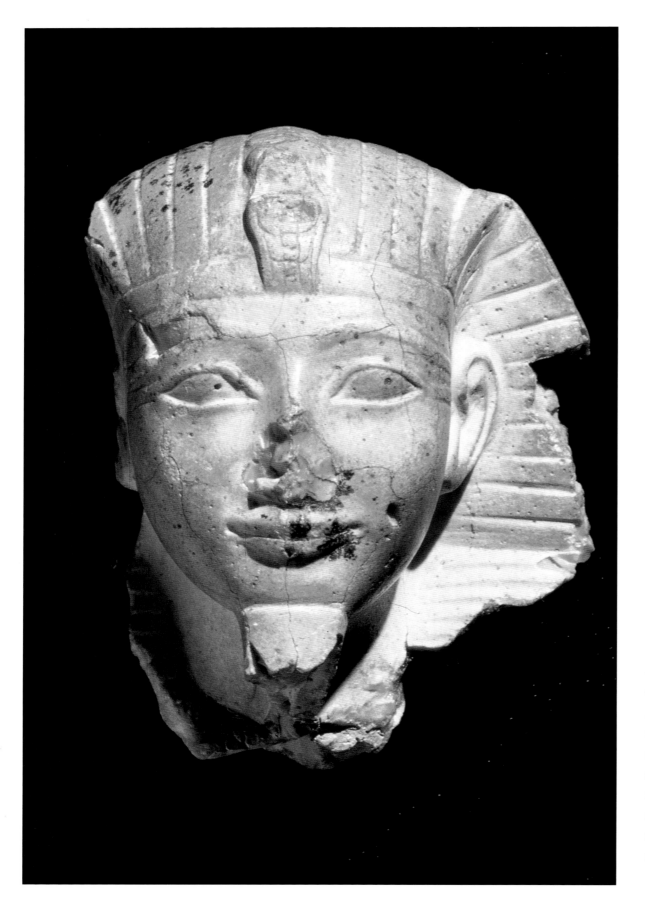

Left: A RARE PIECE OF ANCIENT GLASS SCULPTURE, THIS
CASTING OF THE HEAD OF AMENHOTEP II, PHARAOH OF
EGYPT FROM 1436 TO 1411 B.C., IS THE EARLIEST GLASS
PORTRAIT KNOWN. THE COMBINATION OF GLASS' USE AS A
MATERIAL FOR SCULPTURE AND THE SUBJECT PORTRAYED
SHOWS THAT GLASS WAS CONSIDERED A PRECIOUS MATERIAL
FROM EARLY ON. *Above:* A NORTHERN MESOPOTAMIAN
STAR PENDANT CAST FROM SOLID GLASS AROUND THE
FOURTEENTH CENTURY B.C. COULD HAVE BEEN MADE FOR
ROYALTY OR A WEALTHY CLIENT.

may be more a product of legend than fact, there is no doubt that glass was produced by artisans of several early civilizations, including the Egyptians and Sumerians. The practice of glassmaking later extended through countries of the Mediterranean and the Aegean.

The Asian conquests of Alexander the Great in the third century B.C. brought about a cultural exchange that influenced every aspect of the crafts practiced at that time. Techniques of production and stylistic influences were introduced, shared, and assimilated as foreign cultures interacted. The vast array of surviving glass artifacts provide our only documentation of glassmaking in this era. With them, historians have been able to piece together a visual timetable of glassmaking activities.

The unique properties of glass and the miraculous methods of its creation were enough to sustain its high standing in ancient civilizations, sometimes approaching that of precious metals. Among the ancient Chinese, glass was sometimes thought to possess magical properties. It was a Chinese custom to place glass cicadas on the tongues of their dead. The cicada symbolized life after death.

Above: EGYPTIAN GLASS MOSAICS OF THE FIRST CENTURY B.C. SUGGEST THE HERALDRY AND PORTRAITURE OF STAINED GLASS PRODUCED HUNDREDS OF YEARS LATER. *Left:* THE GLASSMAKING TECHNIQUES USED TO PRODUCE THIS ANCIENT CHINESE CAST-GLASS CICADA WERE LATER USED TO CREATE SHEETS OF STAINED GLASS.

In another legend, the Roman Emperor Tiberius, a collector of precious objects, was presented with an artisan who had invented an unbreakable glass. When a sample vase was thrown to the floor, the vase merely dented, and the artisan quickly repaired the dent with a hammer. Tiberius asked the artisan if he had yet to show his marvelous invention to anyone else. Being assured that he had not, Tiberius had him swiftly beheaded rather than risk compromising the value of his fragile glass collection.

Eventually, however, the Romans brought glass objects into everyday use by means of increased production methods (due largely to the development of glassblowing, discussed later) and their penchant for

rather as a mistake; they had landed on a beach and prepared their meal using blocks of natron (an alkali, one of the ingredients in glassmaking) they had been carrying as cargo. The heat from their fire caused the sand beneath it to melt and subsequently cool, forming glass. Although Pliny's account

commerce and trade. Despite glass' use as a commodity, its fragility and luster supported the aesthetic appeal and value of its finer examples through the centuries.

Early Color in Glass

Light reflected from the surface gave colored glass an appearance not unlike that of gold, sapphires, emeralds, lapis lazuli, and other jewels. The earliest creations in glass—vessels, cups, and beads—display a remarkable variety of color combinations. Some are crude, whereas others are more sophisticated in their composition, rivaling the exquisite nature of jewelry. Despite their reliance on a limited palette, the first glass artists, or artisans, exercised great invention in their works, many of which still provide inspiration today. In studying the history of glass, it is apparent that color imbued the material with unique properties that still provide endless fascination both to its creators and its beholders.

Early glassmakers perfected a number of ways to add color to their works with techniques directly related to the material's workability and reheatable nature. Despite the appreciation of the simplest glassware for its monochromatic (single color) beauty, various techniques for applying additional color to the surface of formed-glass objects were developed. The Egyptians were fond of colorful objects and willing to accept the influences of other cultures on their own works. Their position as an international trade center exposed them to many of the products and techniques of artisans of other countries. They absorbed such influences and

incorporated the new ideas into their own products. This was especially true in the manufacture and crafting of glass, the base ingredients of which were found to react to the introduction of certain metals and oxides. Copper, extracted from a number of sources in the Sinai, and in plentiful supply, provided great variations in color when added to the

molten glass mixture. Depending on the quantity added, an entire range of blue-green tones was possible. Under certain conditions, copper also produced a rich, wine red. Manganese and iron produced black. Manganese on its own would produce brownish tones and, in particular amounts, violet. Cobalt would produce luxurious blues. These

THE TWO JARS ON THIS PAGE SHOW HOW EARLY ARTISANS COMBINED GLASS COLORS IN CORE-FORMED GLASS WORK. *Below:* THE PALE GREEN OF A MESOPOTAMIAN PERFUME BOTTLE MADE BETWEEN 800 AND 700 B.C. IS COMBINED WITH WHITE STRANDS. IT STANDS 6.7 INCHES (17.1CM) HIGH. *Right:* A 4.7 INCH-HIGH (12CM) EGYPTIAN JAR, CREATED BETWEEN 1400 AND 1360 B.C., HAS A HIGHLY DECORATED SURFACE, SUGGESTING A WELL-DEVELOPED SENSE OF STYLE AND TECHNIQUE. *Opposite:* THE BRIGHT COLORS OF EGYPTIAN MOSAIC GLASS WERE PRODUCED BY COMBINING THE MOLTEN GLASS WITH VARIOUS METALS.

inclusions into the base glass and their continued use fostered recipes for colored glass that, over the years, provided a virtually limitless palette.

As experimentation proliferated, so did the possibilities. Early core-formed glass, that is, hot, molten glass spun around a solid mold, or core, was further embellished by trailing thin, spaghetti-like threads of contrasting colored glass around the surface. The mold, or core, was made of clay and sand, or clay and dung. The crude solid core would be attached to a metal rod and submerged in a pot of molten glass. A layer of glass would adhere to the form. It could then be removed from the pot and rolled smooth on a slab of stone or marble. In casting, molten glass would be poured into a hollow mold, and the glass would assume the interior details of the container. Techniques for combining colored glass forms while still hot, allowing them to cool, only to be reheated and reworked, fired the imagination of both maker and beholder.

The Tools of Early Blown Glass

T he ability to turn base elements into a material of beauty has always suggested true alchemy. The unique qualities and lustrous properties of glass inspired even the earliest producers. Once the process was harnessed, imagination, sometimes curbed by function, sometimes not, became the guiding force. Man developed tools and implements to extend and increase the abilities of his own hands to mold, shape, and otherwise manipulate the glowing, hot, molten glass into a desirable and useful form.

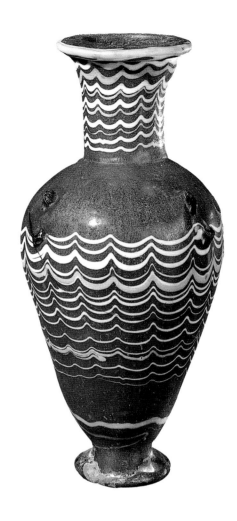

With the discovery that a glob of molten glass would respond to the introduction of air blown into it, a development that has historically been located in Syria during the second century B.C., glassmaking enjoyed a revolution that has yet to subside. This powerful technique did for glass what the potter's wheel did for clay: it introduced the concept of volume, form, and inner space to the vessel. The time-consuming casting and mold-forming of glass gave way to the immediacy of glassblowing. The glassmaker used a blowpipe, or punti, to blow air into a glob of molten glass, using the air to form it into a vessel. Increased production, resulting from the relative speed of blowing glass, brought

glass to the popular market, compromising its status as a luxury material on one hand, while enhancing its value as a commodity on the other. Also, larger works could be created.

The hollow forms of blown glassware proved to be perfect containers. Whether used as drinking vessels or for storage, the properties of glass—its strength, versatility, and potential for reuse—established it as a material of choice. In addition, glass was more hygienically suitable for personal use than other materials of the time. Glass could be sanitized for reuse more completely and

꿍

THE ROMAN TECHNIQUE OF BLOWING GLASS INTO MOLDS TO CREATE VESSELS LASTED FOR CENTURIES AND WAS WIDELY ADOPTED. BY THE NINTH CENTURY, MOLD–BLOWN GLASS OBJECTS SUCH AS THIS ISLAMIC TEXTURED GLASS BOTTLE, SHOWN WITH ITS BRONZE MOLD, HAD LONG SINCE BECOME COMMONPLACE UTILITARIAN OBJECTS AND CONTAINERS.

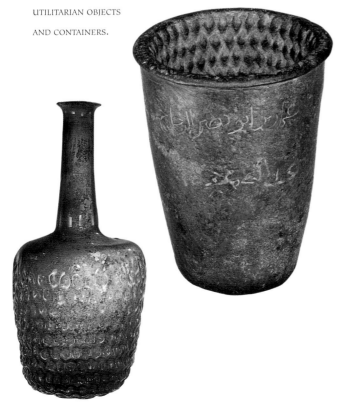

easily than pottery, wood, or metal, the more common materials of the time.

The Romans were quick to realize the benefits of glassblowing. They developed methods of standardizing glass forms by blowing hot glass into a pre-shaped mold of a substance (probably wood) which could contain the hot glass without fusing with it. The injected glass would assume the shape of the mold, which would subsequently be removed from the cooled glass and reused to form another. These methods heralded the earliest forms of mass production of functional glassware. This ingenious treatment of material must be kept in mind for the later discussion of mouth-blown antique glass, one of the most powerful materials used in the ever-evolving art of stained glass.

Early Flat Glass

The earliest flat art glass was born from the art of mosaic. The art of mosaic predates that of stained glass substantially. Decorative floor mosaics set in black and white stone were probably made as early as the eighth century B.C. Some earlier examples of a technique similar to mosaic, surface decorations of pebbles set in patterns, have an approximate date of 3000 B.C. The latter were found in the ancient city of Urik, in Sumeria. Some evidence places the earliest colored glass windows in the fourth century, although popular belief favors the twelfth century.

Historians agree that the first stained glass windows, physical examples of which are lost in the rubble of history, evolved from the techniques of mosaic art. Mosaic is the art

of situating tiles of different colors, or contrast, into patterns suggesting an image. These tiles are set into a stabilizing ground such as cement or a suitable mortar. Mosaicists of ancient times used a number of materials of varying texture, including pieces

Above: GOLD LEAF LAYERED BETWEEN TWO PIECES OF GLASS PROVIDES THE DECORATION ON THIS ROMAN ROUNDEL, WHICH IS ACTUALLY THE BOTTOM OF A DRINKING VESSEL. CREATED IN THE FOURTH CENTURY A.D., THE PIECE ILLUSTRATES ONE OF THE GLASSWORKING TECHNIQUES AVAILABLE TO ARTISANS OF THE TIME. *Left:* THE INDIVIDUAL PIECES—TESSERAE AND SHARDS AND CHUNKS OF GLASS— THAT MAKE UP A MOSAIC LOOK LIKE RUBBLE COMPARED TO THE FINISHED WORK THEY ULTIMATELY ARE USED TO FORM.

and chunks of glass as well as stone, shells, and jewels as their tile material.

These *tesserae*, as the square tiles of mosaic were called, became the basic unit of the art. Their varying arrangements suggested form and movement on a flat plane. As the art progressed, a larger variety of colored materials, including glass, were used. Considering mosaics, one can imagine how the process of laying glass tiles in mosaic to form an image on a ceiling, wall, or floor might suggest the same application for an opening through which light passes, like a window. The translucence of glass, a property being lost to the solid, opaque grounds necessary to mosaic, would provide the inspiration.

Romans were fond of sandwiching gold foil between two layers of flat, clear glass to form the tesserae of their mosaics. The reflective sparkle of jewels and jewel-like substances was infinitely more attractive than the hard, matte surfaces of stone and ceramic. Glass could provide the best of both materials: the glitter and glitz of precious jewels without the expense. The variety of colored glass added to its appeal.

It is easy to imagine the earliest glass artisans looking to mosaics for guidance and technical inspiration, given the fragmented

19

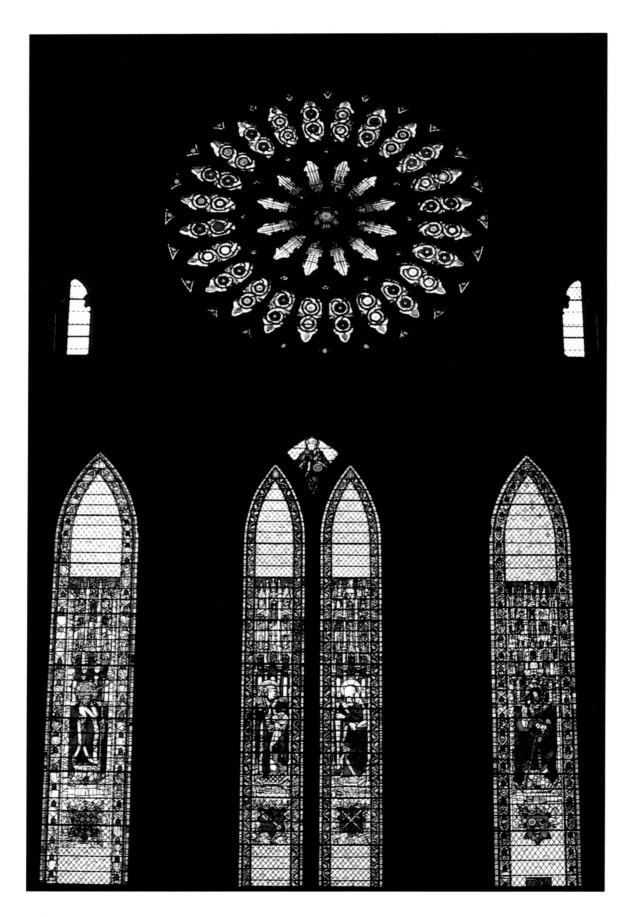

nature of the art. Stained glass could almost be considered mosaic without the stabilizing ground. Yet, early designers of stained glass chose to amplify the scale, or size, of the basic units (pieces of glass as opposed to mosaic tiles) rather than merely translate mosaic into a translucent medium intact. By doing so, early glaziers chose not to adopt a degree of detail that, in the art of the mosaicist, had progressed to a remarkable level of sophistication. Early stained glass efforts are not any less successful because of this, nor were the similarities between mosaics and stained glass neglected completely. In fact, the thirteenth-century *grisaille* (a style of stained glass) windows of England's York Minster, although repetitive in design and color scheme, are very close to mosaic in concept and scale of the individual glass elements in proportion to the expanse of the windows.

When viewing the finest mosaic works, that is, those displaying the greatest achievements of detail and subtle color gradation,

A TOUR OF ENGLAND'S YORK MINSTER CAN BE A LESSON IN STAINED GLASS STYLES AND COMPOSITION. HERE THE GOTHIC INFLUENCE, NEW AT THE TIME OF THE BUILDING'S CONSTRUCTION, IS EVIDENT, AS IS THE ANCIENT MOSAIC-LIKE TECHNIQUE EMPLOYED IN THE STAINED GLASS WINDOWS.

you will note that as you move away from the surface, the small pieces of glass, tile, or stone begin to blend together to form a whole picture. To the eye, the work assumes a painterly or, in the case of early applications, a fresco-like appearance. This optical phenomenon is similar to viewing a stained glass window. When successfully orchestrated, the colors of the glass blend into one harmonious image, and the outlining leadlines disappear, like telephone poles in a landscape.

The earliest stained glass also borrowed from, and found inspiration in, the arts of tapestry and painting. Both were narrative in function, as was stained glass. Both could be used to portray important events in religious history, as would stained glass. Either could be used on a monumental scale, adorning an entire wall or ceiling of a building. Used in this way, they became tied to the architecture, becoming architectural arts by description. Stained glass would eventually replace both as the architectural art of choice for many centuries to come.

A MOSAIC FLOOR IN THE DOM CATHEDRAL OF COLOGNE, GERMANY, ECHOES THE LARGE EXPANSES OF GLASS IN ITS WINDOWS. GENERATIONS OF GLASS HISTORY AND TECHNIQUE COME TOGETHER IN THE GLORY OF THIS EXTRAORDINARILY MAGNIFICENT INTERIOR.

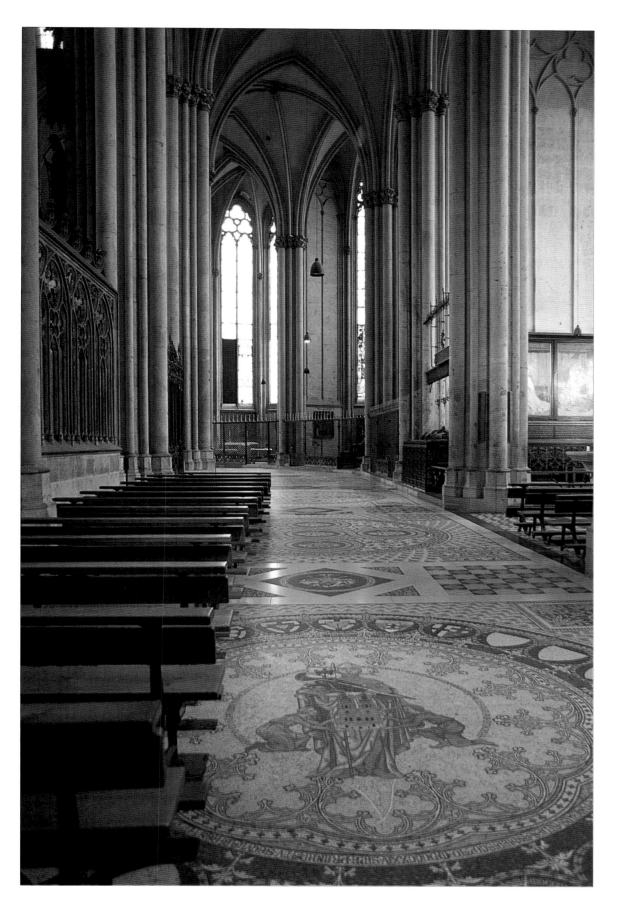

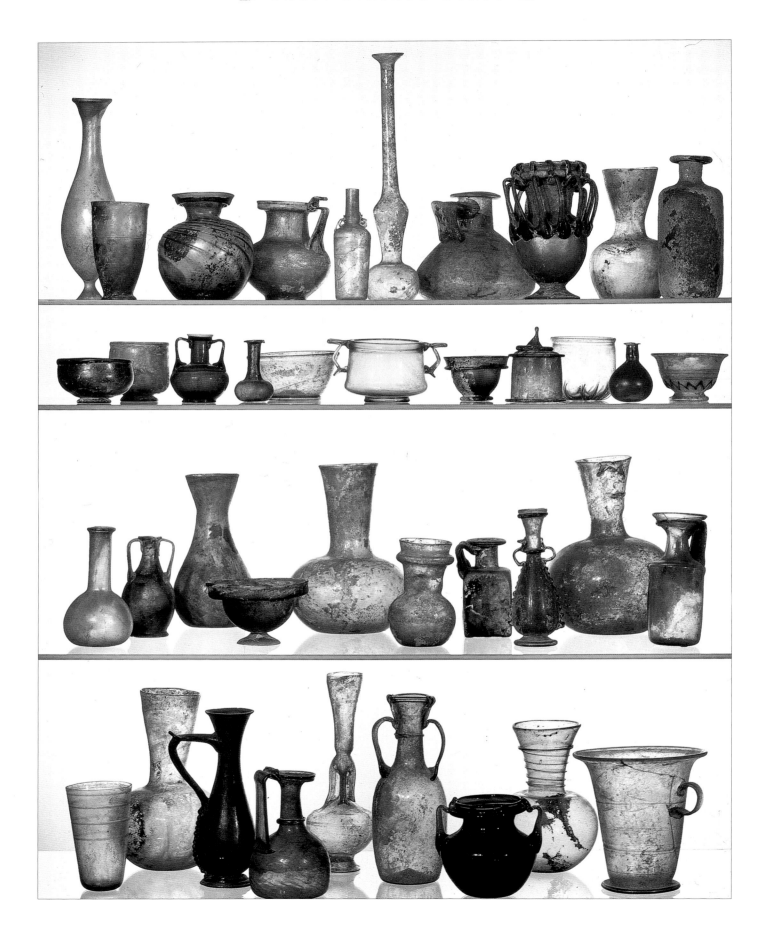

Opposite: THIS COLLECTION OF FIRST- TO FOURTH-CENTURY
A.D. ROMAN GLASS VESSELS RESEMBLES A PAGE FROM A
NINETEENTH-CENTURY PRODUCTION GLASS CATALOG.
IMPROVED AND SIMPLIFIED PRODUCTION METHODS ENABLED
ARTISANS TO CREATE A WIDE VARIETY OF SHAPES AND SIZES
OF FUNCTIONAL GLASS OBJECTS AS EARLY AS ROMAN TIMES.

Above: MOSAIC GLASS MURALS, SUCH AS THE ELEVENTH-
CENTURY MOSAIC OF SAN MARCO IN VENICE, ITALY, HELD
ALL OF THE SPECTACLE AND GRANDEUR OF STAINED GLASS
WINDOWS WITHOUT THE ONE ELEMENT THAT WOULD
FOREVER DISTINGUISH THE TWO—THE TRANSMISSION OF
LIGHT THROUGH THE GLASS.

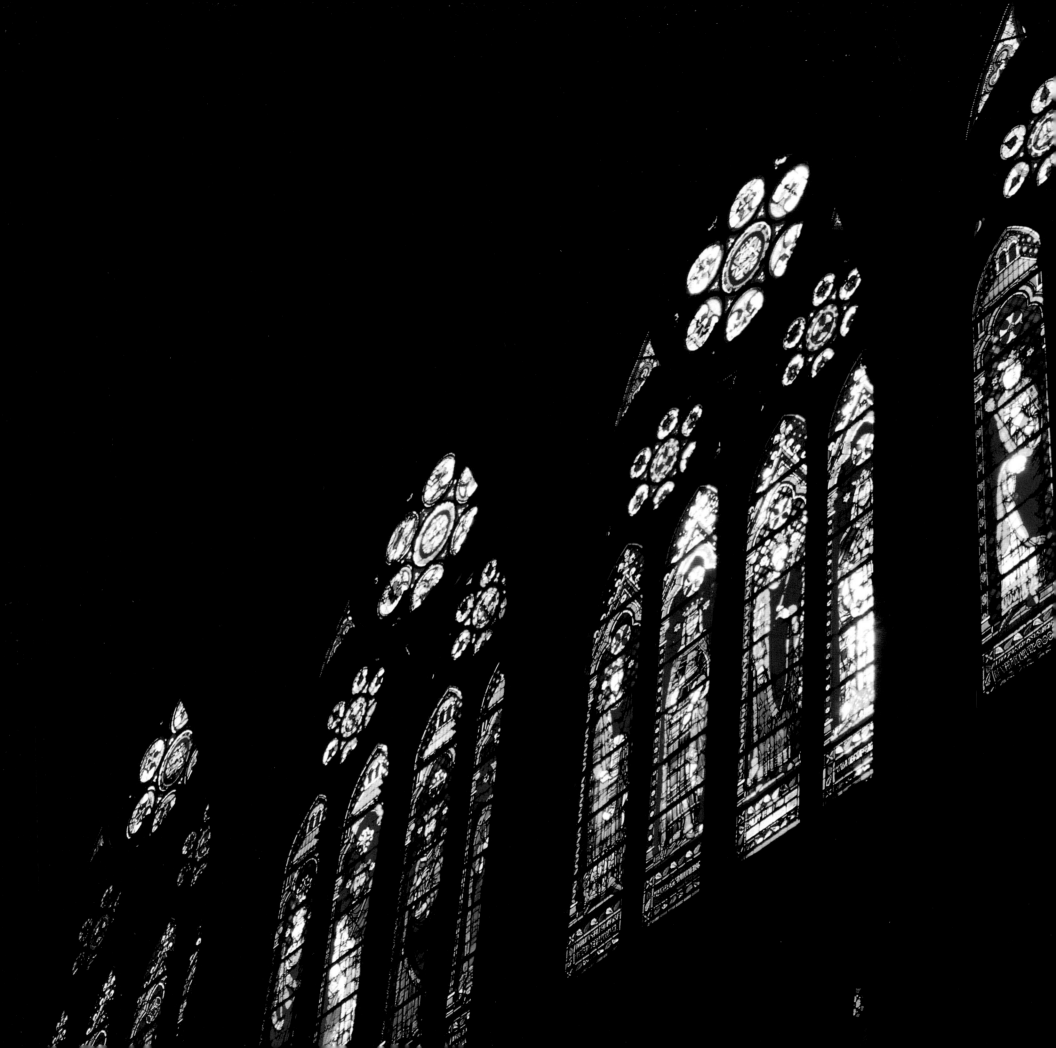

RELIGIOUS STAINED GLASS

The bulk of stained glass' history is rooted in Christianity. The church encouraged and supported the arts and crafts throughout the Romanesque/ Medieval period (the latter part of the Middle Ages, the tenth to fourteenth centuries) and for generations to come.

HISTORICALLY, THE WINDOWS OF SAINT DENIS CATHEDRAL IN FRANCE, COMMISSIONED BY ABBOT SUGER, MARKED THE BEGINNING OF STAINED GLASS' FIRST GREAT PERIOD. THE LARGEST INSTALLATION OF ITS TIME, SAINT DENIS SERVED AS INSPIRATION AND MODEL FOR SUGER'S COMMISSIONING OF THE STAINED GLASS AT CHARTRES CATHEDRAL. THE WINDOWS AT CHARTRES WOULD GO DOWN IN HISTORY AS SOME OF THE MOST BEAUTIFUL EVER PRODUCED.

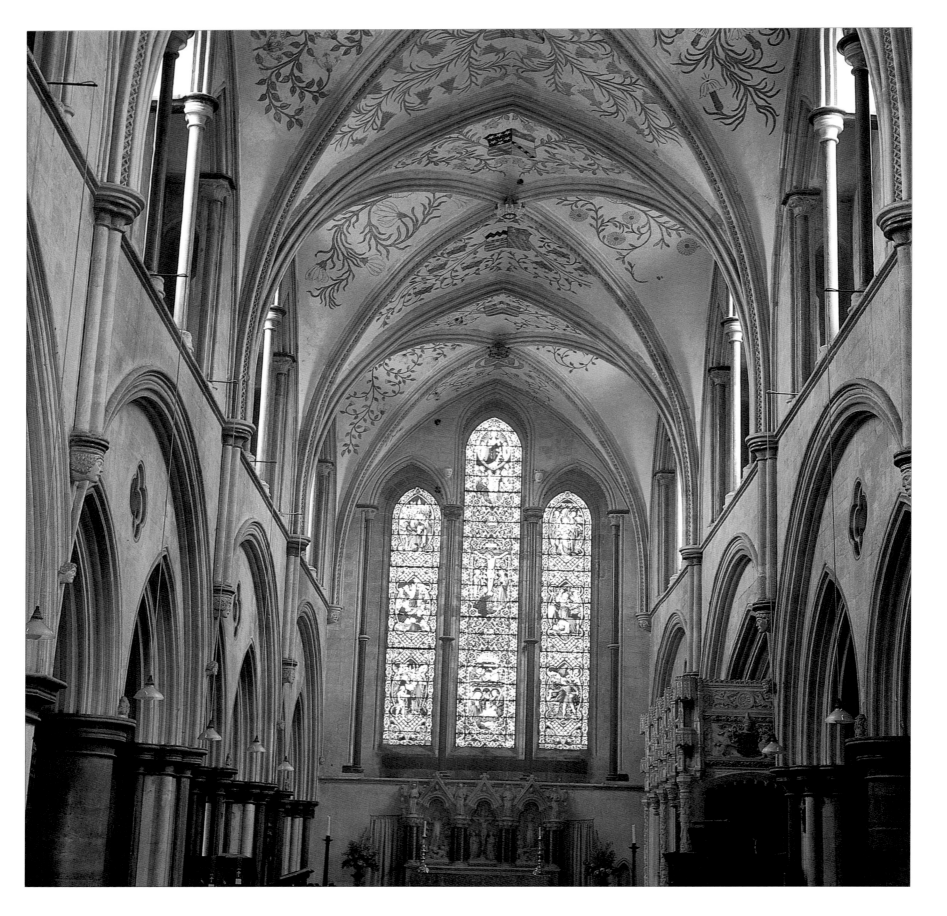

This patronage continues today, although on a smaller scale. The medium's true origins, though, are clouded by the same lack of documentation that is, unfortunately, characteristic of other great revolutionary events in glass.

The Earliest Stained Glass Windows

The earliest stained glass on record was unearthed during archaeological digs. No more than fragments, their history and original surroundings remain unknown. These finds were made long ago under less than desirable conditions that only add to the difficulty of properly dating them. The archaeologist Cechelli, who performed excavations at the Church of San Vitale in Ravenna in 1930, found a grouping of three glass fragments that, when pieced together, suggested portions of a crown showing Christ positioned between alpha and omega symbols. It was assumed they were contemporary with the building of San Vitale, dating them circa 540 A.D., making them the oldest pieces of what could be considered stained glass on record.

∽∾

Opposite: THE ARCHITECTURAL INNOVATIONS OF THE GOTHIC STYLE OF BUILDING ALLOWED LARGER AND LARGER EXPANSES OF GLASS TO ILLUMINATE A CHURCH'S INTERIOR, SUCH AS THIS ENGLISH PRIORY AT BOXGROVE. *Right:* CANTERBURY CATHEDRAL, IN ENGLAND, ORIGINALLY BUILT IN THE SEVENTH CENTURY, FEATURES VERY EARLY LEADED STAINED GLASS WINDOWS.

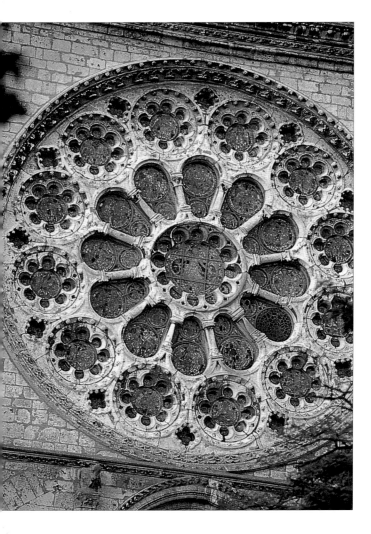

and presented. The Wissembourg Abbey was
rebuilt in the mid-eleventh century, possibly
dating the stained glass from the same peri-
od. It is important to consider that both rep-
resent only pieces of what were once larger
works. How large and how complex these
original works were and how they compared
with other stained glass of their time will
always be a mystery.

AUGSBURG CATHEDRAL

The earliest set of stained glass windows still
occupying their original site can be found in
the town of Augsburg in southern Germany.
There, in the nave of Augsburg Cathedral, is
a group of windows built circa 1100, depict-
ing the prophets Jonah, Moses (actually, the
Moses window is a sixteenth-century copy),
Daniel, and Hosea, each more than six feet
(1.8 m) tall. What is striking is the sophistica-
tion and command of technique apparent in
even these antique windows, which leads to
the idea that the art and craft of stained glass
had a history far older than these treasures
would suggest.

THE RHENISH ABBEY OF LORSCH AND THE ABBEY CHURCH OF SAINT PETER

In 1934 and 1935, excavations performed at
the Rhenish Abbey of Lorsch, near
Heidelberg, Germany, produced an impor-
tant group of glass fragments that, when
assembled, formed the head of a saint sur-
rounded by a halo. Although the painting on
this 12-inch (30.5 cm)-tall remnant is crude
and highly discolored from age, it was simi-
lar to another find made at Abbey Church of
Saint Peter, Wissembourg, in Alsace. This
second painterly head, more complete than
the other, shared many of the same styliza-
tions in the manner in which it was drawn

THE ABBEY CHURCH OF SAINT DENIS

The late twelfth and thirteenth centuries saw
a proliferation of new church building and
subsequent installation of stained glass win-
dows in all the major religious centers of

Europe. Beginning with Abbot Suger's seminal Abbey Church of Saint Denis in Paris in 1140, it seems that glaziers and their patrons never rested in their efforts to fill their new structures with the glow of colored glass. Historians estimate that during the period of 1170–1270 in France alone, 80 cathedrals and 500 churches of comparable size were begun. Many were finished within that same time period. A prodigious output, to say the very least.

Stained glass windows provided a symbolical gateway to the light of heaven and the power of God. The role stained glass played during this time is far removed from what we expect of the medium today. The Romanesque period was a time of passionate, sometimes bordering on maniacal, allegiance to religious and moral convictions. Having an art form that could reinforce and inspire awe and at the same time illustrate the events at the basis of those convictions was just what the religious leaders of the time wanted. Stained glass windows helped them keep the believers faithful.

NOTRE DAME DE CHARTRES

In the city of Chartres, 40 miles (64 km) to the south of Paris, France, stands what has become known as the Queen of Cathedrals, Notre Dame de Chartres. The construction of Chartres Cathedral began in 1145 and

১৯০১

THIS DETAIL FROM CHARTRES CATHEDRAL SHOWS THE GOOD SAMARITAN AND THE CREATION AND FALL WINDOW. EARLY STAINED GLASS EVOLVED FROM OTHER ILLUSTRATIVE ART FORMS SUCH AS MOSAIC AND ILLUMINATED MANUSCRIPTS. BOTH INFLUENCES CAN BE SEEN IN THIS EXAMPLE.

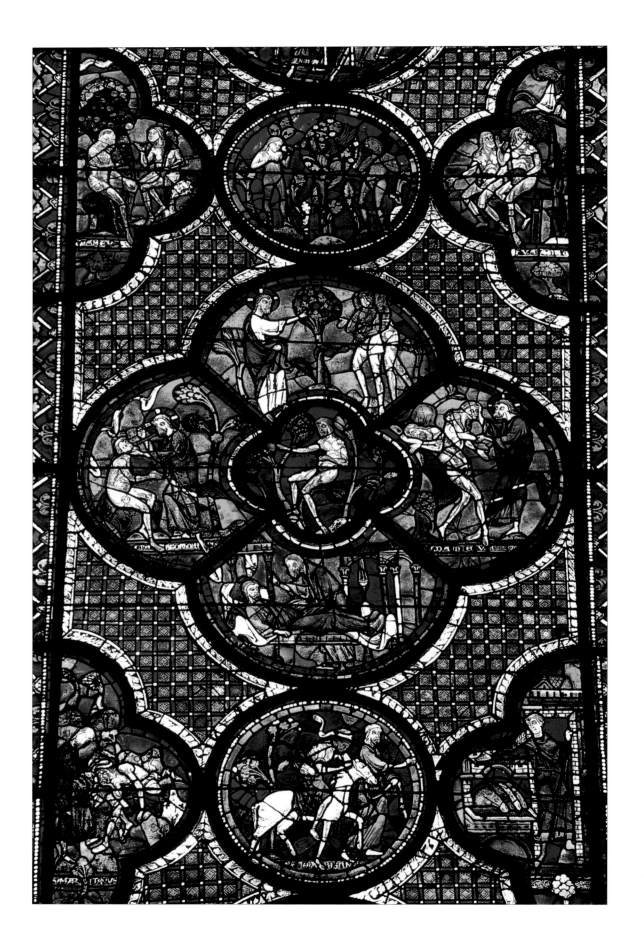

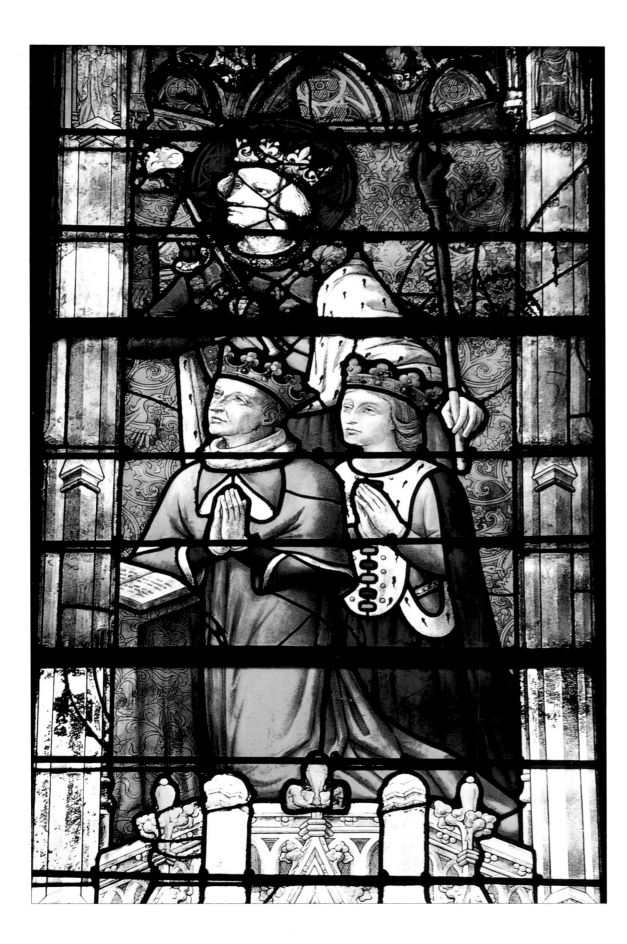

continued for almost a century. Her transept windows, the north and south extensions of the crucifix architectural form, were installed circa 1221. Chartres not only gave the world one of the great masterpieces of Romanesque architecture, but also houses a collection of stained glass windows that some claim are yet to be matched in beauty and sheer visual power.

Chartres Cathedral will always hold a special place for historians and students of stained glass for many reasons. Of all the stained glass of the twelfth and thirteenth centuries, that of Chartres Cathedral has achieved legendary status, if only by being so popular with historians of the medium. Pick up any book on the subject and you will more than likely encounter mention of, and superlatives describing, the otherworldliness of the cobalt-blue glass used throughout the building, the unusually high level of crafts-manship employed in every example of stained glass, the remarkable narrative power of each lancet (pointed window) and panel, the high degree of religious fervor that instills every piece of leaded glass, and the architectural innovations that allowed such large expanses of glass to be created. Not to be overlooked is the humbling effect that accompanies a visit to the cathedral. After extensive restorations of the original glass, performed during 1975–77, Abbot Suger's glass still astounds today's viewers with its power and glory.

PAINTED DETAILS ALLOWED THE GLASS ARTISTS OF CHARTRES CATHEDRAL TO PRODUCE IMAGERY FAR BEYOND THE RANGE OF THE MONOCHROMATIC, OR SINGLE COLOR, GLASS OF THE TIME.

Glassmaking Methods

The art of stained glass, intrinsically tied to that of Romanesque, Medieval, and Gothic architecture, progressed and flourished over the next four hundred years. The advances and innovations made both in window structure and architecture fed on one another, pushing each to higher levels of achievement. In architecture, new ways of supporting the massive cathedral walls and ceilings opened up opportunities for larger expanses of glass to fill them. Improved methods of making the glass itself, in more colors and in larger pieces, allowed yet more variety and imagination to be exercised in window design and fabrication.

From the thirteenth century on, the methods of making the raw glass changed gradually to meet the requirements of the increase in window production, which during this period could be considered a thriving, albeit specialized industry, and the demand for more and varied color, a thirst whetted by the introduction of silver stain, discussed below.

From Saint Denis and Chartres, we go to the cathedrals of LeMans and Poitiers in France and Canterbury Cathedral in England. Here, we see further exercises in the power of stained glass to alter interior light. By this time in the history of stained glass, the art was an accepted and expected addition to communal institutions of worship. The Gothic style almost dictated its use as it became one of the integral elements of this style of building.

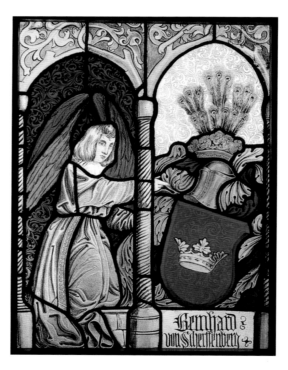

SILVER STAIN

The introduction of silver stain in the fourteenth century allowed artists a wider palette of color. Silver stain is the addition of silver nitrate to specific areas of the glass. The treated sheet is then returned to a kiln to be fired at a high temperature (about 600°F [316°C], far below glass' melting point). The chemical reacts with the glass, fusing to the material and permanently changing its color

Far left: THE WORK OF AUSTRIAN GLASS ARTISTS ECHOED THE DEVELOPMENTS IN THE MEDIUM FROM OTHER PARTS OF THE EUROPEAN CONTINENT, SUCH AS THIS EXQUISITE EXAMPLE FROM THE ABBEY OF ST. FLORIAN SHOWING THE USE OF SILVER STAIN TO CHANGE GLASS COLOR. *Left:* FROM THE SAME ABBEY OF ST. FLORIAN, THIS DEDICATION WINDOW, MADE AROUND 1523, SHOWS GENEROUS CHURCH PATRONS THE VON SCHERFFENBERGS PAINTED ON STAINED GLASS. BERNARD VON SCHERFFENBERG IS ON THE LEFT AND THE SCHERFFENBERG FAMILY COAT OF ARMS IS ON THE RIGHT. *Below:* THE GOTHIC STAINED GLASS AT THE ABBEY OF ST. FLORIAN IS VARIED, SHOWING MANY WAYS OF DECORATING THE GLASS USING PAINTING AND LINEAR COMPOSITION. HERE THE GEOMETRIC BACKGROUND SETS OFF THE DETAILED PAINTING AND SILVER STAINING IN THE FISH.

in those areas where it has been applied. Vitreous (glass) paints were used prior to this, but they were limited in their ability to add color. Silver stain (from which the term "stained glass" is alleged to have originated) and subsequent glass painting techniques that evolved from it forever impacted the dialogue between artist and material.

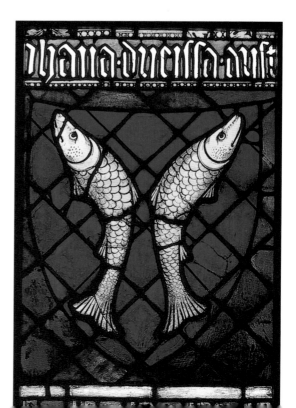

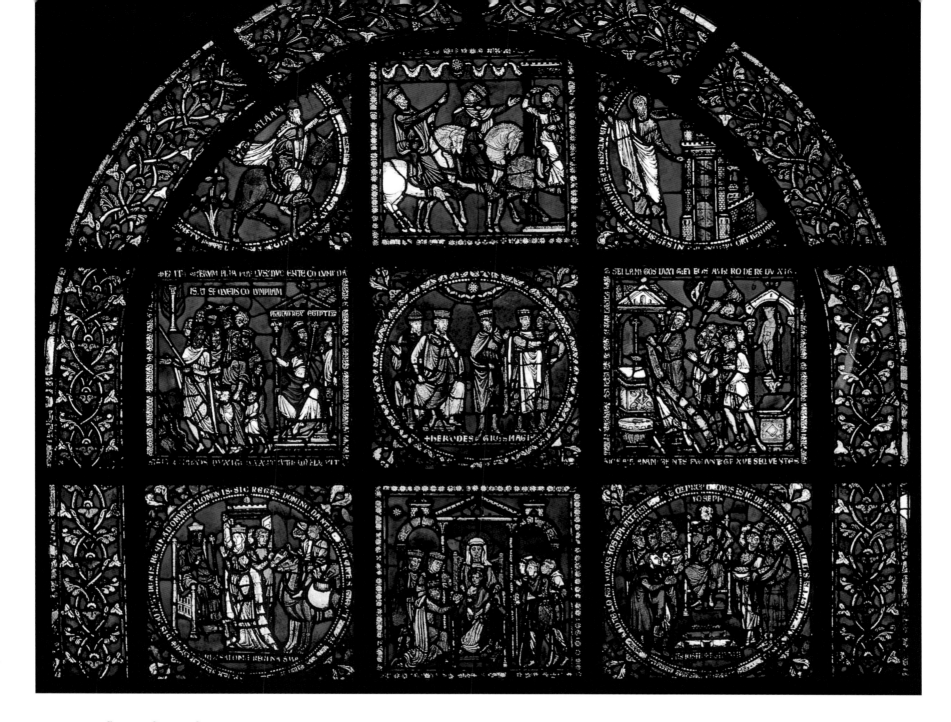

Blown Sheet Glass

Glassblowing, by this time a sophisticated art in itself, provided stained glass artisans with yet another innovation that aided the making of sheet glass. A technique was developed that allowed a glassblower to create a long cylinder of glass at the blowpipe. To begin, a mass of glass (called a gather) is taken from the glass furnace at the end of the pipe. Once formed and solid, both flat ends of the cylinder are cut away, and a long incision is made end to end along the surface of the cylinder. It is then returned to a kiln where it separates at the incision and flattens out, forming a sheet of glass. Then it is annealed (cooled). This method of glassmaking allowed for larger sheets with more texture and depth in the glass. Sheets varied in thickness, density of color, and the imperfections caused by the blowing process. These imperfections reacted with light as it passed through the sheet, adding interest to the glass.

✻

Some of the finest thirteenth-century stained glass work graces Canterbury Cathedral in England. The windows are beautifully drawn and sensitively painted. This window, in the North Choir aisle of the church, tells the stories of the three Magi.

33

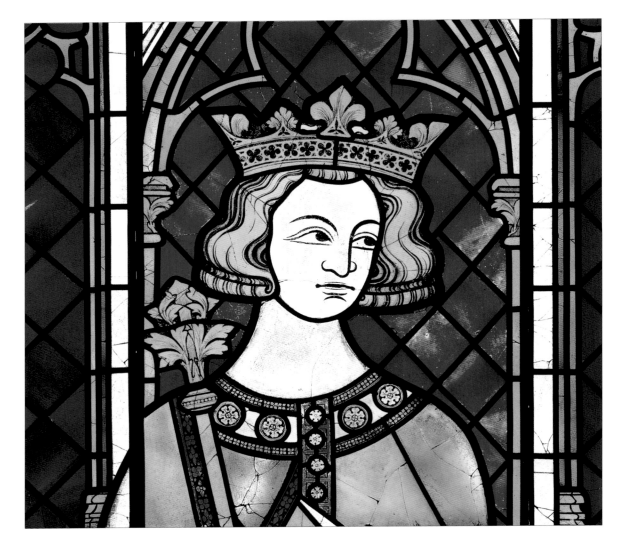

FLASHING

Another important innovation, reportedly developed in the fourteenth century, was that of "flashed glass." "Flashing" created layers of contrasting color within a single sheet of glass during the glassmaking process. The top layer of a sheet of glass was removed by abrasion or by applying acids to the surface, thereby exposing the contrasting color underneath. By controlling the areas to be etched or burned away, details could be created within individual pieces of glass. Armorial or heraldic glass designs profited from this important technique.

COLORED GLASS

Historically, color in stained glass was directly tied to the emotions. The meditative, other-worldly feeling one gets from entering a church, synagogue, or interior where stained glass filters the interior light is no fluke of happenstance. Colors known to achieve that certain effect were intentionally called upon for their emotive powers. The juxtaposition of deep blues and rich red, set off by the intermittent action of another jewel-like color, perhaps gold or yellow, has traditionally been at the top of the list of glass colors that can soothe and hush. In

another context, these same colors can present the majesty of heraldic design. In such heraldic windows, such as those found in Germany's Cologne Cathedral, the richness

and splendor of armorial decoration was
intensified by the power of stained glass.

Proficient users of colored glass win-
dows acknowledged the physical distance
between glass and viewer as both a design
and coloristic concern. Taking the lead from
fresco painting and mosaic, glass artists
scaled their outlines and cartoons (designs)
to compensate for such distance and manipu-
lated color choices to guide the eye to impor-
tant aspects of the work. This was especially
true where illustrative elements or narrative
were essential.

GLASSMAKING CENTERS

Despite the improvements in its manufacture
and handling, the basic makeup of glass
remained constant up to the end of the nine-
teenth century. Until then, little is document-
ed concerning the choice of particular
glasses over others or their source of manu-
facture. Historical accounts describe sheet
glass being made at the site of installation by
the group of artisans building the windows.
Considering how much stained glass was
constantly under construction during this
period, it is not too far-fetched to think that
centers of glassmaking or certain manufac-
turers of the material were established to
alleviate the labor and time- intensive nature
of window building by producing the glass in
larger quantities off site. Unfortunately, not

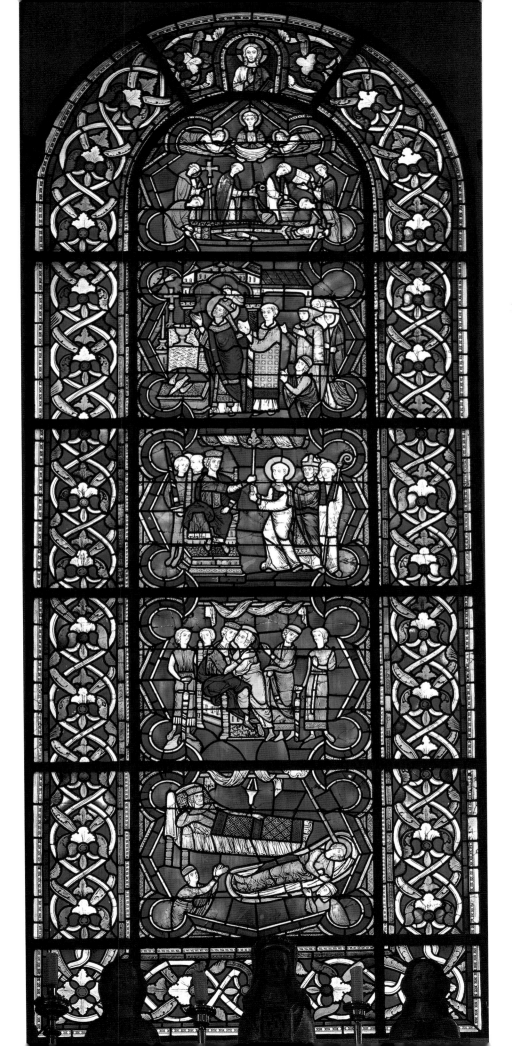

many, if any, records survive concerning such firms or sheet glass-making centers, other than the isle of Murano in Italy, which was best known for producing glass objects rather than sheet glass.

The Emergence of the Glass Artist

As the visual possibilities of stained glass improved, more artists from other media, especially painting, were called upon to render designs, or cartoons, for stained glass windows, a movement that would repeat itself during the twentieth century. The use of silver stain in the fourteenth century was a boon to traditional painters, as the preference for painterly stained glass meant their skills would be in demand. This development prompted some of the period's most outstanding works, such as the windows of York Minster in England and the surviving panels of both León and Bourges Cathedrals. Ironically, the emphasis on painting would later contribute to the medium's most lackluster examples.

With this development, we begin to find names attributed to some of the works, albeit in a far less reliable fashion than that of

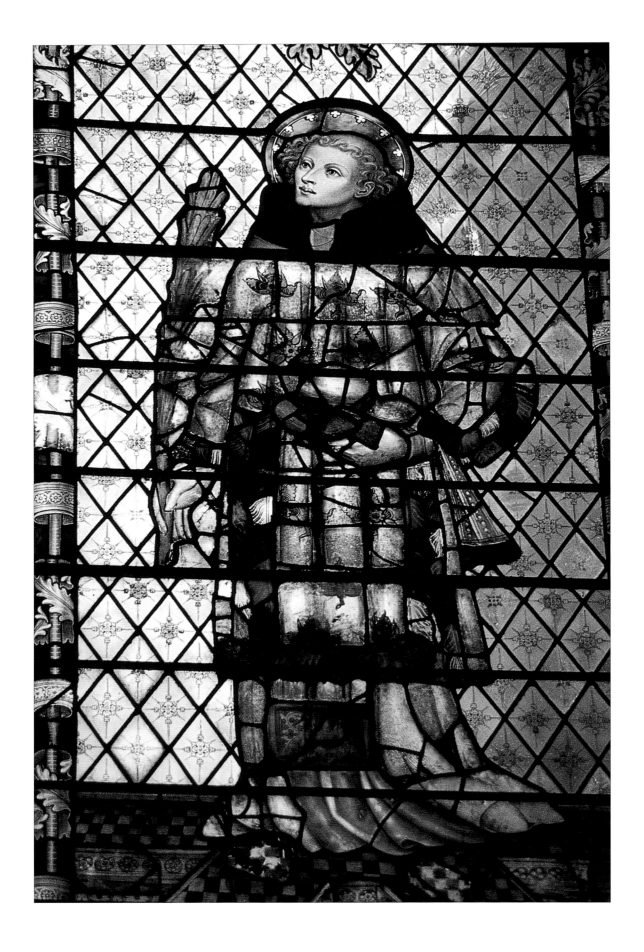

CERTAIN VISUAL CONVENTIONS BEGAN TO APPEAR AS THE ART OF STAINED GLASS PROLIFERATED. IN THIS YORK MINSTER WINDOW, THE PAINTING ON THE FACE AND GARMENTS ENHANCES THE STAINED GLASS WORK WITHOUT OBSCURING THE EXPRESSIVENESS OF THE GLASS ITSELF. THE DIAMOND GRID BACKGROUND SUPPLIES AN ANGULAR CONTRAST TO THE NATURAL LINES OF THE FIGURE.

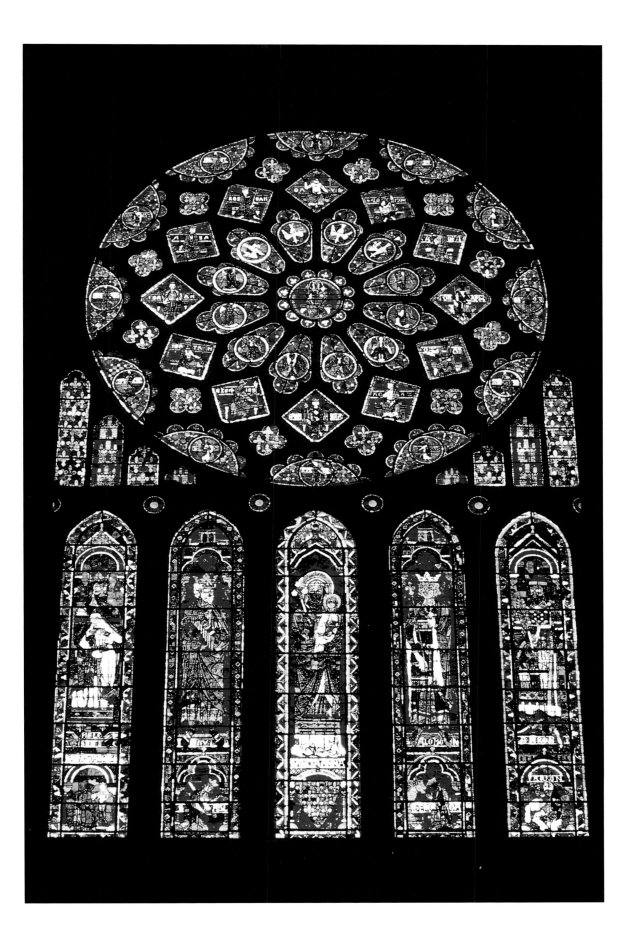

painting or sculpture. It seems that painters, accustomed to the rewards of identifiable authorship, were not likely to be relegated to the anonymity to which glass artisans had then surrendered. If they were to employ their talents, they would seek the appropriate credit for doing so. This brings a new character to the field of stained glass: personality. As painters, or glaziers trained as painters, became familiar with the disciplines of working in stained glass, they naturally found ways to bring their own styles to their commissioned works. In France, for example, we find the names of André Robin, Peter Hemmel, and Jean Prévost attributed to works in Angers Cathedral, the Church of St. Madeleine in Strasbourg, and St. John of Lyon, respectively. In England, the work of John Pruddle, who worked under King Henry VI on the stained glass in Westminster Abbey, is of note. As glass artists and designers gained prominence throughout the continent, more and more were called from their homelands to satisfy commissions abroad, a natural by-product of their success and subsequent fame. By now in the history of the medium, these artists were also being employed to maintain and restore stained glass that needed repair. Restoration began to play a larger role in the industry of stained glass in later centuries.

As the glass artist emerged as a professional called upon for his unique skills, the

THE NORTH ROSE WINDOW OF CHARTRES CATHEDRAL (MADE CIRCA 1230) SEEMS A CACOPHONY OF SHAPES AND COLOR UNTIL THE STRICT GEOMETRY OF THE DARK TRACERY EMERGES TO EXPOSE THE UNDERLYING PATTERN. DOZENS OF ARTISANS MUST HAVE WORKED TOGETHER TO CREATE THIS WINDOW, BUT FEW ARE KNOWN BY NAME.

profession gained in privilege and favor. King Charles V of France, for instance, created tax exemptions for glaziers on many occasions, beginning at the end of the fourteenth century. One wonders how much of an incentive this provided to artists seeking to add stained glass to their repertoire of services. Consider what an impact a similar exemption would have on the field today!

Glass Workshops

The crafting of a stained glass window is not like that of a painting. It is not as portable or as autonomous as a painting might be in terms of size or subject matter. In the scale of works being created for the cathedrals, churches, and palaces of the fifteenth century, stained glass required a team of artisans to execute and install. Although the cartooning, or designing, of a window or even a suite of windows could easily be accomplished by one person, building the actual windows could not. Thus emerged the glass workshops, production centers where the fabrication of the glass took place under the guidance of a master glazier, or designer. Such workshops, like that of Jacob Acker of Ulm, Germany, created windows from painters' cartoons.

Strasbourg, France, became a center of stained glass activity largely because of master glazier Peter Hemmel. Enjoying considerable fame, Hemmel's influence stretched from Alsace to Salzburg. His windows were constructed at his own workshops and then transported to wherever they would be installed. Examples of Hemmel's glass originally installed in the Church of Saint Madeleine can be seen today in the Musée de l'Oeuvre Notre Dame.

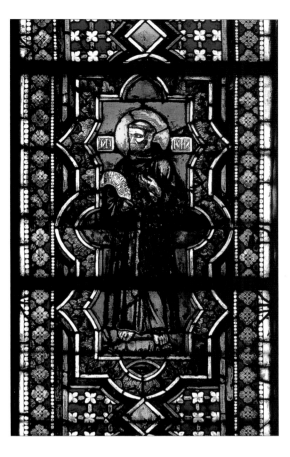

Opposite: The stained glass windows of Georgetown University, in Washington, D.C., created hundreds of years after their medieval and Renaissance predecessors, continue both the tradition of religious stained glass windows and that of glass workshop craftsmanship. *Left and above:* Note the contrast between stained glass techniques used in the transept window of Canterbury Cathedral *(left)* and a window depicting St. Francis at St. Martin's Chapel in Assisi, Italy *(above)*. The leadlines of the Canterbury window, which depicts genealogical figures from the Old Testament, fall in convenient places on the figures while the colored glass pieces show the drapery of their robes. The detail of St. Francis, on the other hand, shows sensitivity to design and composition, but the leadlines are heavy and they cut the head of figure from the body. In addition, painting rather than glass is used to suggest the drapery of the saint's robes.

ITALIAN STAINED GLASS

It's curious that in Italy, where artists exerted such an intimidating influence in other media, stained glass never quite enjoyed the renaissance other media would. Despite the fact that accomplished draftsmen, such as Lorenzo Ghiberti, Paolo Ucello, and Donatello, whose names loom large in the Renaissance, created cartoons for stained glass works in Florence Cathedral, Italian glass seems to lack the grace and elegance of neighboring glass centers. Leadlines, the outlines of metal surrounding all the pieces of glass, seemed forced, their colors harsh, and the pictorial elements looked cramped—busy-ness abounds. The painting is exceptional, but the feeling is not there. Perhaps in Italy we find the germ of decay that would characterize the state of the art during the sixteenth through eighteenth centuries, a period during which much of the stained glass produced seemed self-indulgent, confused, and misguided. Although the thirteenth through fifteenth centuries were blessed with imagination and discovery of what the medium of stained glass could accomplish, many glass critics and historians contend that the next two hundred years were painfully uneventful, though the art began to thrive again in later centuries.

Right: THESE EXAMPLES OF ITALIAN STAINED GLASS FROM THE MAIN CHAPEL OF SANTA CROCE IN FLORENCE, ITALY, SHOW HOW ITALIAN ARTISTS USED PAINTING ON GLASS MORE THAN THE EXPRESSIVE NATURE OF THE GLASS ITSELF TO CONVEY EMOTIONS. *Opposite:* NOTRE DAME DE PARIS, IN FRANCE, WITH ITS MAGNIFICENT ROSE WINDOW, IS AN EXEMPLAR OF GOTHIC ARCHITECTURE.

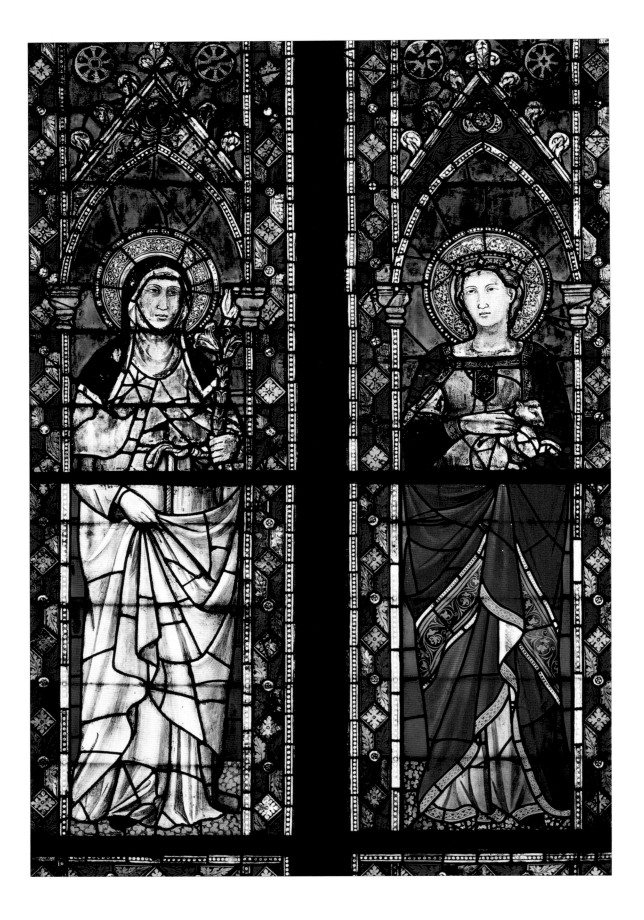

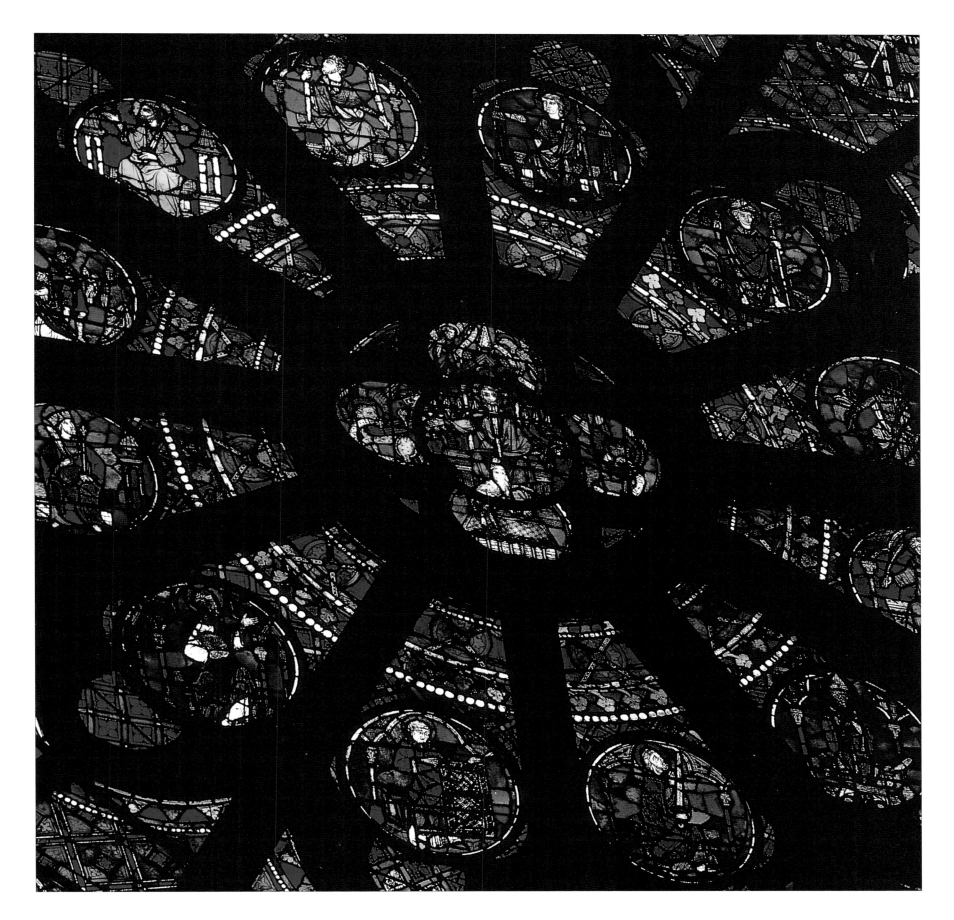

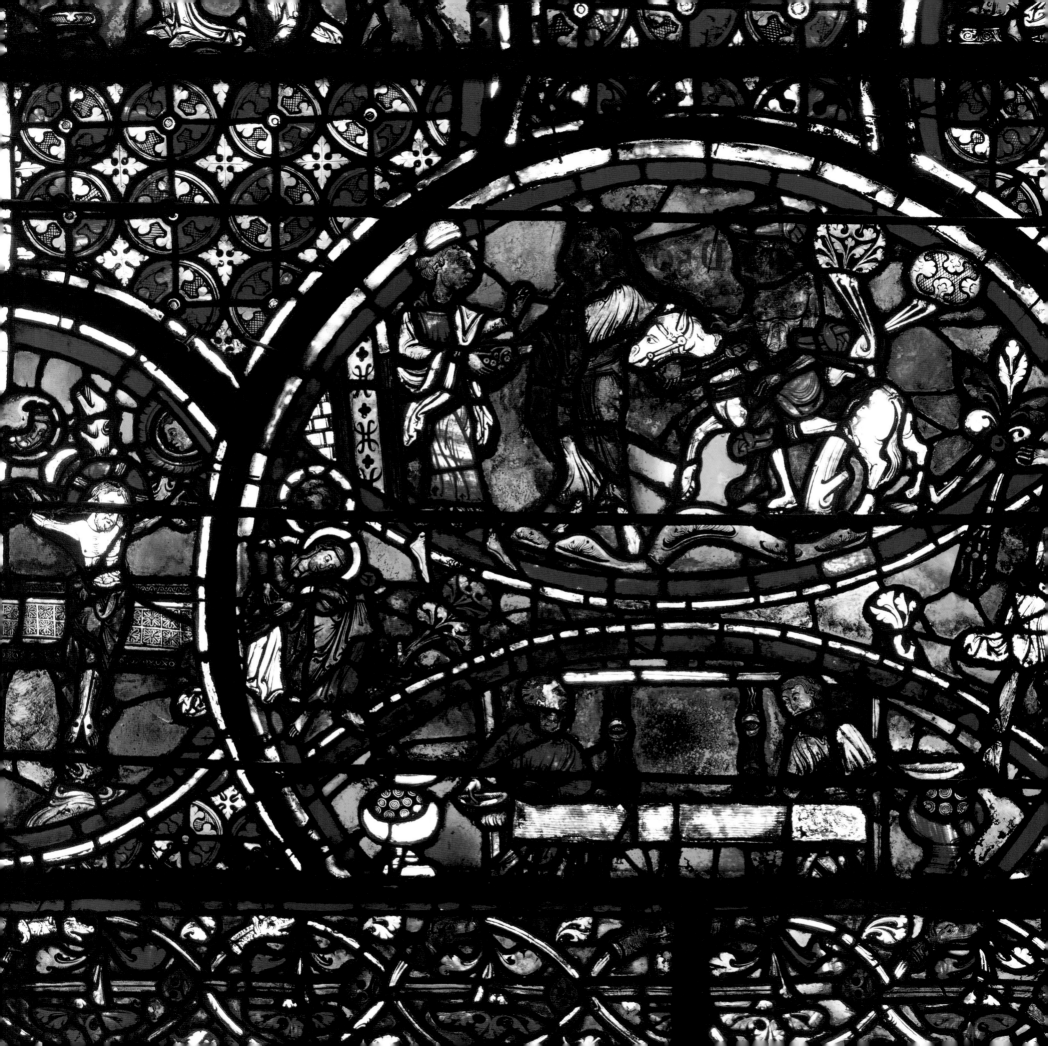

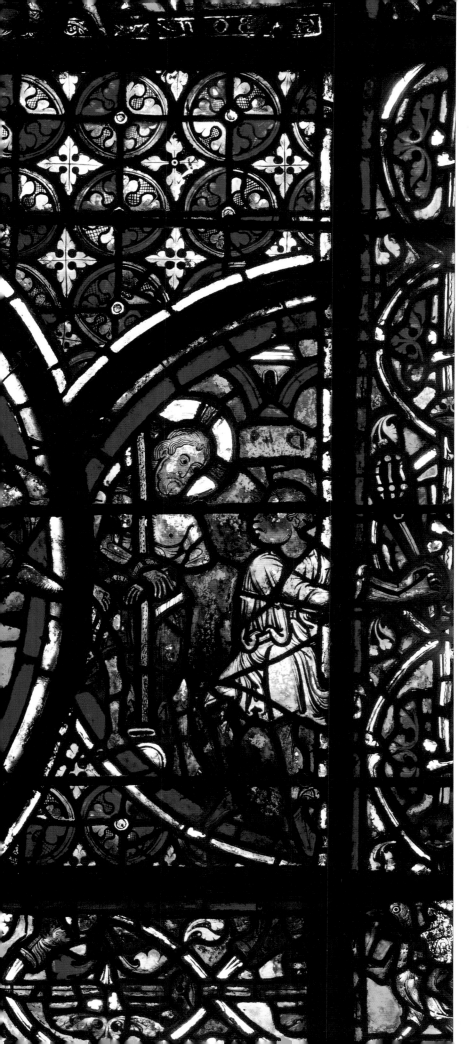

THE FALL AND RISE OF STAINED GLASS

Much has been written about how the sixteenth, seventeenth, and eighteenth centuries represented a dark period for the art of stained glass. Many scholars and critics contend that political,

THE GLASS OF BOURGES CATHEDRAL IN FRANCE IS RIVALED ONLY BY THAT OF CHARTRES. BRIMMING WITH ALL THE POWER OF THIRTEENTH-CENTURY STAINED GLASS, THEY STILL INSPIRE AWE IN GLASS LOVERS AND ARTISTS ALIKE WITH THEIR SCALE AND COMPLEXITY. IN THIS MEDALLION WE SEE THE GOOD SAMARITAN AND, BELOW, THE GUILD OF WEAVERS, DONORS OF THE WINDOW.

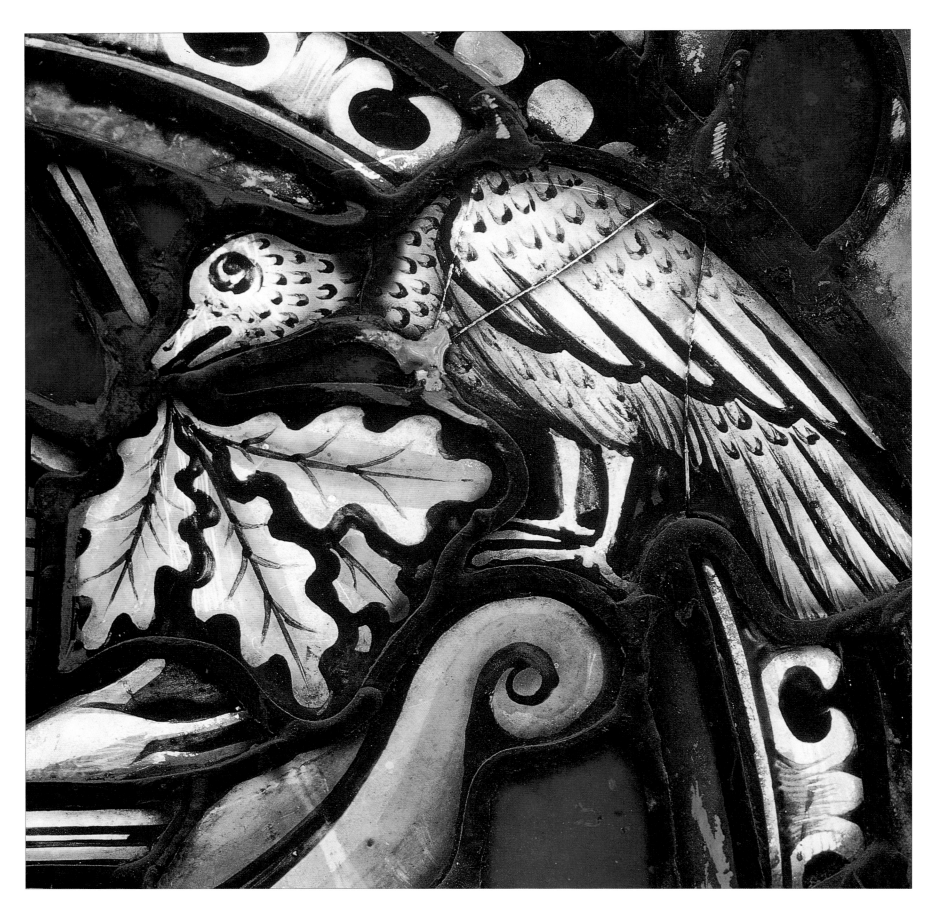

Opposite: A DETAIL OF NOAH AND HIS ARK, CIRCA 1270, ORIGINALLY FROM THE CHURCH OF WIMPFFEN IM TALE IN DARMSTADT, GERMANY, SHOWS THE GREAT ATTENTION TO DETAIL PAID BY GERMAN GLASS PAINTERS. THESE DETAILS WERE PRODUCED BY APPLYING PIGMENT TO THE COLORED GLASS AND FIRING THE GLASS IN A KILN TO MAKE THE PAINTING PERMANENT. *Above:* ANOTHER PAINTED DETAIL FROM THE SAME WINDOW SHOWS GRASS GROWING AFTER THE FLOOD.

∞

religious, and aesthetic pressures exerted unfortunate influences upon the medium. Many reasons worked in concert to stagger the evolution that had moved steadily onward for three hundred years. Ironically, much was accomplished on the technical front to allow artists more control over their materials and more freedom in their artwork despite the pressures that proved detrimen-tal. During the middle to latter part of the nineteenth century, these accomplishments would help rekindle interest and activity in stained glass, setting the stage for the great achievements that would follow.

Technical Improvements

A series of technical advances gave glass artists of the sixteenth, seven-teenth, and eighteenth centuries more aesthetic freedom. One semi-nal development was so basic and practical, it is still in use today. It has to do with the way the individual pieces of glass were cut to form varied shapes.

It was discovered that a diamond could aid in the cutting of glass; indeed, to such a degree that absolute precision could be achieved. The diamond would score a fissure fractions of an inch deep into the surface of the glass. The glass could then be broken along this "score" by separating the areas of glass on either side of it. With good control, a glazier could almost draw freely as he ran the diamond across the glass. This simple but powerful innovation allowed more detail to be built into glass design as smaller and more predictable shapes could now be cut.

The diamond cutting technique spread quickly throughout the world of stained glass, completely replacing older methods, such as the use of heated rods to cause glass to break. The diamond method is so basic and effec-tive, the concept is still in use, although the diamond in most cases has been replaced with a steel or carbide cutting wheel that spins against the glass surface in order to create a score.

Painted Glass

The developing chemistry of making glass constantly offered more colors to the stained glass artists' palette. New pigments, similar to enamel paints, allowed repeated applications of color to the glass along with repeated kiln firings. This layering of color produced more painterly results than ever before. If glass of the sixteenth through eighteenth centuries is to be criticized for mimicking the art of painting, it's a bit unfair. Artists in the field, many trained as painters, found they could create many of the same pictorial effects on glass as on canvas, and they did so.

The emphasis on painting brought with it the visual characteristics of the medium. Less and less do we find stained glass images tied to only two dimensions. Perspective, that pictorial fascination of the early Renaissance, easily found its way into glass works as did the portrayal of landscapes behind the primary images. The ability to add a third dimension of depth to stained glass window design is responsible at once for some of the most difficult stained glass art of the period and some of the very finest.

SAINT JAMES AT THE BATTLE OF CLAVIJO AT THE CHURCH OF NOTRE DAME-EN-VAUX

At the unfortunate end of this preoccupation, we should take a look at the window entitled *Saint James at the Battle of Clavijo* by artist Mathieu Bléville, which was installed at the Church of Notre Dame-en-Vaux, Châlons-sur-Marne, France, as an example of sixteenth-century glass fascination at its extreme. In this painfully crowded scene, although the

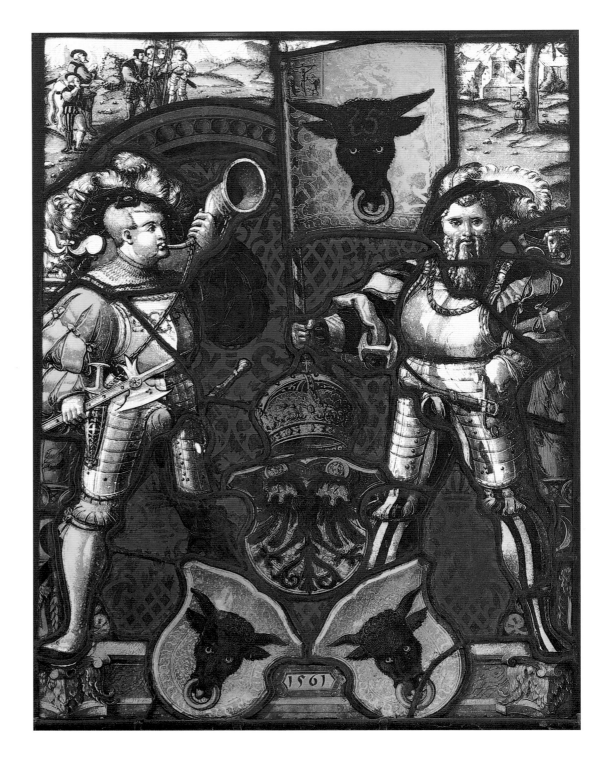

cacophony of battle is certainly brought out in the work, it is so hard to read the imagery, the colors are so dizzying, and the attempts at perspective so crushed into the hard geometric tracery of the window openings, that the results are awkward, at best. Two elements, though, are masterfully executed. The leadlines are carefully placed, allowing them to blend into the imagery without distracting, and the painting is beautifully done.

Opposite: BY THE SIXTEENTH CENTURY, GLASS DESIGN HAD LOST ITS ELEGANCE IN CERTAIN CIRCLES. THE USE OF STAINED GLASS TO CELEBRATE PAGEANTRY AND FOR HERALDIC PURPOSES PRODUCED VARIED RESULTS. HERE THE PICTURE PLANE IS CROWDED, DISORGANIZED, AND OUT OF PROPORTION AND PERSPECTIVE (CIRCA 1551). *Left:* THE INTELLIGENT USE OF LINE AND COLOR DISTINGUISHES GREAT STAINED GLASS. IN THIS WINDOW FROM SAINT WINOWS CHURCH IN CORNWALL, ENGLAND, THE ARTIST RESPECTS THE OUTLINE OF THE HALOES AND FACES BY NOT ALLOWING THE LEADLINES TO INTRUDE OR DISTRACT.

SAINT JAMES AT THE BATTLE OF CLAVIJO IN BOURGES CATHEDRAL

Easier on the eyes, and a far better example of painted glass is *Saint James at the Battle of Clavijo,* in the Baptismal Chapel of Bourges Cathedral In this richly painted window, created circa 1619, we find the virtues of sixteenth-century glass a bit sobered and matured. Within heavy tracery, remnants of medieval glass (the tracery and lancets themselves) were combined with a recent innovation in visual technique, that of employing numerous openings in the wall to portray one continuous and grand design. In older glass windows, each lancet would be used for its own purpose, usually the depiction of one saint or personage. In Bourges, the artist takes advantage of the larger area not only to spread his design out like a mural, but also to split the window into two separate screens, as it were. At the top of the work, enclosed in the complex of curving tracery (called the tympanum), The Assumption of the Virgin is depicted. The lower lancets occupying the largest area of the window depict the

Apostles, performing the title of the work.
They are united by the sequence of the event.
At the left and right bottoms of the panels are
depictions of the donors (patrons) of the
work in glass, in this case the Maréchal de
Montigny and his wife, Gabrielle de Crevant.
Although a better example in general than
that mentioned above, the Bourges
Cathedral window does not share the same
expert handling of the leadlines as the Notre
Dame-en-Vaux effort. The dark seams dissect
faces, robes, scenery, and details without any
regard for linear grace or composition. They
appear haphazard.

REYNOLDS' NATIVITY WINDOW

This discussion of painted glass would be in-
complete without mentioning one
eighteenth-century stained glass window
designed and painted by Sir Joshua
Reynolds for the New College Chapel of
Oxford. Executed by Jervais of London in
1778, it has the dubious distinction of being
probably the most criticized painted window
in all of glass history. The subject matter, the
Nativity (the birth of Jesus), is lost to the
controversy surrounding just about every
aspect of the work: its setting, the painting,
the poor choice of colors, its inconsistent
imagery, and how it sticks out like a sore
thumb in the company of neighboring fif-
teenth-century glass. Reynolds' work didn't
stand a chance. Nonetheless, it still remains
in the Oxford Chapel. Time has justified its
existence, if only as an example of how an art-
work can withstand the heat and indignity of
its censors.

ITALIAN PAINTED GLASS

Italian stained glass of the period encountered its own struggles with emerging technique and the painterly style. In a country where the Renaissance was manufactured and distributed, glass artists, it seems, felt obliged to make their glass look as much like a canvas as they possibly could. If we take the example of Arezzo Cathedral, where glass by Guillaume de Marcillat includes a series of biblical illustrations, we find the painterly influence at its strongest. The emphasis here is on structure, detail, form, and color. All are done with precision and skill, but we have to be reminded that we are looking at glass. That in itself is not bad, as much of the glass of later centuries thrived on that quality, yet it does fan the critics' fire that the glass was no more pertinent to the image than canvas or plaster would be to painting. In an effort to become more like painting, the work became less and less like glass. The magic glow of medieval glass was being replaced with a greater emphasis on pictorial power.

Left and above: IF NOT THE MOST BEAUTIFUL WORKS IN STAINED GLASS, HERALDIC WINDOWS HELPED PRESERVE THE ART AND CRAFTING OF STAINED GLASS DURING THE YEARS OF ITS DECLINE IN POPULARITY. THEY ALSO REPRESENT THE EARLIEST DOMESTIC STAINED GLASS. THESE TWO WINDOWS ARE IN WINCHESTER, ENGLAND.

Heraldic Glass

One byproduct of the period, and one that deserves mention here, is the "Armorial" or "Heraldic" style of window. In these gems of stained glass work, we find the growing popularity of a secular, more private type of commission. Artists in service to patrons of wealth and social standing were called upon

Far left: A COLLECTION OF FAMILY COATS OF ARMS IS RATHER UNUSUAL SUBJECT MATTER FOR A CHURCH WINDOW SUCH AS THIS ONE, BUT PERHAPS THIS WINDOW WAS CREATED TO HONOR MEMBERS OF THE CONGREGATION WHO SUPPORTED THE CHURCH. *Left:* THIS 1588 WINDOW, WHICH COMMEMORATES A MARRIAGE BETWEEN TWO FAMILIES BY COMBINING BOTH COATS OF ARMS, IS FROM GEORGE WASHINGTON'S FAMILY'S ANCESTRAL HOME, SULGRAVE MANOR, NEAR BANBURY IN ENGLAND. THE WASHINGTON COAT OF ARMS IS ON THE LEFT HALF OF THE SHIELD.

out competing with the central image for the attention of the viewer. No doubt much heraldic work served egos more than anything else, yet the style offered another avenue of expression, albeit curbed to specific needs, for period glass artists and glaziers.

Rediscovery and Revival

The state of the art of stained glass by the nineteenth century was poor. A telling quote by one Charles Nicholas Cochin, made in response to a petition to the Superintendent of the King's Buildings by Frenchman Jean-Adolphe Danneker, hints at the popular attitude of the day: "In truth, use is no longer made of it [stained glass] because neither in apartments nor even churches do people want anything that may diminish the light. Thus, in the event of it being proved that it [the art of stained glass] had been lost and that it had been rediscovered, people would not know what use to make of it." Not an encouraging testament to the lasting power of stained glass!

to glorify events, honors, family crests, and the like. In doing so, they not only found a new application for stained glass, but also a more sophisticated use of sixteenth-century technical innovations.

Heraldic designs usually consisted of a central shape, either a circle, shield (escutcheon), or similar geometric form upon which heraldic symbols or dramatic scenes could be painted. They would be surrounded by a quiet, unassuming geometric pattern, such as continuous diamond patterns, chain links, or stylized lattice work. Some heraldic works were more complex than others, but the overall concept held true in most cases despite the complexities. The style required that the focal point of the work would be the heraldry, and to that end any surrounding glass could not, or should not, distract. The background design was to support the illustrative sections of the work with-

However, a curiosity of the nineteenth century was its preoccupation with antique items. The Gothic Revival was kicked into gear by enthusiasts such as Horace Walpole, who went so far as to employ one of the few glass craftsmen left in England at the time, William Price, and had him restore and install stained glass windows in his Strawberry Mansion.

Early efforts, heroic considering how obscure the art had become, were nonetheless poor. Colored glass of any decent quality could not be found. Any restoration of old windows or commissions for new ones were at the mercy of what raw materials and skilled artisans could be found. And the pickings were slim. In 1849, Charles Winston, a glass hobbyist of the period, wrote a book containing drawings of medieval stained glass. With the help of Whitefriars Glassworks, one of the most underrated of nineteenth-century British glass factories, Winston sought to rediscover the methods of medieval flat glassmaking. His efforts, and that of others throughout the continent, set into motion a series of events that would cull a new beginning for the art and craft of stained glass from the debris of generations of destruction and neglect.

Glass continued to intrigue glassmakers and enthusiasts to the point that experimentation and research continued, regardless of the inadequate results. On the popular front, interest in stained glass windows increased as interior decoration increased. Between the years of 1828 and 1854, the factory of Sèvres was commissioned by King Louis Philippe to create windows for the royal chapel at Druex. The painters Jean-Auguste-Dominique Ingres and Eugène Delacroix, leading art figures of

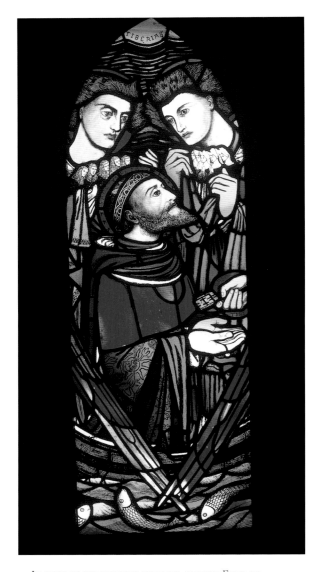

In the mid-nineteenth century, painter Edward Burne-Jones and designer William Morris rediscovered stained glass and used it in many of their interior designs. *Above: The Call of St. Peter,* designed by Burne-Jones and executed by James Powell and Sons in 1857, offers a more dramatic twist on a traditional religious theme. *Opposite:* William Morris' Painting from *King Rene's Honeymoon* Series, done in 1862, shows how stained glass was becoming a more decorative art rather than a religious one. Today the window is in the collection of the Victoria and Albert Museum, in London, England.

the day, produced the figurative cartoons for the windows; the borders were designed by another important figure in the plight of nineteenth-century stained glass: the talented architect, artist, and writer Eugène-Emmanuel Viollet-le-Duc.

In Viollet-le-Duc, we find an interesting combination of historian, architect, restorationist, writer, and glass enthusiast. As a product of the nineteenth century, he had the required curiosity in medieval decorative arts combined with a position of influence as inspector general of the French Commission des Monuments Héroiques. With Viollet-le-Duc, we encounter what could very well be the birth of modern stained glass restoration and conservation.

In 1861, England's William Morris, along with painter Edward Burne-Jones, founded Morris & Co. Ltd., a decorative arts firm that would exert its influence upon many facets of the decorative arts, including stained glass, well into the twentieth century. In addition to their strong painterly attitude toward the stained glass they produced, Morris & Co. considered decoration an essential part of the entire structure. The firm and its school of professionals not only sought to design the glass, but also the furniture, fabrics, wallpapers, and so on that would make up the entirety of buildings or homes. Following their example, the firms of Louis C. Tiffany, John LaFarge, and later Frank Lloyd Wright would seek the same extensive influence in their architectural and interior design commissions in the years to come.

These efforts, as well as others throughout Europe and the United States, were given great encouragement by the proliferation of Universal Exhibitions held regularly begin-

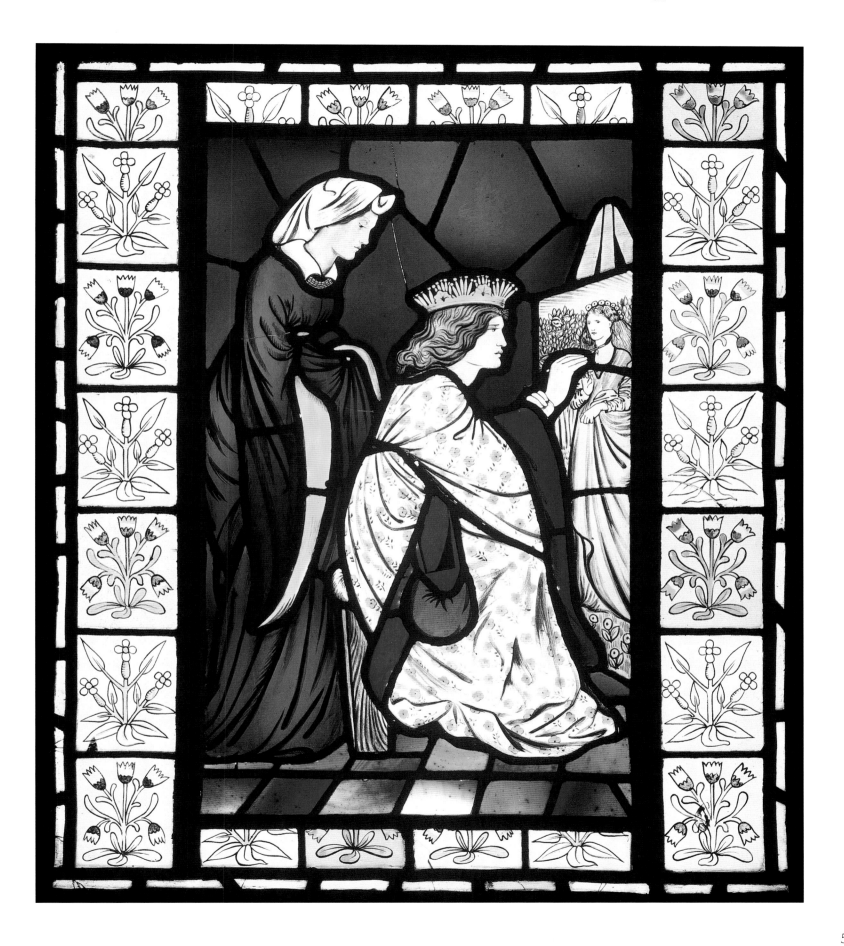

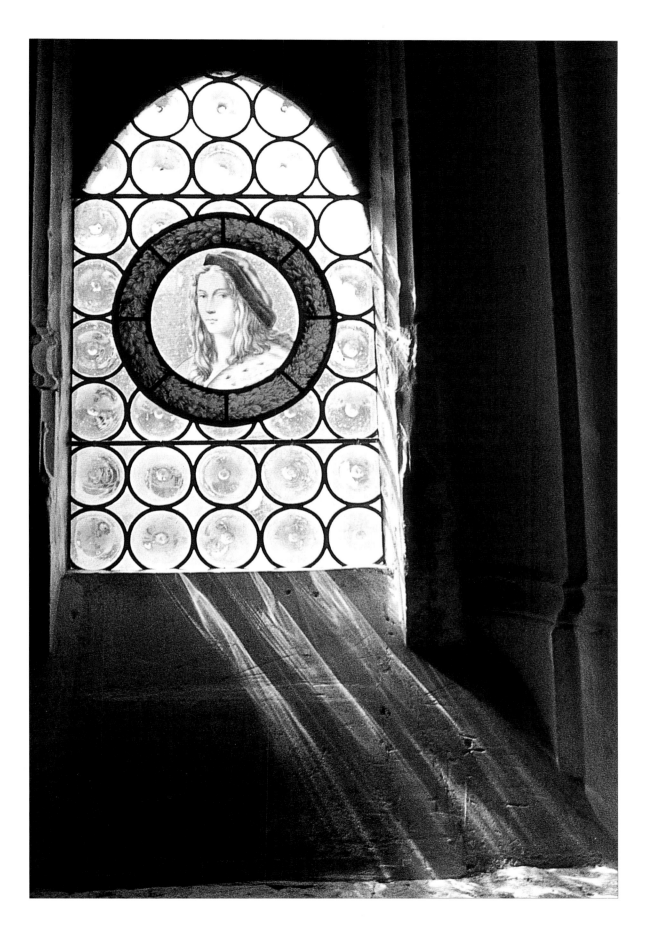

Opposite: THE FORMAL SPANISH FLAVOR IS EVIDENT IN THIS WINDOW DEPICTING KING ALFONSO VIII, FROM THE NARAS OF TOLOSA. THE ROUGHLY SQUARE GLASS PIECES IN THE BACKGROUND EVOKE STONE WALLS THE KING MIGHT HAVE CONQUERED. *Left:* THE SMALL CIRCLES THAT MAKE UP THIS WINDOW FROM THE CHATEAU CHAUMONT IN THE LOIRE VALLEY, FRANCE, ECHO THE LARGE CIRCLE OF GLASS ON WHICH THE FACE OF THE YOUNG MAN, CLEARLY AN IMPORTANT PERSONAGE AT THE MANOR TO BE DEPICTED SO PROMINENTLY, IS PAINTED. GLASS PORTRAITURE IS SIMILAR TO HERALDIC GLASS IN ITS USE TO PORTRAY SECULAR AS OPPOSED TO RELIGIOUS IMAGERY.

ning about halfway through the nineteenth century. At these very popular and highly publicized international events, stained glass studios and artists, as well as other members of the decorative arts communities, could display their best works in an effort to attract patronage and the prestige of recognition. Stained glass enjoyed the special privilege of being made part of the display pavilion's architecture. Competitions provided yet more inspiration for makers to show their most outstanding works.

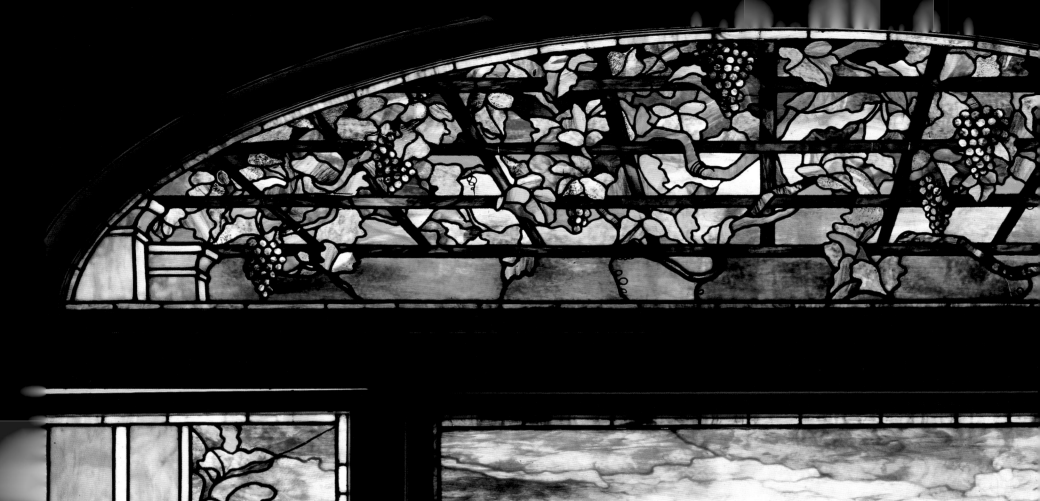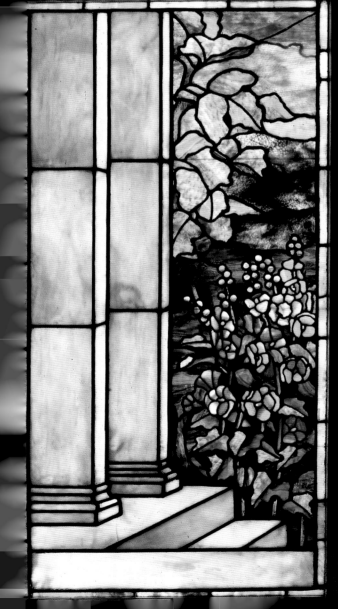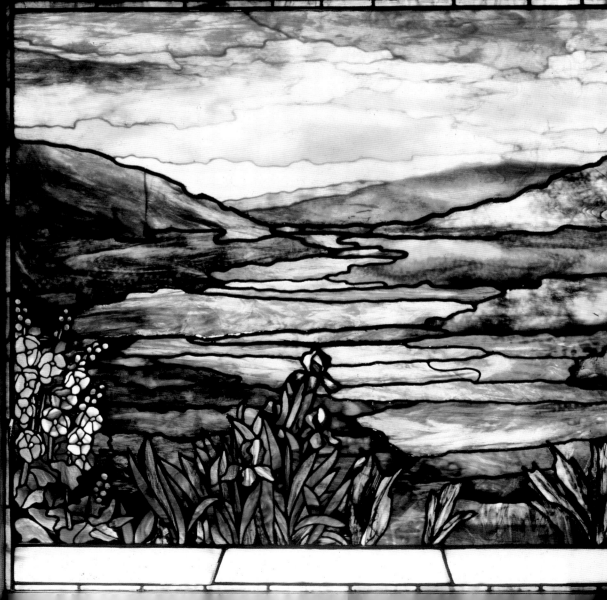

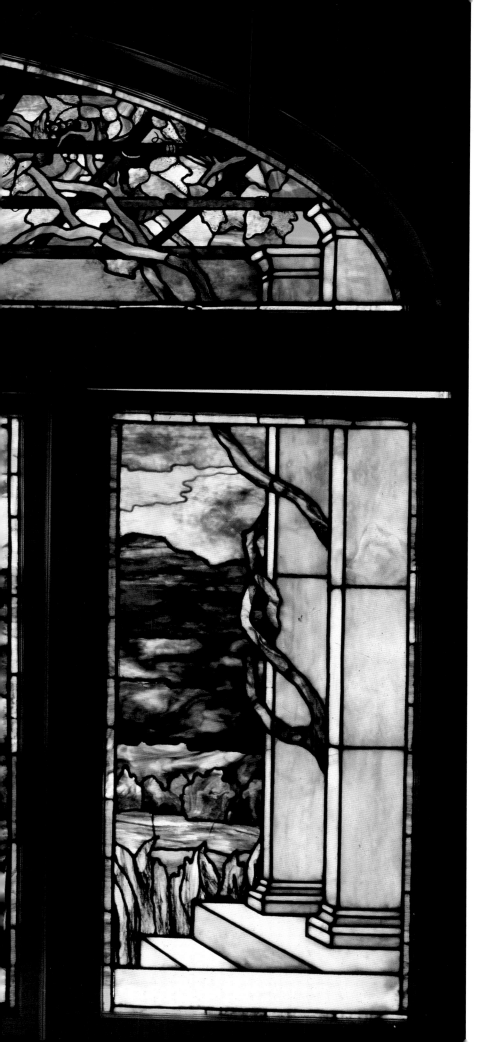

LAFARGE, TIFFANY, AND THE AGE OF AMERICAN ART GLASS

One of America's first industries was glassmaking. Jamestown, Virginia, settled in 1607, was the site of America's first glassmaking efforts. The New-York Historical Society has examples of small, painted, coat-of-arms

THE TIFFANY STUDIOS NOT ONLY CHANGED THE WAY STAINED GLASS LOOKED; THEY ALSO CHANGED THE WAY IT WAS MADE. LOUIS COMFORT TIFFANY'S BACKGROUND AS A PAINTER SHARPLY INFLUENCED HIS EXTENSIVE WORK IN STAINED GLASS. HE WANTED GLASS THAT WOULD CAPTURE THE PAINTERLY EFFECTS OF A BRUSH AND SO CREATED OPALESCENT ART GLASS TO USE IN HIS WORKS, SUCH AS THIS DRAMATIC LANDSCAPE WINDOW.

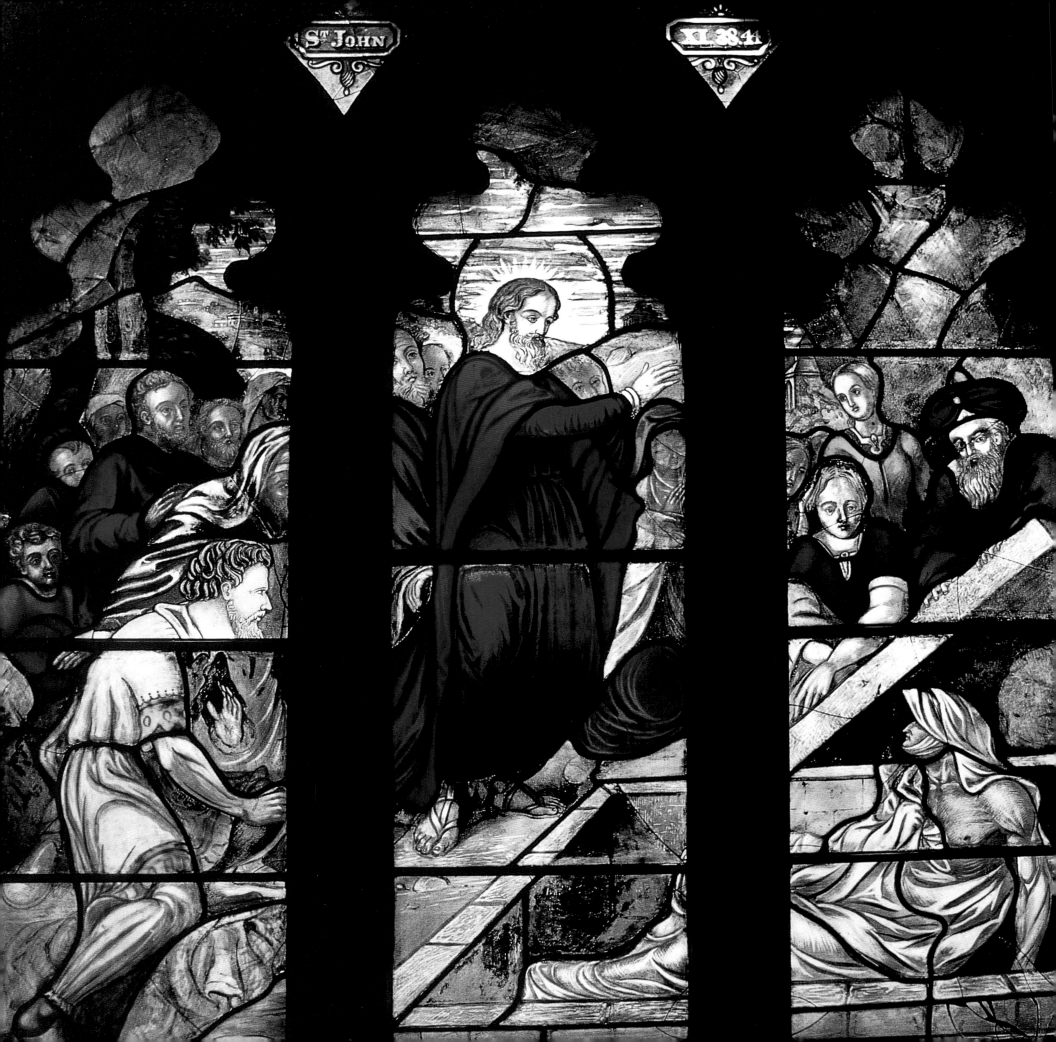

Not until the nineteenth century were American churches able to afford major stained glass works of art. The Bolton brothers created important stained glass windows that carried on European tradition; their work in Trinity Church *(above)* of Brooklyn, New York, stands out as some of their finest. *Opposite:* All three parts of a Trinity Church window are used to tell the story of Jesus raising Lazarus from the dead. *Right:* Different colored glass, painting, and silver stain combine to create this portrait of Jesus at Trinity Church.

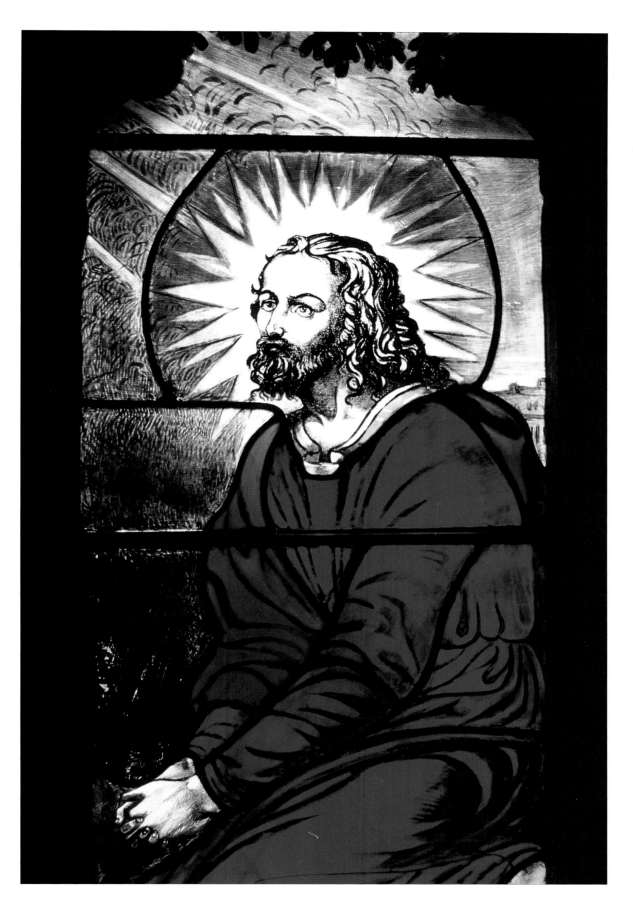

style windows that adorned Dutch homes in the New Amsterdam area in the 1630s. By 1654, a glassworks was operating in lower Manhattan, New York, under the ownership of one Jan Smeedes.

However, churches and religious groups of early America were generations away from affording the luxury of any decorative arts.

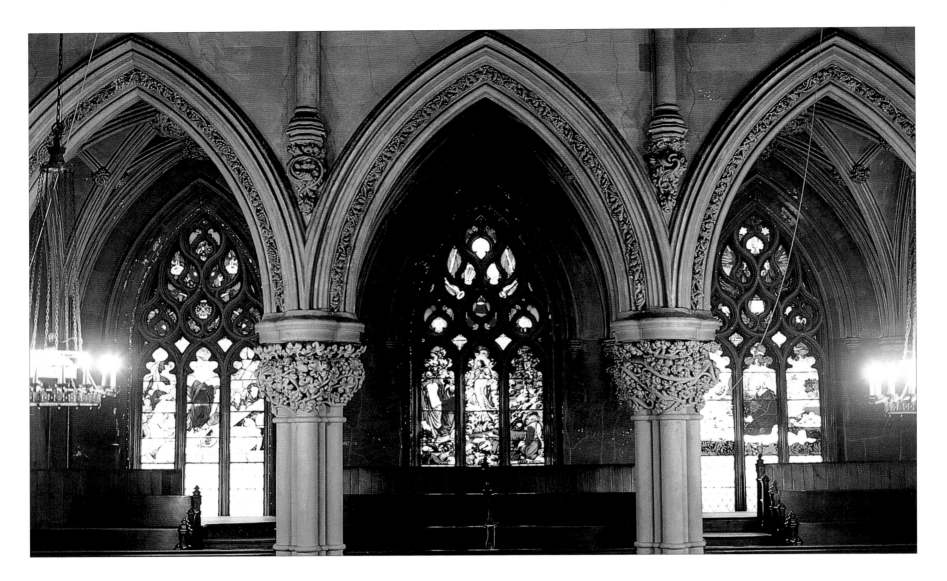

Not until 1843 do we find a major installation of religious stained glass in America. In 1843, the brothers Bolton, William Jay and John, were commissioned to create windows for what is now Saint Ann's and Holy Trinity Church in Brooklyn, New York. The Boltons' windows, executed in traditional European style, met with much critical acclaim.

As American society prospered, and the industrial revolution got under way, the prospects for stained glass and the arts in general improved. What followed during the latter half of nineteenth-century America is what many have come to call the Golden Age of American Art Glass.

Many factors contributed to this description, the most formidable one being the invention of opalescent glass. Raw stained glass was translucent by nature and by tradition. It was also monochromatic. Any opacity or additional color needed to portray an image or part of an image had to be added to the raw glass by means of vitreous paint. The painted glass would then be returned to a kiln where the new color would be fired, or fused onto the glass surface, making it permanent. The long, illustrious history of stained glass is in fact the history of this type of glass work. Along came American glassmakers and the pioneering spirit inherent in many of

their efforts. They challenged that basic element of the stained glass art with the desire to achieve yet more painterly effects from the traditional medium. Opalescent glass was born of this desire.

The great revolution and controversy that occurred over this new material can be credited to two artists of the period, John LaFarge and Louis Comfort Tiffany. Together, they would change forever the look of secular and architectural stained glass.

John LaFarge

John LaFarge was an accomplished painter and draftsman. He was born in New York City in 1835, the son of prominent New Yorkers: John Frederick LaFarge, made wealthy through his dealings in shipping, real estate, hotel keeping, and fire insurance, among other enterprises, and Louisa Josephine Binsse de Saint Victor, herself of prominent French parents. Upon his father's death, LaFarge was left with a considerable inheritance—one that allowed him to do whatever he wished. After a short period studying law, he turned to the arts.

LaFarge's formative years were spent as an easel painter. His works, now prized by collectors, met with mixed criticism at the time. It wasn't until LaFarge was commissioned to create the painted murals for Trinity Church in Boston, Massachusetts, in 1877, that he achieved fame. He went from being one of many painters of the American School to "the father of American mural decoration." The Trinity Church commission not only was a seminal project in the career of John LaFarge, but it was equally as impor-

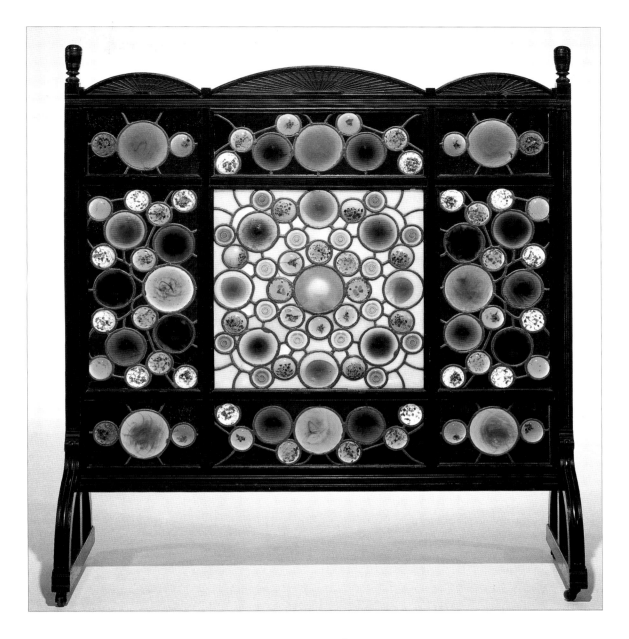

tant in the relatively short history of American architectural embellishment.

LaFarge's interest in stained glass began with his extensive travels. He had studied medieval churches during his early visits to Europe, an experience he no doubt put to great use during his Trinity Church project. In 1873, when he visited England, he met the Pre-Raphaelite painters, great promoters of the art, and he was able to discuss the latest activities within the craft with Edward

AS STAINED AND DECORATIVE GLASS BECAME A DOMESTIC EMBELLISHMENT, NEW APPLICATIONS BECAME POPULAR. JOHN LAFARGE FASHIONED GLASS ROUNDELS INTO A FIRE SCREEN, CIRCA 1883.

∞

Burne-Jones, the painter and associate of William Morris. There in the midst of the rediscovery of stained glass with some of its staunchest promoters, the seeds were sown for what would become John LaFarge's contribution to the medium.

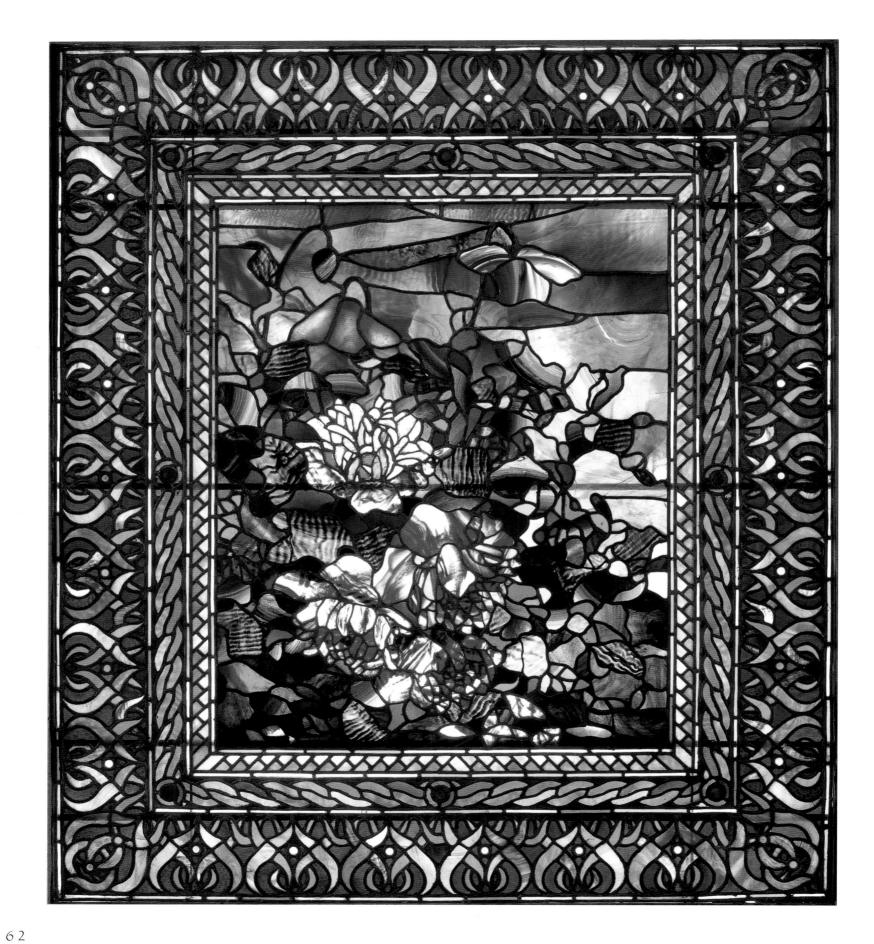

OPALESCENT GLASS

LaFarge's first experiments with stained glass took place during the mid-1870s, as a result of a commission he received for stained glass from one Henry Van Brunt. The artist was quick to realize the limitations inherent in the current crop of materials then available to the stained glass artist. The palette of color was limited and quality products for fabrication were few. He was so displeased that he even destroyed one of his early works, a window done for Memorial Hall at Harvard in 1876.

More than anything else, LaFarge longed for a glass that would allow him the expressive freedom he experienced as a painter. He found the monochromatic nature of contemporary glass inadequate for his purposes. The story of how LaFarge came upon the remedy for his displeasure rings with the stuff of legend, but has been repeated so many times that it has achieved the level of accepted popular truth. Supposedly, while ill in bed and pondering the problems he was encountering in his glass work, he chanced to catch a stream of light passing through a cheap glass apothecary jar. This little bottle was made of a streaky glass that resembled china or porcelain. The light did not freely pass through, but rather illuminated the glass.

Whether this tale is true or not, something certainly inspired John LaFarge to what can only be described as an obsession for making opalescent glass.

∞

Opposite: JOHN LAFARGE AND TIFFANY STUDIOS' ACCOMPLISHMENTS WITH THE NEW AMERICAN STYLE OF OPALESCENT GLASS PARALLELED EACH OTHER. THIS CIRCA 1897 BORDERED BOUQUET WORK BY LAFARGE DISPLAYS MUCH OF THE STYLE THEY SHARED.

Glassmaking is a craft tied to technology, to furnaces and machinery. Glass needs the fire of intense heat, a facility where the elements making up the material can be brought to a molten state, manipulated, and cooled to a workable temperature. It is not a craft for amateurs. Someone with the desire to make glass should find someone practiced at the art and craft of furnace work, and either direct them according to their wishes or, if they are fortunate enough to find such an opportunity, learn the process from them. LaFarge found such a situation at two glass houses in the New York area, Thill's Flint Glass Shop and the Louis Heidt glassworks, both in Brooklyn. Under his supervision, he had the glassmakers produce glass in which he could find the colors he longed for. As he and his technicians experimented, his prospects of finding the colors improved. In his own words, he describes the properties of his new opalescent glass: "The material seemed to be the proper basis for a fair venture into the use of free color in windows, even when it was used only in small patches alongside of the English [traditional] glass, whose flatness was relieved by the opal's suggestion of complementary color."

LAFARGE AND THE NEW ART GLASS

John LaFarge's progress from his early use of available glass to his developing his own can be seen in two fine examples of his work. In *Morning Glories*, a six-panel set of windows built for the William Watts Sherman House in Newport, Rhode Island, in 1878, now in the collection of the Museum of Fine Arts in Boston, LaFarge calls upon British and European influences, most notably the

works of William Morris and his circle of artisans. The panels are richly and completely painted. In contrast, LaFarge's *Peonies in the Wind*, built a year later, in 1879, for the Newport house of Henry G. Marquand and now in the collection of the Metropolitan Museum of Art, uses no paint at all. His ideal of creating all the imagery, detail, and depth of his compositions by means of colored glass alone had become a reality.

LaFarge's church work not only differs from his secular glass in subject matter, but also in his treatment of subject matter. Whether it was having to adhere to preconceived imagery, as would be the requirement when being commissioned by a church or institution, or a difficulty in merging his inventive use of opalescent glass within a traditional concept, his more decorative, naturalistic works contain a freedom and energy that will always set them apart. As an example, compare LaFarge's *The Fruits of Commerce*, built in 1881 for the Vanderbilt House in New York and now part of the Biltmore House in Asheville, North Carolina, with his *Peonies in the Wind* and *Kakemono Borders*, built in 1893 for the Washington, D.C., house of John Jay and now at the National Museum of American Art, Smithsonian Institution, also in Washington.

The Fruits of Commerce is an impressive work in glass, but the viewer gets the feeling that the traditional-looking figures are uncomfortable in their setting, which is a background and border similar to LaFarge's more signature-style work. In his *Peonies* window, the artist's vision and execution are seamlessly meshed. The glass is at its most expressive. Here, the new opalescent glass

enhances the imagery, taking its cue from nature, and, as in the most successful of naturalistic art, improving upon it.

Considering John LaFarge's labor-intensive, hands-on method of working, performing almost every duty of building a window, including that of making the glass, his output was formidable. His body of work included not only stained glass but numerous paintings, drawings, writings, and interior design schemes. Truly a Renaissance man, the work of John LaFarge continues to inspire artists of all disciplines.

The Tiffany Glass Studios

The name Tiffany is magical. Today, it is synonymous with wealth, beauty, opulence, and, most of all, stained glass windows and leaded glass lamps. No other name figures so prominently in any study of late nineteenth- and twentieth-century glass, and for good reason. In Louis Comfort Tiffany, we find the perfect marriage of American aesthetic restlessness and nineteenth-century industrialism. He was probably the most influential force in the glass arts ever.

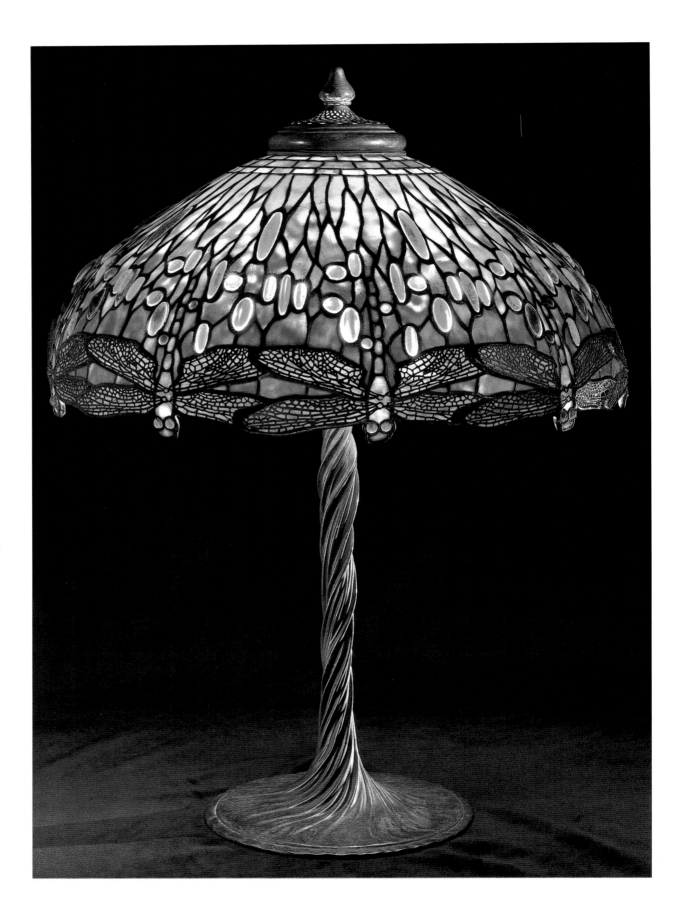

THE LEADED GLASS LAMPS OF THE TIFFANY STUDIOS ENJOYED GREAT SUCCESS AS DECORATIVE ACCESSORIES. ALTHOUGH THEY FELL FROM FASHION DURING THE LATE THIRTIES, FORTIES, AND EARLY FIFTIES, THEY NOW ENJOY TREMENDOUS POPULARITY AND VALUE. PICTURED HERE IS THE FAMOUS HANGING HEAD DRAGONFLY LAMP ON A BRONZE TWISTED VINE BASE, CIRCA 1910.

Louis Tiffany was born in 1848 into the jewelry dynasty of his father, Charles. He grew up in an environment conducive to the pursuits that would occupy his professional life. Restless to a fault, Louis wanted a career in the arts. He did not wish to follow his father in the family jewelry business. Reluctantly, Charles Tiffany surrendered his control over his son and allowed the young Tiffany his freedom of expression.

L. C. Tiffany & Associated Artists

As a student of painting at first, Louis spent a short time (1866–67) at the National Academy of Design in New York, later frequenting the studio of the painter George Inness. During a brief period in Paris, Tiffany studied under painter Léon-Charles-Adrien Bailly. Whatever lessons the young Tiffany extracted from his formal and informal art training, he was to find his true passion elsewhere. Although talented, he had certain shortcomings as a painter of which he, along with his critics, was acutely aware. Never at a loss when manipulating color or rendering a landscape, Tiffany's less skillful handling of the human figure and features plagued his efforts. In 1879, Louis Tiffany turned to interior design and formed L. C. Tiffany & Associated Artists with a few fellow practitioners of the applied arts— Candace Wheeler, Samuel Colman, and Lockwood DeForest.

TIFFANY'S CRAFTSPEOPLE EXCELLED IN MANY AREAS OF THE DECORATIVE ARTS. THEIR BLOWN GLASS OBJECTS ARE STILL CONSIDERED SOME OF THE MOST INNOVATIVE EVER CREATED. THIS FLOWER FORM VASE, MADE AROUND 1896, IS TYPICAL OF THE STUDIO'S WORK.

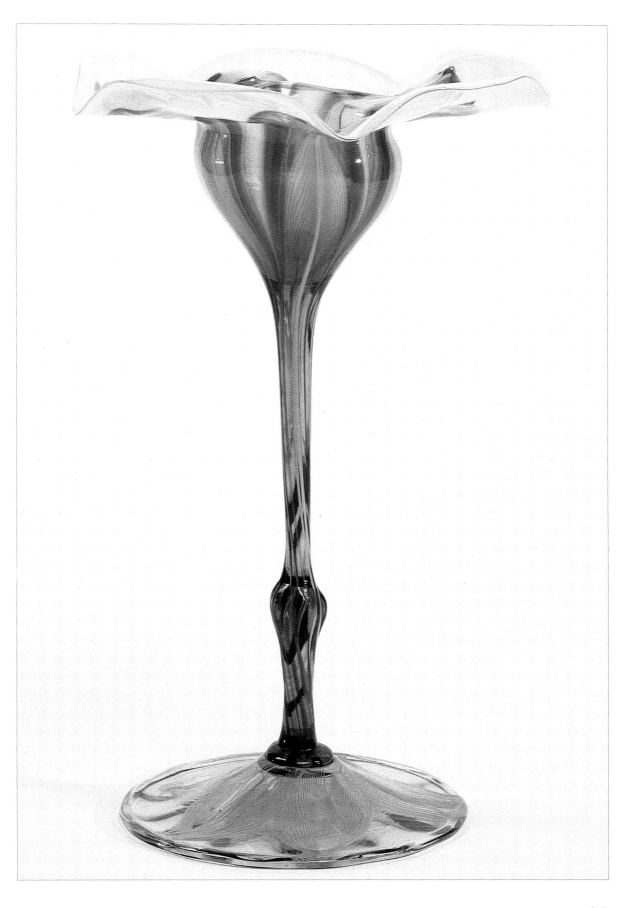

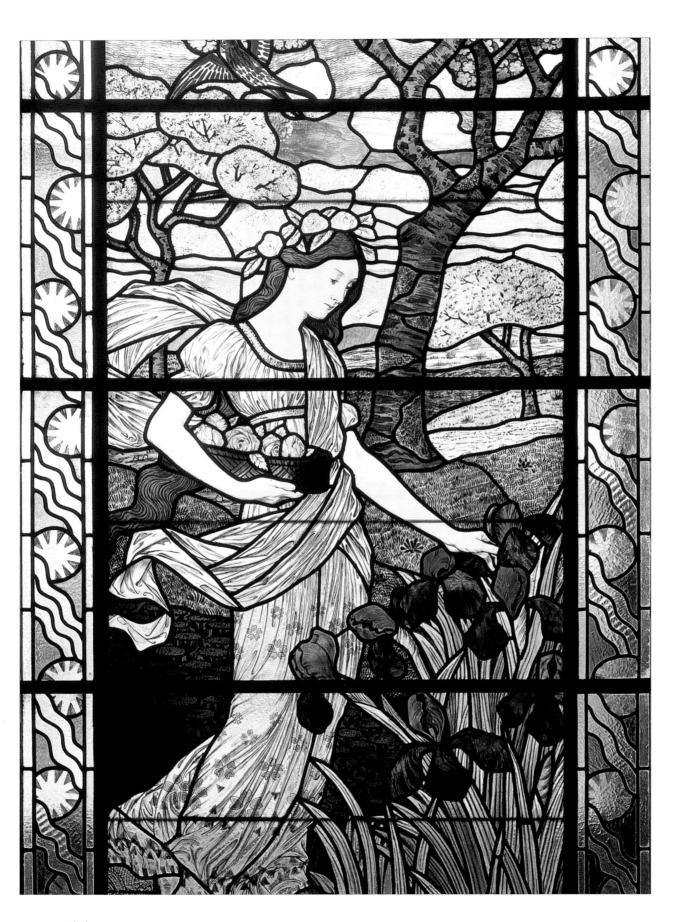

Left: TIFFANY AND LAFARGE'S WORK INFLUENCED ARTISTS AROUND THE WORLD, AS IN THIS PANEL BY EUGENE GRASSET ENTITLED *FRÜHLING*, MADE IN 1884 AND NOW IN THE COLLECTION OF THE MUSÉE DES ARTS DECORATIFS IN PARIS. *Below:* ONE OF THE MOST RARE AND COMPLEX CREATIONS OF THE TIFFANY STUDIOS IS THE SPIDER WEB TABLE LAMP, MADE OF LEADED GLASS, BRONZE, AND GLASS MOSAIC, AND BUILT AROUND 1900.

It isn't hard to imagine how fortuitous it was to have the Tiffany name at the head end of a decorative arts firm's calling card. Access to the wealthiest clientele of the era was a given: Tiffany's Associated Artists maiden voyage into the world of interior decoration was providing the drop curtain for Steele MacKaye's Madison Square Theater in New York. Not bad for a fledgling firm. That was quickly followed by a commission for the interior of a salon in the New York home of wealthy pharmaceutical supplier George Kemp. In 1880, the firm completed a commission to decorate the Veteran's room and a library in the Seventh Regiment Armory, also in New York, with no less than influential architect Sanford White as consultant. In 1882, with only three years under its belt, the firm was invited by President Chester A.

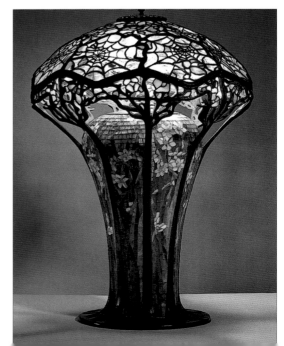

Arthur to refurbish several rooms and areas of the White House.

All along, Tiffany and his associates included glass in their interior treatments. Tiffany's interest in the material began during the 1870s and continued as almost a hobby throughout his formative years as a decorating professional. Tiffany spent time at both the Thill and Heidt glassworks in Brooklyn, the same haunts of John LaFarge. He wished to create a glass that would allow him more coloristic and pictorial freedom. His aspirations were similar to those of LaFarge.

Who really created the first opalescent glasses? We may never know for sure. It was probably one of the experienced glassmakers working at the Heidt or Thill glass houses under the guidance of either LaFarge or Tiffany. Neither had their own facility and had to share access to the kilns and annealing ovens, as was typical when using commercial glass facilities.

THE TIFFANY GLASS COMPANY AND THE TIFFANY STUDIOS

Louis Tiffany found in glass a unique medium which allowed him the expressiveness that eluded him as a painter. His efforts at interior decoration became less a priority as his preoccupation with glass grew into a passion. In 1883 the Associated Artists disbanded amicably. In 1885 Tiffany formed the Tiffany Glass Company. Finally at the helm of an independent enterprise, he could explore his

∞

THE TIFFANY "FAVRILE" GLASS VASE, MADE AROUND 1897, USED OPALESCENT ART GLASS TO CREATE THE ILLUSION OF SOFT PEACOCK FEATHERS. THE STUDIOS' BLOWN GLASS ESTABLISHED THE FAVRILE (MADE BY HAND) LABEL AS EXCLUSIVE TO TIFFANY.

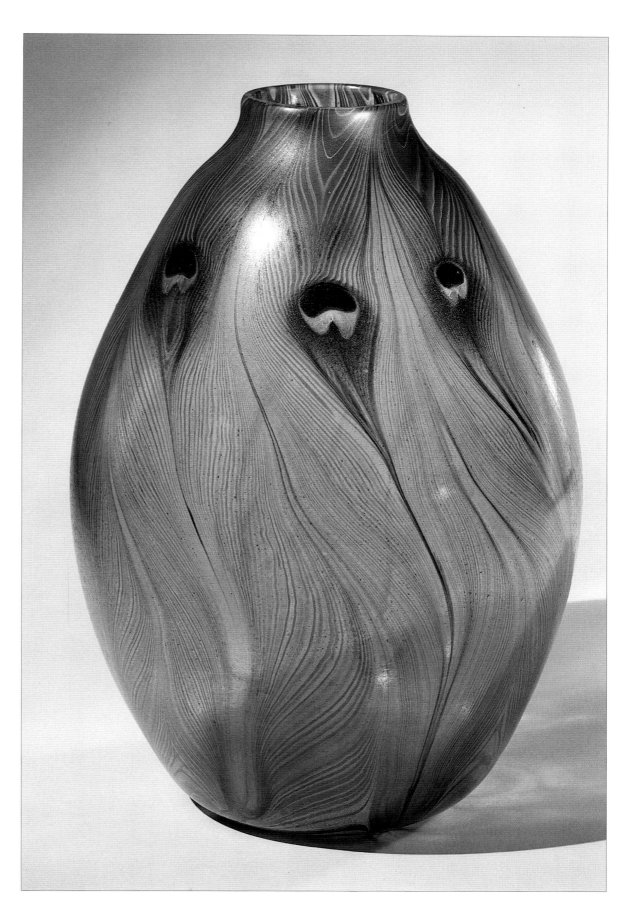

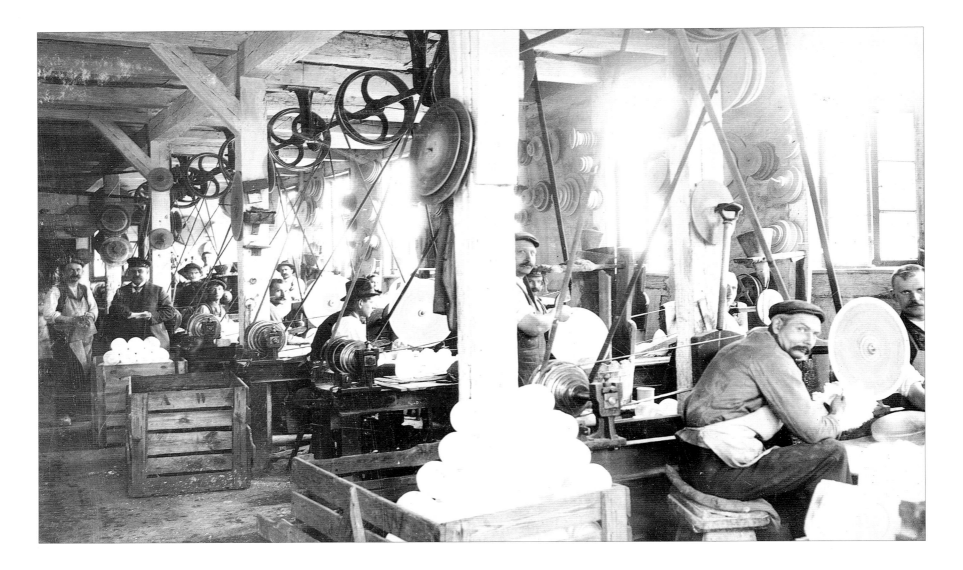

interests, by now firmly committed to glass. At the same time, he could capitalize on the exploding market for stained glass that developed in the latter years of the nineteenth century and the beginning of the twentieth. He could now also make his own glass.

Tiffany did not work alone. In sharp contrast to the image of young Louis sitting at his easel creating his artwork, his function as head of the Tiffany Glass Company and, later, the Tiffany Studios was more of a benevolent patron than that of an artist or craftsperson. No doubt the products of his firm reflected his aesthetic theory and taste, but the works themselves were created by the best artists, craftspeople, and technicians his wealth and influence could buy. This alone may be Tiffany's finest contribution to the art of stained glass. For a brief period, and under one roof, some of the best artisans of the time were allowed to exercise their abilities and vision in pursuit of excellence in the decorative arts. Thanks to Tiffany's wealth, expense was not a concern.

Between the years 1885 and 1932 (when the firm declared bankruptcy), for almost fifty years, the Tiffany workforce created an enormous body of work. The firm was in constant demand for window work from both ecclesiastical and secular clients. The Tiffany (or leaded glass) lamp, a unique member of the decorative arts repertoire, had its unknown beginnings somewhere in the late nineteenth century, and was adopted by the Tiffany firm, later to become its signature product, albeit a mass-produced one. The demand for Tiffany's lamps was to become so great that window production suffered to meet it.

TECHNOLOGICAL INNOVATIONS

The legacy of the Tiffany Studios goes beyond the body of work his craftspeople left behind. They were also responsible for

Opposite: IN THE EARLY TWENTIETH CENTURY, STAINED GLASS PIECES LIKE LAMPS AND VASES WERE MADE IN GLASS WORKSHOPS; THE PIECES WERE THE RESULT OF MANY CRAFTSMEN WORKING TOGETHER. PICTURED IS A TYPICAL EARLY TWENTIETH-CENTURY GLASS FINISHING SHOP WHERE COMPLETED WORKS WOULD BE GROUND AND POLISHED TO PERFECTION. *Right:* EXHIBITED AT THE 1893 COLOMBIAN EXPOSITION, TIFFANY'S FAMOUS *FEEDING THE FLAMINGOS* GLASS PANEL HELPED ESTABLISH THE ARTIST AS A PIONEER IN THE MANUFACTURE AND USE OF THE NEW ART GLASS.

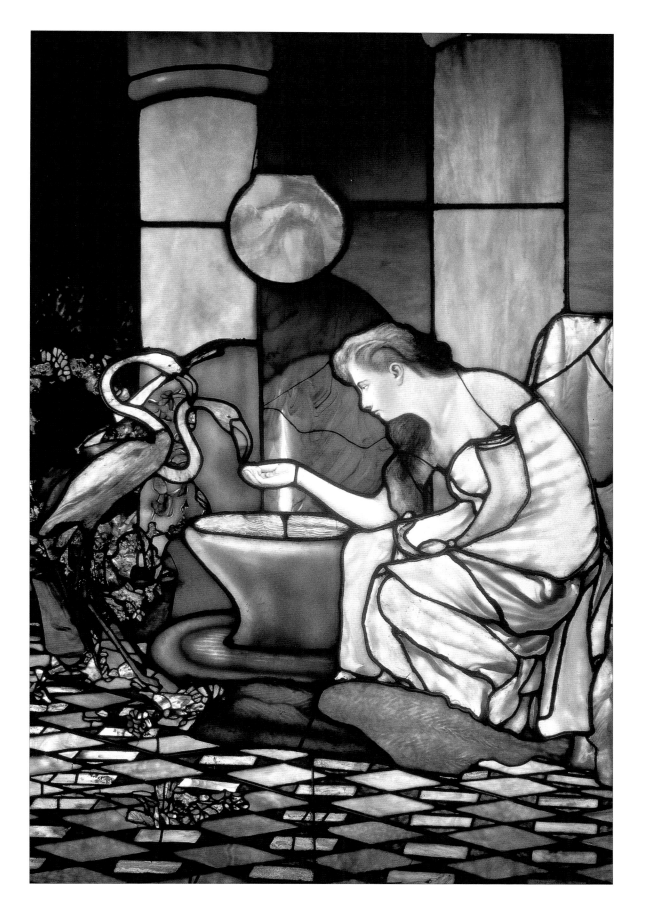

bringing a great deal of invention and innovation to almost all the crafts they practiced. Two major contributions interest us. First, there was Tiffany's glass. As mentioned earlier, Louis Tiffany realized that to achieve what he wanted in the art of stained glass, he'd have to make his own. For the life of the studio, his chemists and engineers produced glass to meet the demands and visions of his artists. Multicolored, opalescent, textured, rippled, drapery, and iridescent glass poured from Tiffany's furnaces daily. This outstanding and proprietary material set the studio's works apart from everyone else's and continues to be one of the major reasons Tiffany glass objects are so treasured today. Only the Tiffany Studios made Tiffany glass.

The other major technological breakthrough the studio made had to do with the method by which one piece of stained glass is joined to another. Traditionally, strips of lead came (lengths of lead wrapped around the edges of the pieces of glass which allowed the pieces to be soldered together) served this purpose. But the bulky came made detailed work difficult, if not impossible in some cases. To remedy this situation, Tiffany's craftspeople came upon a technique of wrapping each piece of glass with a thin foil of

copper. This allowed one piece of glass to be soldered to its adjoining pieces without came and was conducive to working with the smallest pieces of glass in the most detailed of designs. The famous Tiffany lamps were made using this method. Today, the copper foil technique is the most popular form of working in stained glass.

The End of the First Golden Age of Glass

Tiffany's glass, and LaFarge's for that matter, brought to stained glass the drama and awe-inspiring spectacle it hadn't enjoyed since the Middle Ages. Despite the critics who pooh-poohed the new American School of Stained Glass and its vehicle, opalescent glass, as being too far removed from traditional stained glass, the public openly embraced it. Until the turbulence of the world wars and changing tastes cast glass again into a dark period, churches, schools, libraries, railway stations, commercial buildings, the palaces of the rich, and even the transoms and doorways of the middle class everywhere contained stained glass. It had successfully entered the mainstream of American decorative arts, if only temporarily.

⁂

TIFFANY STUDIOS OFTEN USED FLOWER AND PLANT MOTIFS IN THEIR WORKS. ONE OF THE MOST POPULAR WAS WISTERIA, WITH ITS VARIOUSLY HUED PURPLE FLOWERS TWINING AROUND LAMPS AND WINDOWS. THIS WISTERIA CASEMENT WINDOW WAS CREATED IN 1905.

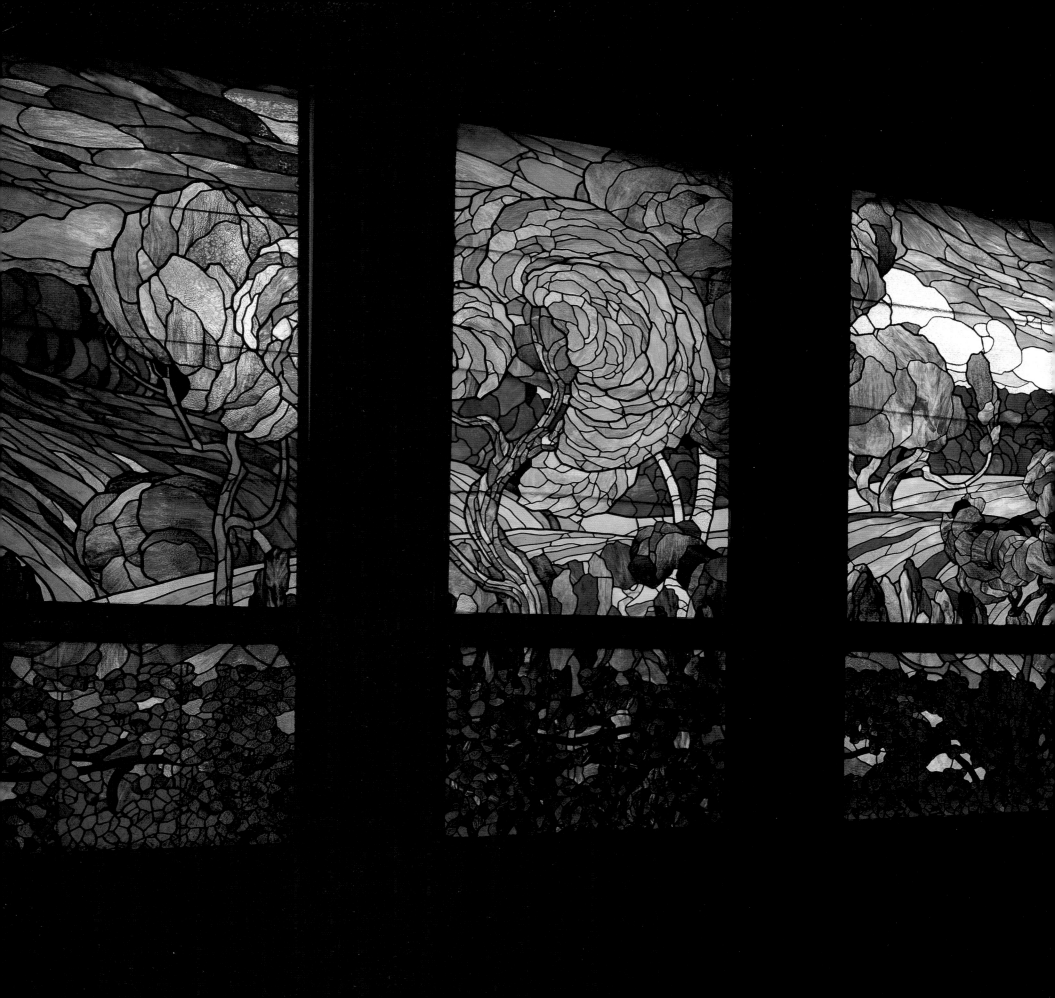

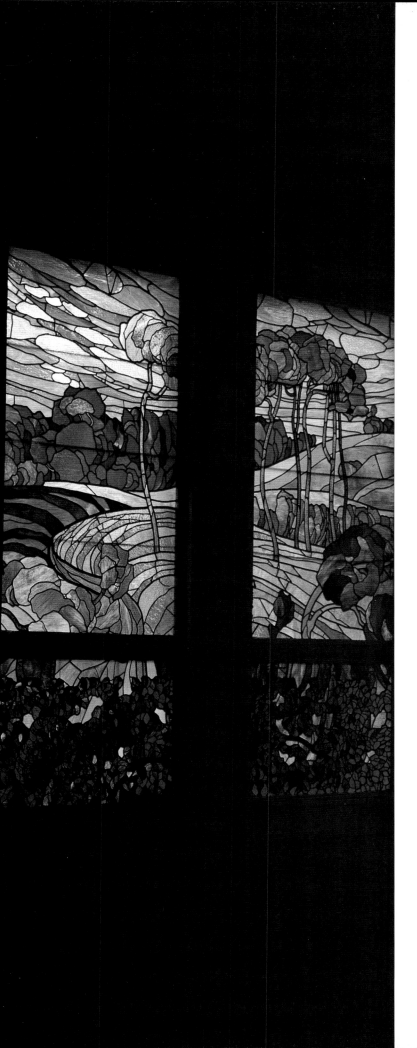

THE EARLY TWENTIETH-CENTURY AVANT-GARDE

As an art form

with a history of reacting to changes

in the visual arts rather than initiating

them, stained glass of the early

twentieth century found

itself at a crossroads.

The American school

of Tiffany and

THIS SUITE OF WINDOWS IN VILLA WAGNER, IN VIENNA, AUSTRIA, BY STAINED GLASS
ARTIST ADOLF BOEHM, EXEMPLIFIES MANY OF THE QUALITIES OF ART NOUVEAU GLASS
WORK: THE FLOWING LINES, THE INTEGRATION WITH ARCHITECTURE, AND THE RICH,
FLAMBOYANT COLORS.

LaFarge, with its emphasis on color and spectacle, prospered during the flowering of the Art Nouveau movement, placing a definitive American signature on traditional European stained glass. On the other hand, European influences, the Art Deco and International styles to be specific, pressured glass artists to respond to the latest architectural innovations in an entirely different way.

Frank Lloyd Wright and the Dawn of the Modern Movement

Architect Frank Lloyd Wright occupies a unique place in the history of stained glass. Wright was a contemporary of LaFarge and Tiffany. He produced the bulk of his important work during the same turn-of-the-century/early twentieth-century period, yet his style is far removed from the opulence of his fellow glass designers.

Frank Lloyd Wright was born in 1867. In 1887, as an engineer's assistant, Wright became apprenticed to one of the period's most respected architects, Louis Sullivan. From the first, his design work had the stamp of originality. Drawing from many of the same Japanese influences as LaFarge and Tiffany had, Wright's signature style is married to geometry, with an emphasis on the integration of architecture and embellishment rather than spectacle. Wright responded to the discipline and logic underlying Oriental composition rather than its representational subject matter. In a meta-

morphosis that joined his outside influences with the vagaries of the American spirit, Wright, like Tiffany and LaFarge, was able to create something new.

Almost minimalist in composition, Wright's strictly patterned stained glass stands in strong contrast to his contemporaries' organic complexities and fantastic color schemes. No doubt Wright was aware of the glass work of Tiffany and LaFarge, but he managed to remain free of their influences regardless of their popularity, forging his own highly identifiable style.

GLASS AND ARCHITECTURE

Wright was one of the few architects who included stained glass (more specifically, leaded glass windows and occasionally lamps) as an integral part of his design work. For clients commissioning a home design from Wright, stained glass would more than likely be part of the package. This intimate relationship of building and ornament, aided by the fact that the architect was also the designer of the glass, was unique for its time. In most cases, stained glass was an added afterthought in domestic installations, and the stained glass artist reacted to the style of the building instead of its being included in the initial composition. Most glass studios of the era operated in the same fashion. In the case of Frank Lloyd Wright, the stained glass was a prominent expression of his design philosophy "to bring the out-

THE MINIMAL STYLE OF FRANK LLOYD WRIGHT'S STAINED GLASS ECHOES THAT OF PAINTER PIET MONDRIAN IN ITS SIMPLE USE OF SHAPE AND COLOR.

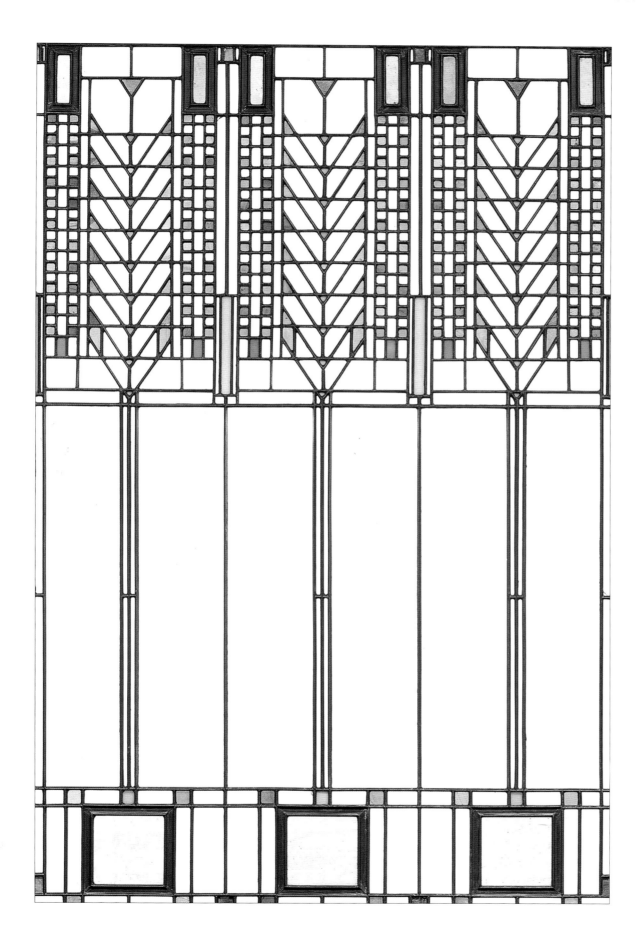

side in." Large expanses of glass, half walls, and open floor plans characterize a Wright design, and his stained glass bears his signature of abstracted motif and understated elegance. By its very nature and by Wright's affinity for translucent glass accented by highly controlled areas of color, stained glass provided the gateway between the precision of his interiors and the contrasting, less controlled beauty of nature outside.

THE SUSAN LAWRENCE DANA HOUSE

One of Wright's most successful projects, and one in which his hand is evident in every aspect of the structure's design and ornament, is the Susan Lawrence Dana House, built in Springfield, Illinois, in 1902. It is important to consider Wright's glass designs in light of their dates. Compared with the Victorian/Impressionistic works of other American glass artists of the time, they stand apart.

The stained glass of the Dana house included leaded windows and lamps fabricated by the Linden Glass Company of Chicago. The window design was based on abstractions of the prairie sumac plant. The lamps—most notably, Wright's Butterfly Hanging lamp—point straight into the future with their heavy reliance on geometric pattern, repetition, and economic use of color.

A STYLIZED SUMAC PLANT WAS WRIGHT'S INSPIRATION FOR THIS NATIVE AMERICAN–STYLE WINDOW. HE WOULD RETURN TO THIS MOTIF FOR A NUMBER OF HIS WORKS.

WRIGHT'S INFLUENCE

Frank Lloyd Wright, who denied being influenced by any visual style and claimed rather to respond only to the needs of his buildings, not only can be considered a pioneer in the school of American art glass, but also an artist of the early twentieth-century avant-garde, a roster

❦

FRANK LLOYD WRIGHT'S SIGNATURE STYLE OF STAINED GLASS REMAINS TRUE TO HIS ARCHITECTURAL STYLE—SPARE, GEOMETRIC SHAPES AND FIELDS OF COLOR. ALTHOUGH HE WAS A CONTEMPORARY OF TIFFANY AND LAFARGE, THIS SUITE OF WINDOWS FROM HIS ROBIE HOUSE PROJECT SHOWS NO SIGN OF EITHER'S INFLUENCE.

that included the painters Piet Mondrian, whose works Wright's works resemble, and painter/glass artist Josef Albers, among others.

Wright's work stood at the forefront of what has become known as the Prairie style. Under this heading, we also find the glass works of other Arts & Crafts (another stylistic moniker) designers and studios such as William Morris & Co. in England, and Charles Rennie Mackintosh of Glasgow, Scotland. Neither of these glass designers subscribed to the hard geometry of Wright. Their works provide a link to both the Prairie/Arts & Crafts style and the more European Art Nouveau.

Art Nouveau and the Arts & Crafts

The Art Nouveau style influenced all the decorative arts, stained glass in particular. Translated as "new art," the style was similarly labeled Jugendstil in Germany, Nieuwe Kunst in Holland, and Stile Liberty in Italy. Except for the Italian version, the style enjoyed a vigorous life and inspired a multitude of artists in all the graphic, visual, and applied arts.

The flowing lines and graceful curves of Art Nouveau translated beautifully into the

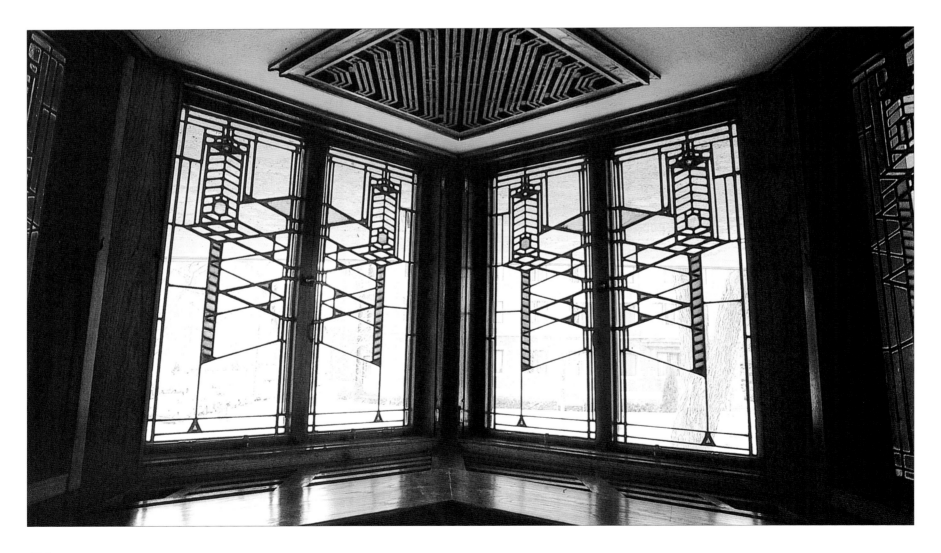

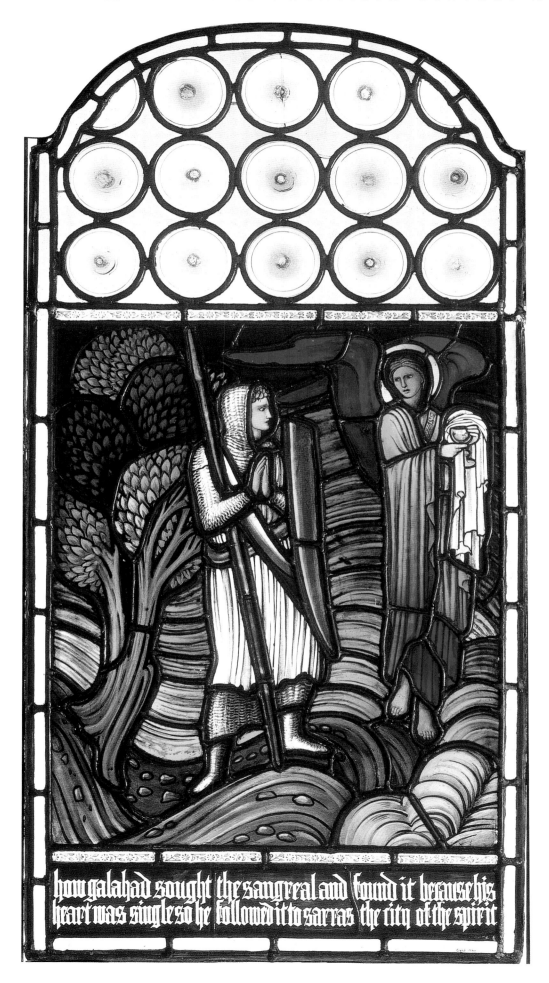

leadlines and curves of cut glass pieces. The seductive surfaces and organic colorings of art glass were a perfect match for the idiosyncrasies of this flamboyant style. Additionally, Art Nouveau's strong, two-dimensional characteristics were tailor-made for the wide planes of the new opalescent art glass. In the best Art Nouveau–inspired stained glass, the viewer is treated to the curvilinear beauty of the design plus the interaction of the picture plane, its color, and the landscape beyond. If ever there was a style that shamelessly and completely supported the virtues of art glass, it was Art Nouveau.

Practitioners of the Art Nouveau style shared Frank Lloyd Wright's commitment to the integration of architecture and ornament without his allegiance to hard geometry. The imitation and observation of nature and her splendors would provide the dividing line between classic Art Nouveau artists, such as Victor Horta of Belgium, the Frenchman Hector Guimard, Henry Van de Velde of Belgium, and the more grassroots style of the Arts & Crafts/Prairie school.

Art Nouveau was a worldwide phenomenon that occupied designers in all the visual arts. Nicknamed "the cult of the line," it provided a springboard for the rediscovery of the seductive elements of graceful line. Architec-ture, although not as conducive to soft, flowing lines, accommodated this very popular style by providing the backdrop for some of Art Nouveau's greatest successes in stained glass. Hector Guimard's entryway

77

hall for the Maison Coilliot in Lille, France, shows how the simple elegance of the long, flowing lines of stained glass sidelights, transoms, and door inserts can render the surrounding architecture fluid. Victor Horta's integration of glass and metal in his own Brussels residence shows how glass can unite all the decorative elements of an integrated Nouveau interior.

If we measure a style's importance by its longevity and its ability to withstand the inevitable change of the guard of popular taste and fashion, none of the above mentioned periods—Prairie style, Art & Crafts, Art Nouveau, or the following Art Deco—would qualify as significant beyond their short spurt in the limelight. In the quick pace of cultural and political change that characterized the landscape of the first half of the twentieth century, each enjoyed great prosperity followed by a fall from grace, so to speak, only to be replaced by what was new and currently fashionable. It wasn't unusual for many of the finest examples of Art Nouveau lighting, or Prairie-style stained glass, for instance, to suffer the indignity of neglect or, at worst, be dismantled for scrap.

Art Deco

The flourishing sinews of Art Nouveau and the quiet dignity of the Craftsman style were supplanted first by the Art Deco of the twenties and thirties, a futuristic style of the times that restricted ornament to cold and sleek, hard-edged stylization.

JOHANN THORN PRIKKER

As an example of Art Deco, we can look to the work of Johann Thorn Prikker, a student of Henry Van de Velde. Armed with experience gained under the tutelage of one of Art Nouveau's prime practitioners, Thorn

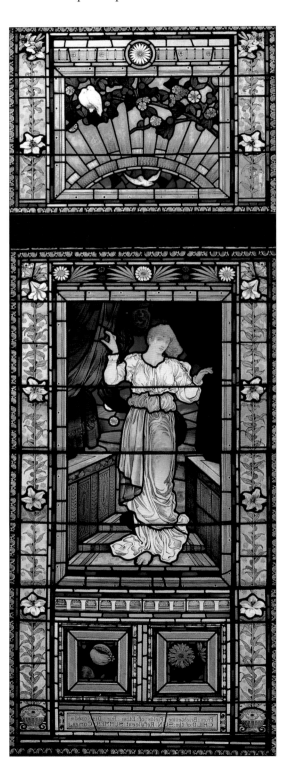

Left: STAINED GLASS FELT THE INFLUENCE OF THE ARTS & CRAFTS MOVEMENT IN ENGLAND AND SCOTLAND, AS WELL AS NORTH AMERICA. THIS SCOTTISH EXAMPLE IS FROM CASTLE LEVAN GOUROCK IN RENFREW. NOTE THE STYLIZED BORDER DESIGN. *Opposite:* FIRMLY ENTRENCHED IN THE ART NOUVEAU STYLE IS ANTONI GAUDI'S CASA BATLLO, AN APARTMENT HOUSE IN BARCELONA, SPAIN. NOTE THE INTEGRATION OF STAINED GLASS AS PART OF THE ARCHITECTURE.

Prikker, who was born in 1868 and lived until 1923, was trained as a painter. He possessed a natural affinity for the influences contemporary painters were exerting upon the design world. One of the first to integrate modern design precepts into ecclesiastical interiors, Thorn Prikker's glass shares that same sense of unity which characterizes the work of Wright.

Thorn Prikker looked to the surrounding architecture as his point of departure. His are some of the earliest compositions to use the strength of the supporting leadline as a design element. Thorn Prikker's windows called upon all the graphic elements available to the medium of stained glass to create, as did Frank Lloyd Wright, an "organic" whole in terms of glass and architecture. If we look at his St. George windows in Cologne, Germany, we see elements of the sleek, streamlined tendencies of the Deco style married to a palette of strong, vibrant color. These 1928 windows predate the full force of the post-war movement by almost twenty years. Their Art Deco label belies the influence they would have on the glass artists who found inspiration and direction in Thorn Prikker's innovative style. As we will soon see, he was to provide inspiration for an entire school of glass artists and

designers. What was once a representational and decorative art blossomed into a powerful voice for the very expressive nature of the modern visual artist.

The International Style

The International Style, spearheaded by architect Walter Gropius, who was also the director of the Bauhaus art school in Dessau, Germany, delivered a second, more decisive blow to Art Nouveau and the Craftsman style.

The stranglehold the International Style had on building theory represented a complete turnaround in attitude as far as ornament was conceived and concerned. In practice, ornament and decoration were stripped from the structure, leaving only functional essentials. The dictum "less is more" that fueled the engine of this movement could have been translated as "less stained glass is more" as it forged its allegiance with clear, plate glass as the only vitreous embellishment its architects would use. In some neighborhoods of the design community, stained glass would have to take a back seat.

The International Style began during the 1920s and gradually gained influence under the leadership of architects Walter Gropius and Swiss-born Le Corbusier, who ironically did include a minimal amount of stained glass in his Notre Dame-du-Haut. For more than two decades, it would be the style of choice for urban architecture, offering little for us to discuss.

The Painters

The opportunity to work in glass is a seductive one for artists in other media. Throughout the first half of the twentieth century, a number of influential painters came to the craft armed with their own methods of working with line and color. Stained glass artists made an attempt at wooing the fine art community as early as the late nineteenth century when Paris art dealer Samuel Bing called upon a number of artists to submit works to be reproduced in the new exciting American Art Glass by none other than the Tiffany Studios, whose works he sold in his shop. Bing, in an effort to stir interest in his "new" Art Nouveau concept, sent the prospective designs to Louis Tiffany, who made the final choice, using his own judgment about which would best be depicted in glass. Works by eleven artists were executed. The artists included Henri Toulouse-Lautrec, Albert Besnard, Paul Ranson, Ker-Xavier Roussel, Pierre Bonnard, P. A. Isaac, H. G. Ibels, Edouard Vuillard, Maurice Denis, Félix Vallotton, and Paul Sérusier, who had three of his designs chosen for the project. Bing proudly displayed the works during the 1895 Salon of the Société Nationale des Beaux-Arts. Drawing mixed feelings from many of the critics, some accused the works of being too primitive and "bizarre."

It wouldn't be long before painters would again embrace stained glass for a chance to work with a tool they could only toy with in their canvases—light.

MARC CHAGALL

The most noteworthy examples of stained glass by a major figure in the fine arts are the windows designed by Marc Chagall, who, like Henri Matisse, was a painter at the peak of his powers who had already made a tremendous impact on the art world when he began working in stained glass. Critics will argue that Chagall made no concessions to working in the medium and imposed his painting style onto the glass without any concern for its basic elements or structural restraints on design. Most of the criticism is aimed at the haphazard and distracting cacophony of leadlines that characterizes his windows. Yet his output, keeping in mind the stage of his career, and his age, was considerable. By age ninety-nine, Chagall had twenty years' worth of stained glass window work installed throughout the world.

His most famous installations, and certainly the ones enjoying the most visibility, were the windows created for the Dag Hammarskjold Memorial in the United Nations Building in New York City. Among others were his windows for the Hadassah Hebrew University Medical Center of Jerusalem, a window in Chichester Cathedral in Chichester, England, and his Old Testament windows in Metz, France.

Opposite: AMONG MAJOR TWENTIETH-CENTURY PAINTERS CALLED UPON TO DESIGN FOR STAINED GLASS, MARC CHAGALL PRODUCED WORKS THAT BROUGHT, AND STILL BRING, MUCH ATTENTION TO THE MEDIUM. THIS WINDOW IS FROM METZ CATHEDRAL IN THE LORRAINE PROVINCE IN FRANCE. SOMETIMES CRITICIZED FOR NOT BEING SENSITIVE TO THE BASIC DESIGN ISSUES OF LEADLINES AND THEIR RELATIONSHIP TO IMAGE OUTLINES, CHAGALL'S IMAGES SEEM TO HAVE BEEN PAINTED ON AN EXISTING GLASS INSTALLATION.

GEORGES ROUAULT

Painter Georges Rouault served as an
apprentice in a stained glass shop early in his
career. Although he soon turned to painting
as his medium, his works show a distinct
influence from his early experience. Rouault
used the "look" of stained glass, fields of
color surrounded by the dark outlines creat-
ed by lead came or strips, as a stylistic
signature. His ecclesiastic subject matter con-
jures the feeling of medieval stained glass.
The brooding tones he chose for his palette
suggest the dimly lit religious windows of
European cathedrals as their colored glass
reacted to glimmers of light.

When Rouault returned to stained glass
later in his career, he did not have to alter
his style to accommodate the material. In
fact, he simply imposed his already matured
"stained glass" stylizations upon the medium
that inspired them. His St. Veronica win-
dow, built in 1947 for Notre Dame de Toute
Grâce, in Assy, France, can easily be mistak-
en for one of his paintings. All the earmarks
of his art are brought to life in the handling
of the glass under the craftsmanship of glass
painter Paul Bony, who executed the win-
dow. Throughout the suite of windows
installed in the church, especially the
Bouquet and the *Flagellated Christ*, the
power of Rouault's images is made even
more dramatic in the glass.

FERNAND LÉGER

Fernand Léger's mechanical-looking paintings, like his *City of 1919*, bear little resemblance to the stained glass windows he later designed during the 1950s. Although his debt to Cubism can be detected in his use of glass and lead and/or *dalle de verre* glass (thick slabs of glass set into a wall of mortar), as seen in his 1951 *Holy Tunic* window now in the collection of the Vatican Museum, or his windows for the Church of Courfaivre, in Courfaivre, Switzerland, Leger was drawn to glass as another outlet for his expression.

HENRI MATISSE

Henri Matisse, with his prominent place in the art hierarchy, made contributions that will forever influence members of all fields of art and design. His foray into the world of stained glass came late in his career, but not so late that he could not make substantial additions to its roster.

Matisse, master colorist and painter, had by the 1950s reduced his style of painting to its simplest components, virtual cut-outs of color against contrasting solid areas of color, far removed from the complexities of his post-Impressionist work. When, at the suggestion of Sister Jacques Marie, a Dominican, he proposed to create the stained glass windows for the chapel at Notre Dame du Rosaire in Vence, France, in 1951, translating his art to the leadlines and glass of stained glass offered a rare opportunity for Matisse to transpose his highly identifiable style into glass intact. As with Rouault before him, little had to be done to alter his imagery.

Whether Matisse created these wonderful windows as a favor to his Dominican nurse, or as a folly in his old age, or as a significant step in his matured career, the Vence windows prove again how the medium had found its way out of the guilds of the Middle Ages into the forefront as a valid means of visual expression for the most accomplished artists.

OTHER PAINTERS

Other painters ventured into the medium of stained glass with mixed results, most notably Josef Albers, Alfred Manessier, Jean Bazaine, Jean Cocteau, and Georges Braque. All were masters in their own right. Stained glass, like most media, has its own language, its own strengths, and its own limitations, as do any of the visual arts. Mastery in one field does not presuppose mastery in another. In examining some of the glassworks of these otherwise illustrious artists, the question arises as to whether they might have been better served by the medium if they had a better grasp of its traits. For instance, Georges Braque's Nave Window for the Chapel of St. Dominic in Varengeville-sur-mer, France, profits from Braque's imprimatur. It would otherwise be overlooked as the work of a beginner.

Artists in other disciplines continued to be drawn to glass as the medium asserted and reasserted itself throughout the second half of the twentieth century. Their efforts, however superficial they seemed to insiders of the art and craft, brought renewed attention of the medium. Stained glass found itself part of the discussion in certain circles where it might not otherwise have been considered.

MARC CHAGALL'S GLASS IN METZ CATHEDRAL TRANSFORMS NOT ONLY THE WINDOW ITSELF, BUT THE GRAY STONE INTERIOR OF THE CHURCH.

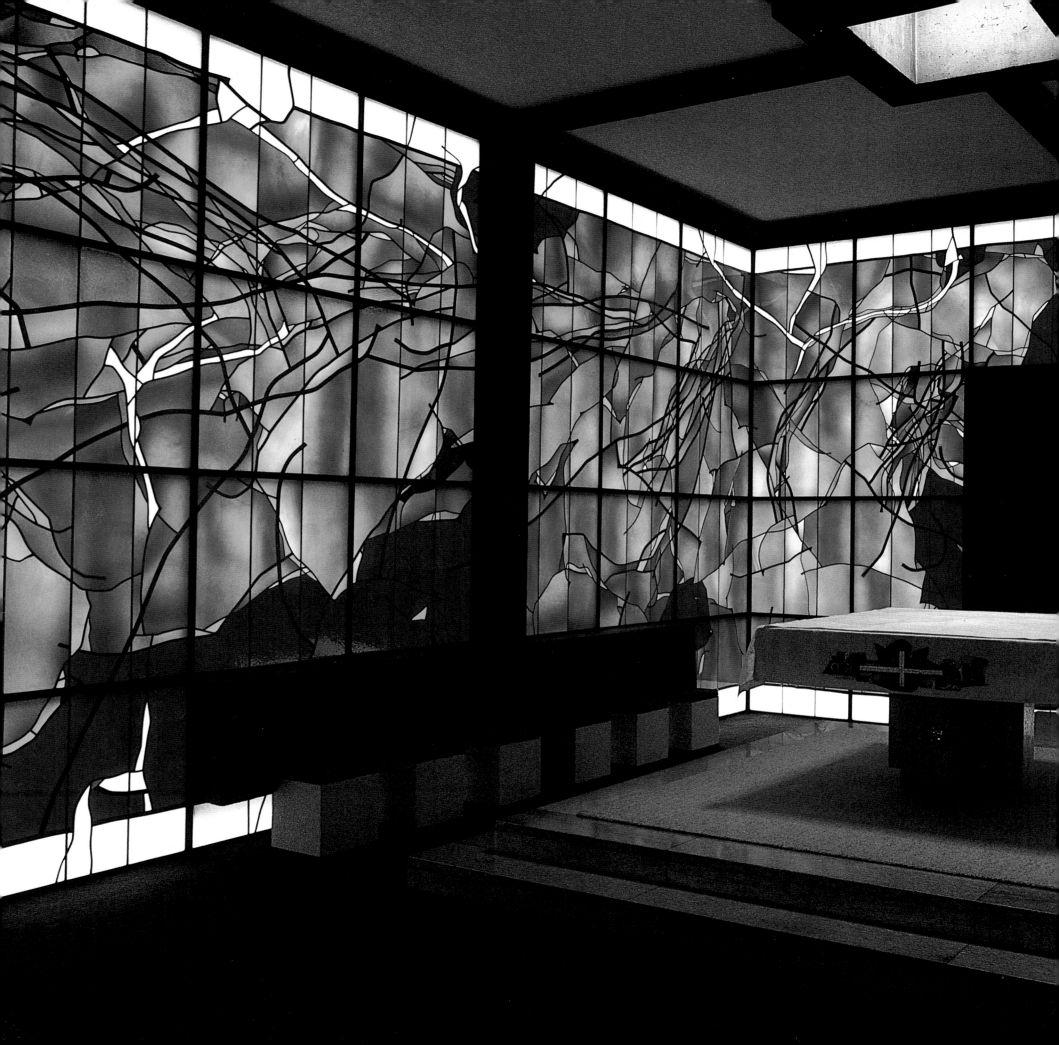

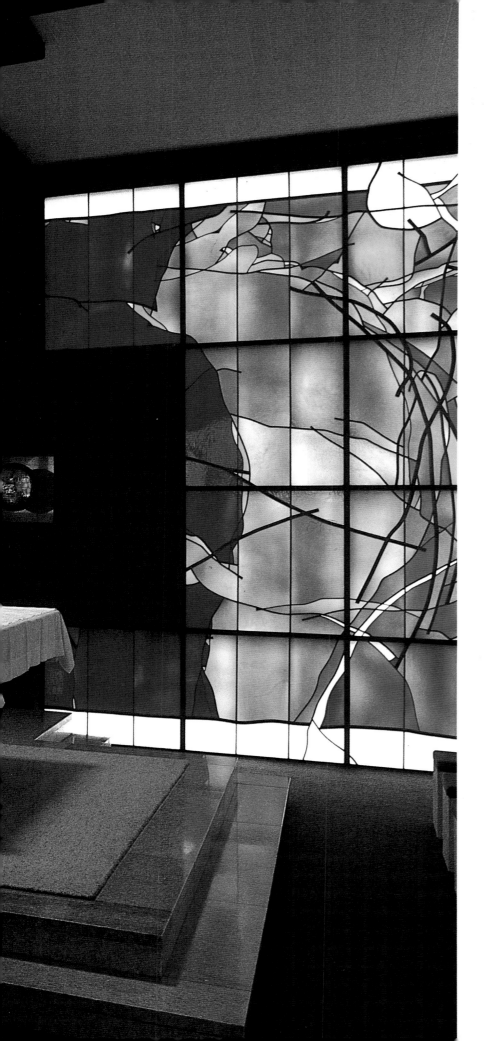

THE GERMAN SCHOOL OF STAINED GLASS

Post-war Europe was a landscape of ruin. Many major city centers faced a period of reconstruction that would take years of manpower and financing. France and Germany had been rich in ecclesiastical structures and stained glass that dated back centuries, but modern warfare has no concern for history and

JOHANNES SCHREITER WAS ONE OF A HANDFUL OF POST-WAR GERMAN GLASS ARTISTS WHO MADE SIGNIFICANT BREAKTHROUGHS IN THE AREAS OF DESIGN AND FABRICATION. ONE OF HIS MOST FAMOUS INSTALLATIONS IS THE ALTAR SPACE OF THE CHAPEL AT THE EXERZITIENHAUS JOHANNESBUND, IN LEUTESDORF.

even less aesthetic conscience. Except for a few instances where valuable stained glass windows were removed from their openings and either hidden or stored in some safe haven, many priceless works were either lost or destroyed forever.

In an odd turn of events, this tragedy for glass history bode well for its future. In an effort to reclaim what the war had taken, a small-scaled renaissance of stained glass occurred—one that had such impact on the medium that its influence is still being felt today. The most important work of the day was done in Germany, ironically, because that country played such a pivotal role in the war. Important stained glass works were completed in France, but none with the lasting effect and historical importance of those created by a handful of innovative German visionaries.

The Artist in the Light

By this time in the history and development of stained glass, an important change had taken place. Artists such as Tiffany, LaFarge, and Wright had quietly but completely established the importance of authorship within the field. The anonymity of the authors/artists who created many of the great stained glass works of the past had itself become part of the past. The twentieth century brought the glass artist

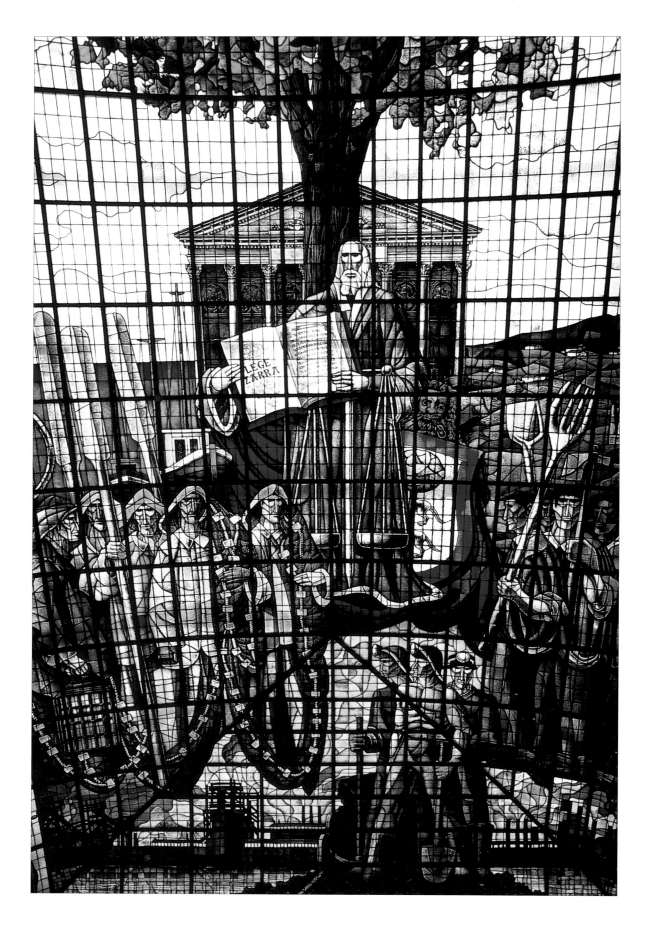

TWENTIETH-CENTURY STYLE AND SUBJECT MEET TRADITIONAL IMAGERY IN THIS CEILING INSTALLATION FROM THE BASQUE AREA OF SPAIN DEPICTING LAW AND INDEPENDENCE. TWENTIETH-CENTURY EVENTS SUCH AS THE SPANISH CIVIL WAR HAD TREMENDOUS INFLUENCE ON STAINED GLASS ART AND ARTISTS.

A CASUALTY OF WAR. COVENTRY CATHEDRAL, BUILT IN THE FOURTEENTH CENTURY, SURVIVED MORE THAN HALF A MILLENNIUM BUT WAS NO MATCH FOR GERMAN AIR RAIDERS DURING WORLD WAR II. NOTE ALL THE WINDOW OPENINGS WHERE GREAT WORKS OF STAINED GLASS ONCE WERE.

1961

into the light. Where once the name of the designing artist had been lost in a crowd of artisans responsible for the work, the artist would now enjoy the rewards of his or her efforts, thus creating an incentive for artists to attain ever greater skill, creativity, and flexibility in their work. The artist's unique signature was becoming an important and valuable part of the stained glass window itself.

Visual Arts in the Post-war Period

Before we examine the works of stained glass of the period, we should take a brief look at the field of the visual arts in general to better understand the impact the new stained glass artists

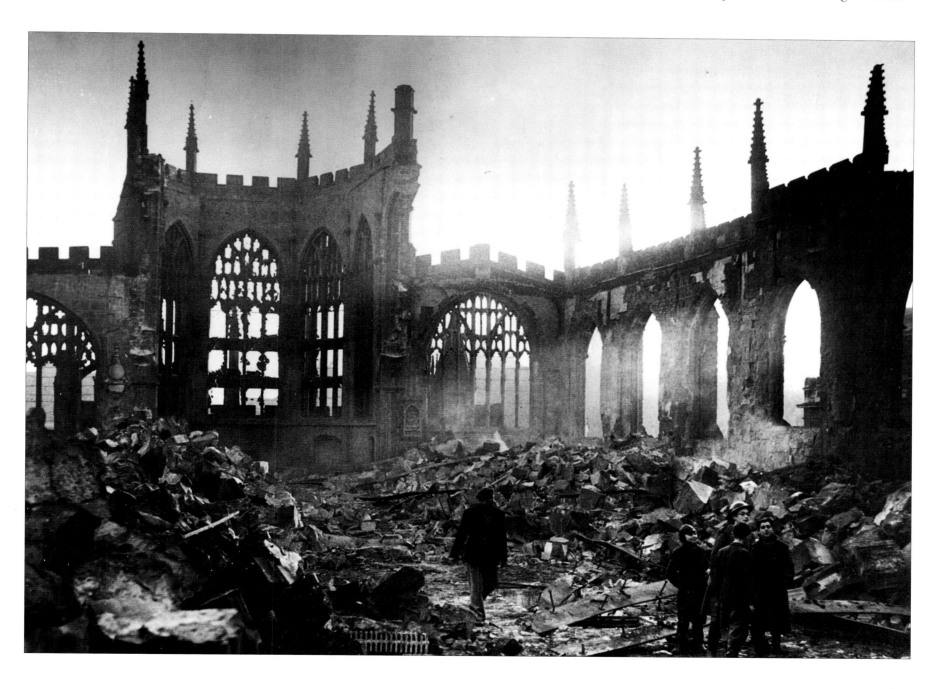

had and why their methods were considered so unusual and innovative.

The first half of the twentieth century was a volatile period for all of the arts. The visual image was never so tortured, broken apart, disassembled, and reinvented as it was between 1900 and 1945. Painting, the medium most likely to be accused of leading the way, blazed a path from Impressionism through Pointillism, Expressionism, Fauvism, Cubism, Constructivism, Dadaism, Surrealism, and a series of lesser "isms" that left a breathless art world wondering how many ways an image could be reinvented and still be considered an image. The decorative and applied arts had already endured through Victorian, Arts & Crafts, Art Nouveau, Art Deco, and the International Style.

Up until this time, stained glass had been a reactive member of the arts community, in many cases taking its lead from other influences. Stained glass may have been rich in history, but it was poor in leadership. But now this was about to change. Two world wars had wreaked havoc on every level of human endeavor, from the everyday life of the common man to the members of the arts community, many of whom had their careers suspended or brought to an abrupt end for the duration of the chaos.

Glass Artists of Post-war Germany

Prior to World War II, a number of German glass artists were very active. Among the fathers of modern German stained glass were

Anton Wendling, whose abstract windows for the choir of Aachen Cathedral were precursors to what would follow, and George Meistermann, whose first windows were installed in 1938 in the Church of St. Englebert in Ruhr, Germany. Both artists provide links between pre- and post-war German stained glass. In the overview of history, though, Meistermann has proven the dominant force, exerting influence on a small group of stained glass artists who, each in their own way, would personify the post-war German contribution.

Wilhelm Buschulte, Ludwig Schaffrath, Johannes Schreiter, and Jochem Poensgen are four glass artists/designers whose names are synonymous with contemporary German stained glass. Their works, more than any others, are called upon time and time again as examples of how the essence of twentieth-century art theory was finally and successfully translated into glass and how it created a new language for the medium.

It is a dual phenomenon of post-war German glass that it first reclaimed an evocative power for stained glass it hadn't enjoyed since the great Gothic period without emulating it, and, secondly, despite the introduction of contemporary graphic theory into buildings that were in many cases

ⓢ

hundreds of years old, the introduction of the new stained glass proved beneficial. For instance, Wilhelm Buschulte's slab glass windows installed in the Church of St. Clemens in Drolshagen, an eight-hundred-year-old structure, look perfectly at home despite the centuries-old structure that separates them. The same was true for numerous works commissioned from this group of glass designers. It's almost as if they found a formula that, by some stroke of aesthetic luck, worked against the odds. The group of glass artists involved with reconstructing Germany's glass heritage represented one of the most successful concerted efforts in the history of the medium to rebuild on a national scale. Whether they realized it at the time or not, their combined efforts were forging a new language for the medium, and the flurry of activity they created would not be matched again until the U.S. craft revival of the late 1960s and 1970s.

What exactly characterized the innovations of post-war German stained glass? Had the artists found a new method of portraying an image in glass? Had technological breakthroughs been made, as was the case in the past, that would affect either the glass itself or the way it was manipulated?

What we encounter in post-war German stained glass is a quantum shift in what could be expected from the coexistence of shards of cut glass, strips of lead, and the role each of the elements could assume in the context of the stained glass window. Gone are the strict reliance on representationalism and the dependence on the glass to deliver the intended imagery. In a total reevaluation of their purposes, glass and lead (or line) could, the artists found, work with each other in both the linear and perspective context to express

an emotion and/or an image. Color was used to support the graphics as drawing, long considered the physical manifestation of the thinking process, emerged from the background of the work to give it its movement and personality. It could easily be said that painting, long considered to be lurking in the background of a stained glass window as it attempted its emulation, was all of a sudden given up for the pencil line and its power to express in stained glass.

MEISTERMANN'S PASCAL WINDOW

In his 1957 *Pascal* window for Wurtzburg Cathedral, George Meistermann, who for some initiated the liberation of stained glass from much of its traditional ties, used elements that would be restated and embellished again and again among this group of glass artists and designers.

The window itself is traditional in shape, basically a pointed arch (lancet) separated into twelve sections. The images are nonrepresentational. They consist of a large, loosely drawn shieldlike shape that occupies the major part of the work, set against an equally loose set of horizontal lines that cut across three-quarters of the window. At the bottom of the design, closely drawn waving lines fill the lowest quarter of the window.

Meistermann's *Pascal* window brings his drawing to the forefront. Gone are any attempts at precision geometrics as in Prairie school artwork or any stylized imagery as found in Art Nouveau and Deco glass. Without stretching definitions, it is not an easy task to find any painterly style that has an equal dependence on line and color other than drawing itself.

LUDWIG SCHAFFRATH

Ludwig Schaffrath's work focuses upon the sheer energy of line and pattern. Schaffrath, more than any other member of the German school, elevated the importance of the lead-line to be on equal footing with the glass. Meistermann's influence is evident, especially in Schaffrath's affinity for parallel lines, but Schaffrath further reduced his own style to its essence, as can be seen in his signature Cloister window of Aachen Cathedral. Using only clear glass, Schaffrath employed varying thicknesses of lead came members to create a skeletal sculpture in glass. As one looks through this work, the external landscape suggests form, texture, and perspective beyond the two-dimensional drawing. Schaffrath used this technique in a number of his commissions. Later in his career he would expand his color palette, as in his 1981 work for the Omaya Railway Station in Tokyo, Japan, without compromising the great energy of his graphic style.

IN THE WORK OF LUDWIG SCHAFFRATH, WE EXPERIENCE A REEVALUATION OF THE LANGUAGE OF STAINED GLASS. AMONG OTHER INNOVATIONS, SCHAFFRATH ESTABLISHED THE LEADLINE AS AN IMPORTANT GRAPHIC ELEMENT, AS IN THIS UNTITLED 1968 WORK.

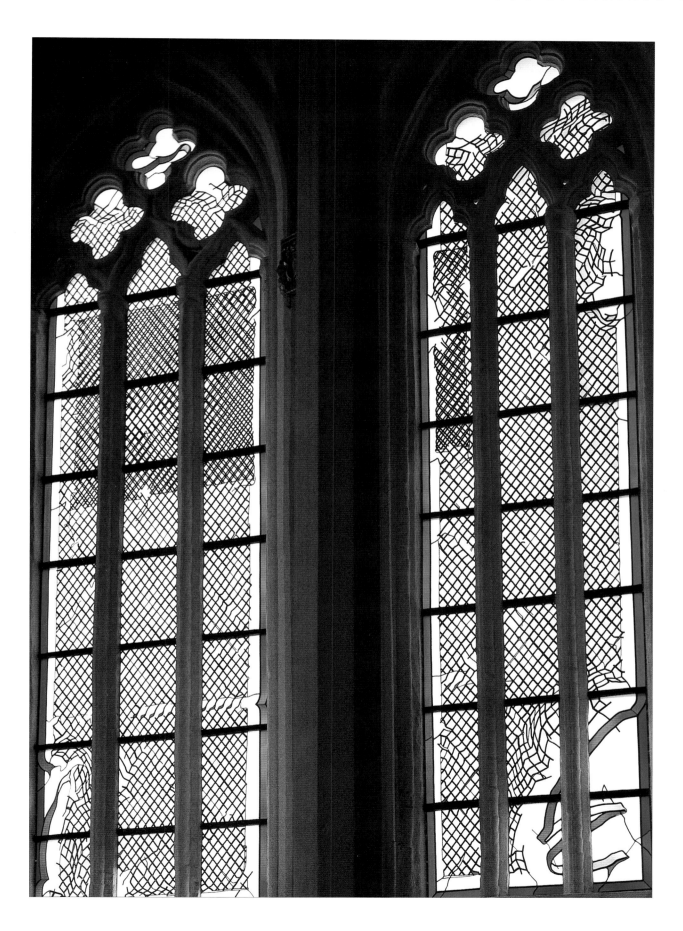

JOHANNES SCHREITER

Although it seems that color is not a dominant factor in the work of this group, it is arguable that color's absence in a conventional sense establishes its importance. Color need not be flashy and overbearing to make its point. Johannes Schreiter brings to his work the question of color and how it amplifies his innovative drawing style and the unique methods he employs to build his windows. In Schreiter's works, color is stated in flat planes. If we look at one of his later commissions, a wall of glass for the Exerzitienhaus Chapel in Leutesdorf, Germany, installed in 1965, the method is obvious. Wide monochromatic (one color) areas are accented by a single section of concentrated color and a leading technique called "pointing off," in which the ends of the lead channels holding the glass in place extend into space, trailing off like scribblings on paper. This modern design innovation became a signature element in post-war German stained glass. It is almost a trademark of the "drawn" style of this group of artists.

Schreiter's Altar Space for the chapel at Leutesdorf is another of the landmark achievements of this school. The glass walls of the chapel are built entirely in shades of blue, with a simple border of white at the top and bottom. The scribbled patterns, or lack of patterns, in the masterfully executed leadlines are the focus of the work. It is at once

IN JOHANNES SCHREITER'S WEST WINDOWS OF THE LETTER CHAPEL IN ST. MARIEN, LÜBECK, GERMANY, WE FIND GLASS DESIGN TOTALLY DIVORCED FROM CONVENTIONAL SUBJECT MATTER AND PATTERN, DESPITE THE VERY TRADITIONAL ARCHITECTURAL TRACERY.

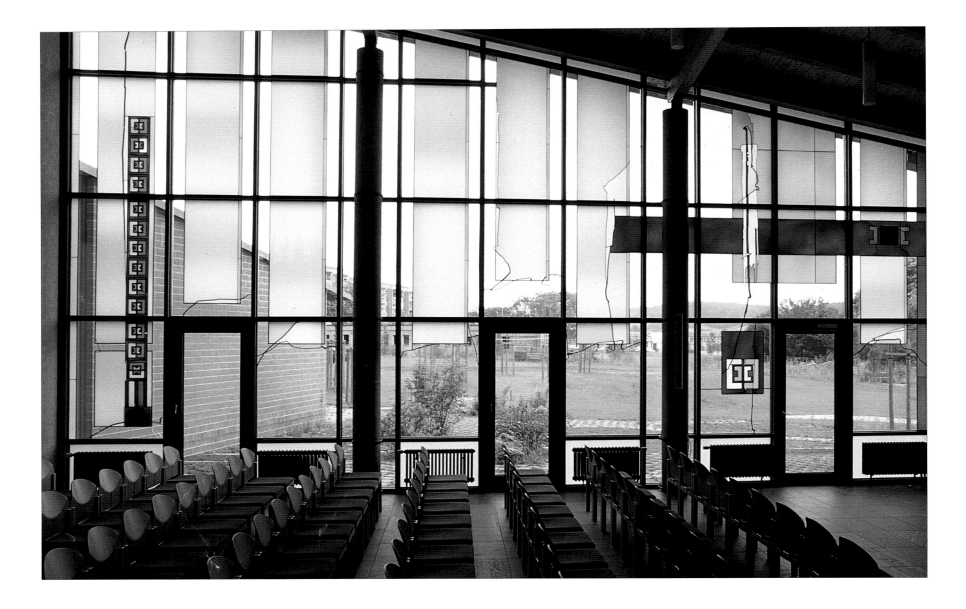

A WALL OF TRANSLUCENT, ALMOST GHOSTLIKE GLASS ART BY JOHANNES SCHREITER WAS DESIGNED AND INSTALLED IN 1993 FOR THE RECONCILIATION CHURCH IN PLAUEN. IN TRUE POST-WAR STYLE, SCHREITER CHALLENGES ALL CONVENTIONAL NOTIONS OF STAINED GLASS DESIGN, MINIMALIZING HIS GRAPHIC ELEMENTS. THE VAST, MONOCHROMATIC SURFACES OF HIS CHURCH WINDOWS AMPLIFY THE CONTEMPLATIVE POWERS OF THE MEDIUM.

exciting to see and soothing to the emotions, thanks to the cool blue glass.

Johannes Schreiter continued to bring innovative ideas to the window plane. In his 1984 Friedenskirche window in Wörth/Rhein, Germany, a large painted fingerprint fills the lower right area of a pair of windows. His choice of images, unconventional to say the least, would go on to include the musical scale, computer printouts, computer chip wiring schemes, and what can only be described as wire meshlike patterns, like those of his eclectic installations in the traditional framework of the Letter Chapel in St. Marien, Lübeck, Germany.

Schreiter's works have had a great influence on many younger artists of the second half of the twentieth century.

SCHREITER'S 1994 WINDOWS FOR THE CHRISTCHURCH IN
INGBERT ARE ENGAGING EXAMPLES OF THE ARTIST'S
SOPHISTICATED STYLE. HERE, IN CONTRAST TO TRADITIONAL
GLASS DESIGN, HE USES REPETITIVE GEOMETRY AGAINST
ABSTRACT, ARCHITECTURAL SHAPES TO DRAW THE VIEWER INTO
THE WORK.

JOCHEM POENSGEN

Jochem Poensgen, an artist and teacher,
shifted the emphasis from glass to light.
Always aware of the illuminating properties
of light, he approaches his work thinking
about how the glass will react to the light. In
many ways, his works relate to those of other
German glass artists, but like Schreiter,
Schaffrath, and Buschulte, he brings his own
insights and concerns to the glass. Poensgen's
works call for a connection to the viewer, an
engagement that onlookers can experience.
He equates much architectural glass to a
"golden cage"—beautiful and seductive, but
a trap. Without dialogue with the viewer, the
glass falls short of its purpose. This concept
will turn up again and again in modern glass
ideology.

In his 1962–68 Nave Window for St.
Maria Empfangnis, Wuppertal-Vohwinkel,
Germany, Poensgen merges the feeling of
ancient glass with his modern concepts of
light versus glass versus space. The "chunky"
leadlines suggest the scribblings of a
Schreiter window without the curves and
arcs. More "scratches" than scribbles, they
add strength to the color fields that Poensgen
employs. Poensgen's attitude, personally and
in his glass, represents a chink in the armor
of architectural glass theory which dictates
that stained glass speak only to the building.

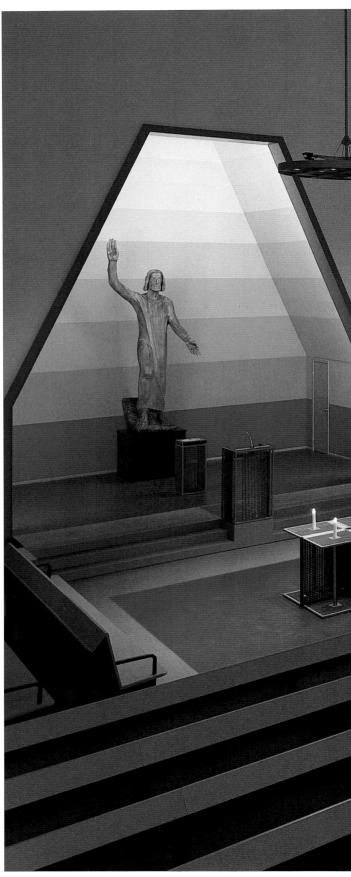

In his own words he describes his feelings: "I would like to contribute to the creation of spaces in which people can feel comfortable. By that I mean that they will feel sheltered, provided for, protected, at peace, accepted, welcomed, and placed in a situation to use the spaces in accordance with their appropriate function."

∞

Above and right: JOCHEM POENSGEN ONCE SAID, "ART MUST LEAVE THE GALLERIES, COLLECTIONS, AND MUSEUMS, FOR IT NEEDS MORE VITAL CONNECTION WITH LIFE." HIS GLASS CONNECTS WITH BOTH THE SURROUNDING ARCHITECTURE AND THE VIEWER. POENSGEN'S 1997 SILK-SCREENED AND ACID-ETCHED WINDOWS AT BUGENHAGEN CHURCH IN HAMBURG, GERMANY, REPLACED THE ORIGINAL 1929 GLASS WORK THAT WAS DESTROYED IN 1939 BECAUSE IT WAS CONSIDERED DECADENT.

The Impact of the German School

The visual concepts and innovations of the German school inspired an entire generation of glass artists all over the world. Traditionalists would dismiss the new works as "gimmicky," "cold," "lifeless," and inaccessible. But as we will see, those artists who could successfully digest the German influence and filter it through their own experiences would bring us the stained glass masterpieces of the seventies, eighties, and nineties.

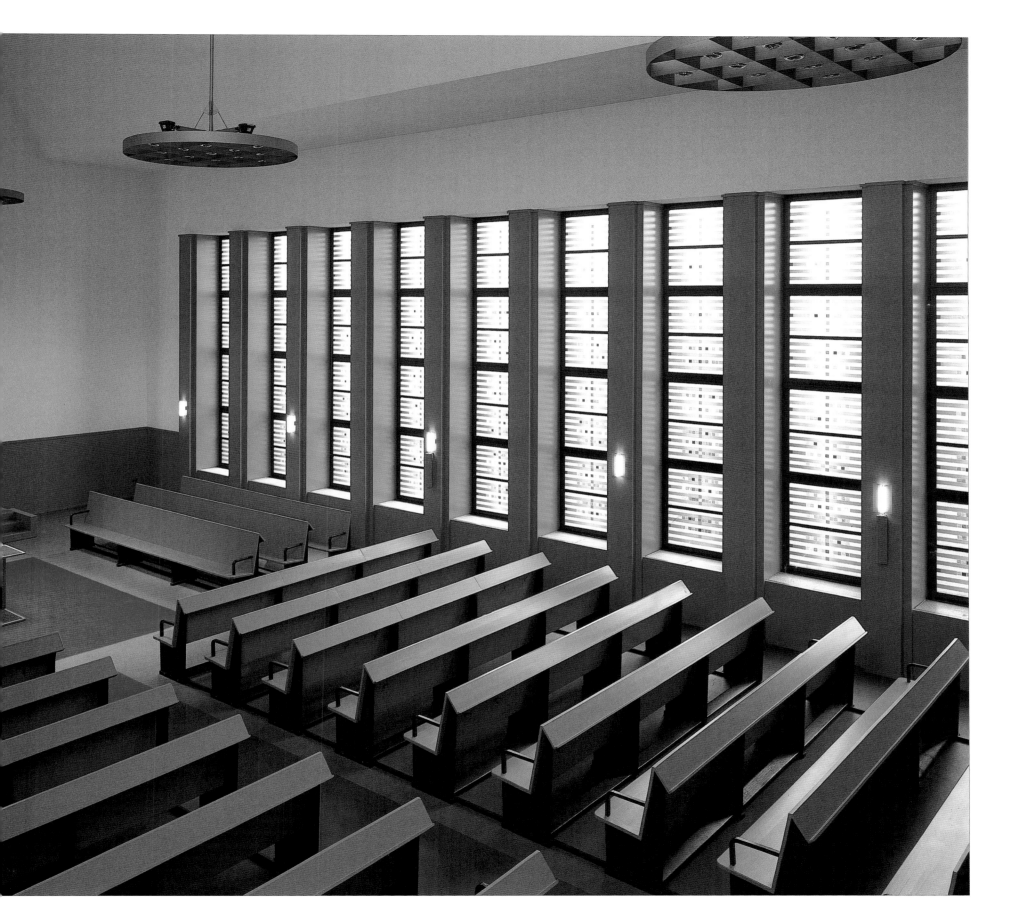

Right: STEPPING OUT OF THE ARCHITECTURAL FORMAT INTO THE FREE EXPRESSION OF AUTONOMOUS GLASS, JOCHEM POENSGEN CREATED THIS 1996 *CONCEPT FOR A GLASS TOWER* MADE OF SANDBLASTED FLOAT-GLASS, A TYPE OF CLEAR PLATE GLASS. *Opposite:* IN A FURTHER CHALLENGE TO TRADITIONAL STAINED GLASS TECHNIQUE, POENSGEN ELIMINATED THE HEAVY, DARK OUTLINE OF THE LEAD CAME STRIPS BY LAMINATING THIS GLASS, ALLOWING LIGHT TO IDENTIFY THE SPACES BETWEEN THE AREAS. THE PHOTO SHOWS DETAILS OF A ROOM DIVIDER MADE FOR THE MUSEUM FÜR KUNSTHANDWERK, FRANKFURT AM MAIN, GERMANY, IN 1990.

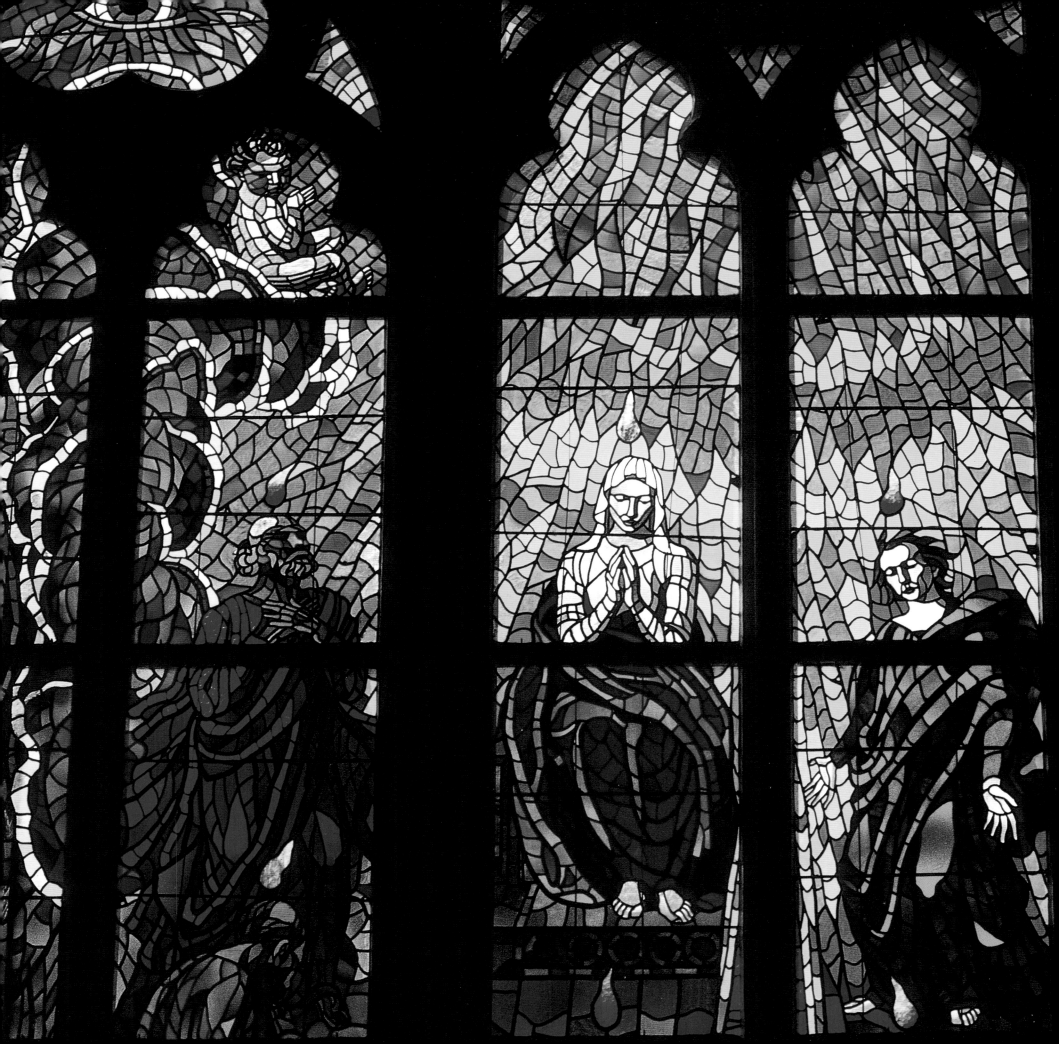

THE CRAFTS REVIVAL AND THE NEW GOLDEN AGE OF GLASS

I f the post-war period marked the birth of modern stained glass, then the decades of the 1960s through the 1990s would represent both its adolescence and blossoming. More would happen within the field of glass in these thirty-plus years than in any comparable period in history.

TODAY'S GLASS ARTISTS HAVE A RICH HISTORY OF ART AND TECHNIQUE AS WELL AS STATE OF THE ART MATERIALS AND EQUIPMENT TO CALL UPON IN PURSUIT OF THEIR PERSONAL VISION. PICTURED IS THE STAINED GLASS OF SAINT VITUS CATHEDRAL IN PRAGUE, THE CZECH REPUBLIC.

The State of the Art in the 1950s

Before we discuss why and how the late twentieth century would give birth to an entire movement in stained glass, we need to look at the condition of certain aspects of the craft during the same period. Religious and institutional glass had long been the barometer of the art. What was installed in churches,

ces

Below: THIS WORK IS A CARTOON BY SIR EDWARD BURNE-JONES FOR THE LOWER SUBJECT PANELS OF A STAINED GLASS WINDOW IN THE WEST TOWER OF ST. CHAD'S CHURCH, IN ROCHDALE, ENGLAND. BURNE-JONES RECEIVED THE COMMISSION TO DESIGN THE WINDOW FROM MORRIS & CO., AND COMPLETED THESE DESIGNS ON JANUARY 1, 1873. PICTURED IS A CROUCHING VICE TO APPEAR BENEATH THE FEET OF A VIRTUE, SUCH AS DESPAIR BENEATH HOPE.

Right: THE CONSTRUCTION OF A STAINED GLASS WORK INVOLVES FAR MORE THAN DRAWING A PICTURE, CUTTING THE GLASS, AND FITTING THE PIECES TOGETHER. HERE THE EDGES OF THE LEAD CAME SURROUNDING THE PIECES OF COLORED GLASS ARE BEING SOLDERED TOGETHER FOR A HERALDIC WINDOW INSTALLATION AT CANTERBURY CATHEDRAL IN ENGLAND.

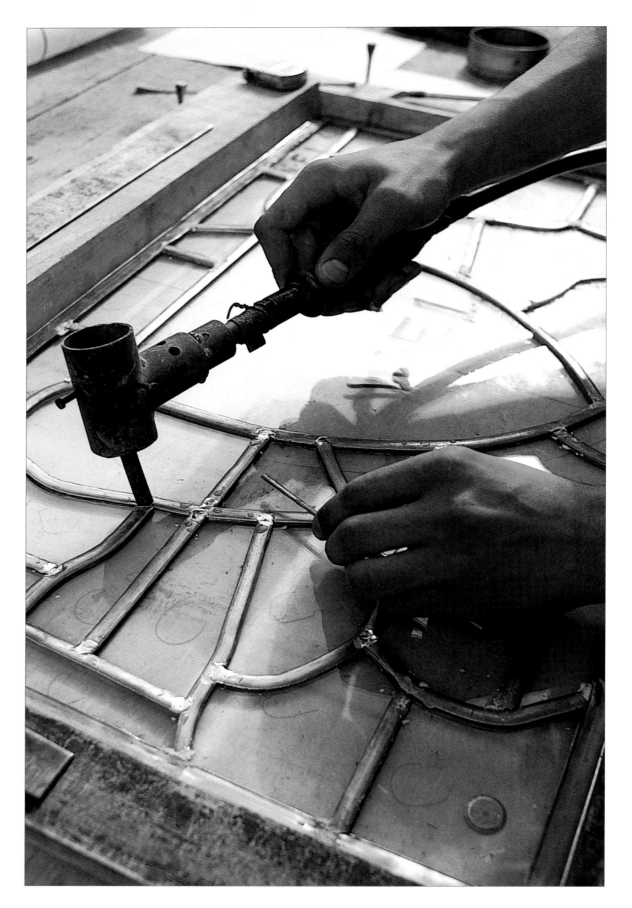

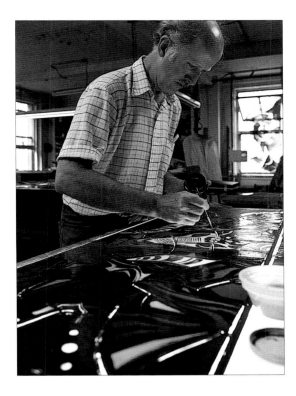

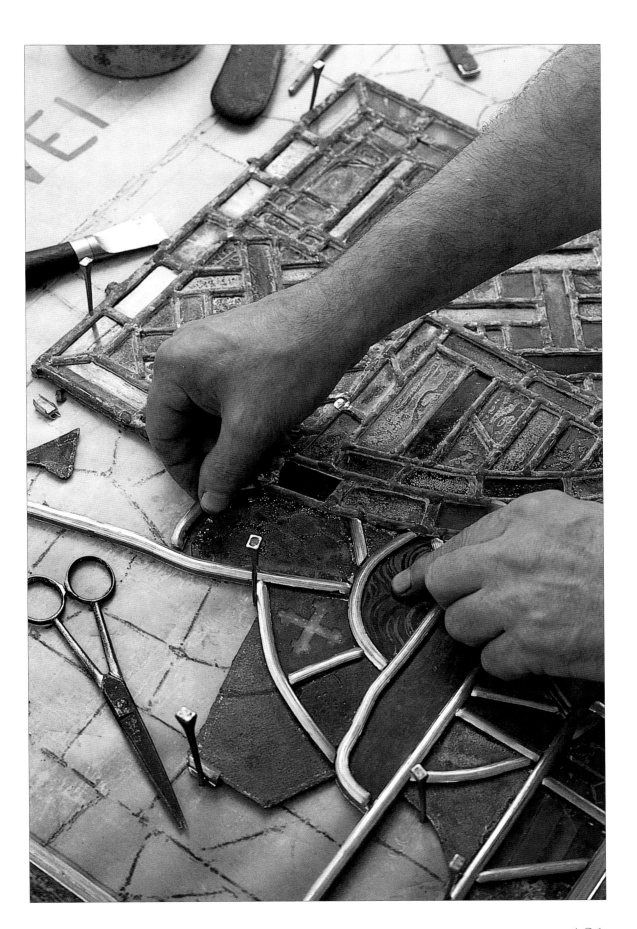

Above: At the National Cathedral in Washington, D.C., an artist puts the finishing touches to a stained glass panel. *Right:* The crafts revival of the 1960s saw a resurgence of interest in the crafting of stained glass. In this photo, lengths of lead came are being fitted around cut pieces of glass for a work being done at Canterbury Cathedral, in England.

✤

synagogues, and other venues of worship provided the theater for stained glass, many of its traditions and innovations, and much of its recorded history. It represented a small universe of opportunity for an equally small community of artists, designers, and fabrication studios. The short spurt of domestic stained glass installations that the Tiffany Studios, John LaFarge, and their competing contemporaries enjoyed and helped to inspire disappeared by the 1950s for a number of reasons. First and foremost, in the

United States, like in Europe, recovery from World War II was an intense, nationwide effort that did not allow much room for luxuries such as stained glass. The country had other priorities to tend to. The idea of stained glass as a personal decorative item simply did not exist in the popular psyche.

The opalescent glass that had made works by Tiffany and LaFarge and a number of their contemporaries so special, namely hand-rolled art glass, had not been produced in any quantity for decades. The Tiffany Glass made exclusively by and for the Tiffany Studios hadn't been produced since the studio closed its doors and declared bankruptcy in 1932. A small number of firms, such as the Paul Wissmach Glass Company of Paden City, West Virginia, and The Kokomo Art Glass Company of Kokomo, Indiana, continued to make colored glass throughout the early and mid-twentieth century, servicing the surviving studios of the period with a consistently colored, mass-produced art glass. Stained glass lamps, the most popular byproducts of turn-of-the-century glassmakers, were reduced to the "curiosities" collectors began to acquire. Finding someone who knew how to repair a leaded glass lamp, much less create one, was virtually impossible.

Why had this been allowed to happen? How could such a vital and active sector of the creative community disintegrate so? To understand the answer to this question, we

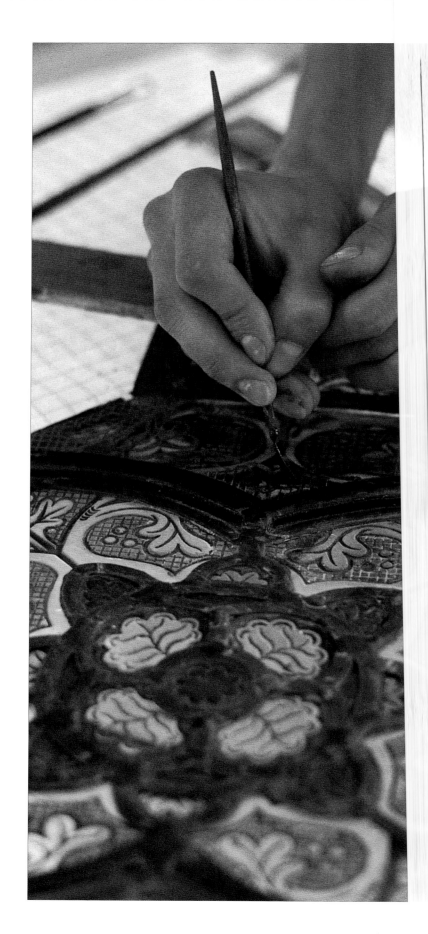

THE NEW GENERATION OF GLASS ARTISTS AND CRAFTSPEOPLE DISCOVERING STAINED GLASS INVESTIGATED ALL ASPECTS OF WORKING WITH GLASS, INCLUDING PAINTING ON GLASS. HERE, A CRAFTSMAN, ALSO AT ENGLAND'S CANTERBURY CATHEDRAL, WORKS ON THE DETAILS OF A PAINTED PANEL.

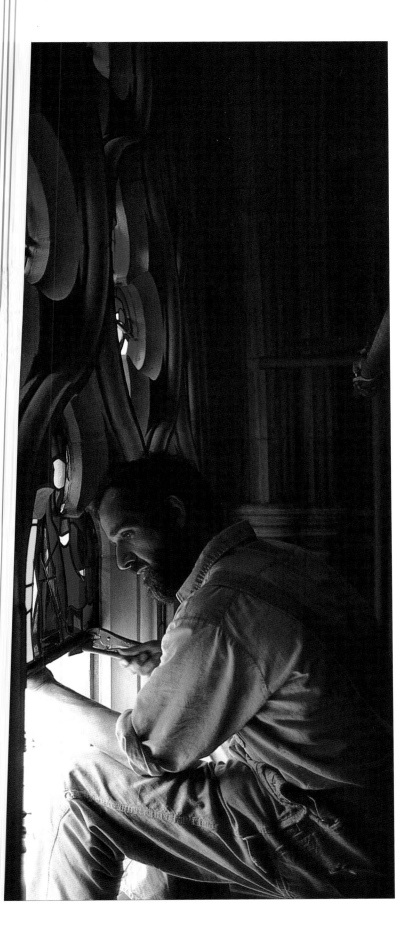

must first understand the process of creating or building a stained glass window or leaded glass "Tiffany"-style lamp.

THE LOSS OF THE STUDIOS

When we look at a work in stained glass, we may be looking at the art work or design of an individual, but the object itself is more than likely the product of a group of craftspeople or artisans. For example, window production would begin with the design and color instructions of the artist, then go to the fabrication team, who would, in most cases, bring the design to its full size and create the working templates for the glass cutter, or cutters, who would actually cut the glass pieces. The next team of craftspeople in the production line would be the fabricators, who would wrap each piece of cut glass with the lead strips, or came, that allowed one piece of glass to be fastened to another. This group may or may not perform the soldering of the lead came into a large network of glass and metal. A last team of contractors would install the finished stained glass panel into its designated wall space or window. Any number of people could be responsible for even small

NEW METHODS OF INSTALLATION USING STATE OF THE ART MATERIALS ARE A NATURAL BY-PRODUCT OF LATE TWENTIETH CENTURY STAINED GLASS. ARMED WITH THE KNOWLEDGE OF HOW NATURE AND THE ELEMENTS WREAK HAVOC ON GLASS AND METAL, NEW INSTALLATION TECHNIQUES THAT ALLOW FOR A WINDOW'S EXPANSION AND CONTRACTION AND THE RELEASE OF HEAT AND MOISTURE ADD YEARS TO NEW OR RESTORED WINDOWS. IN THIS PHOTO, A CRAFTSMAN AT THE NATIONAL CATHEDRAL IN WASHINGTON, D.C. INSPECTS THE WINDOW FOR PROPER INSTALLATION.

projects. In modern terminology, stained glass windows may have been authored by one person, but their construction surely qualified as an industrial art. Stained glass lamps were built by similar "teams."

When the large studios like Tiffany's closed their doors, their workforces scattered: groups of highly specialized craftspeople, each proficient in their own aspect of the craft, but none possessing all of the skills necessary to continue to work on their own. No single member of the team could create their own windows or lamps. Additionally, some of the individual crafts on the periphery of, yet necessary to the creation of the physical work, such as glassmaking itself, with its complex (sometimes regarded as secret) chemical color formulas, and patina or metal finishing, with its fiercely guarded processes, were always considered products of a "closed shop." As such, they were off limits to all except for the master craftsperson and the chosen apprentices; the rest of the world was not welcome for fear their "secrets" would be discovered and their livelihood threatened by competition. Compound this disability with the lack of demand for the products the members of these groups were trained to create, and you have all the makings for a "lost art."

The Tiffany Revival

Beginning with the mid- to late 1950s, a curious thing began in the world of antiques, of all places, and with none other than Tiffany Glass, which had fallen from favor and fashion some twenty years earlier. A small group of curiosity seek-

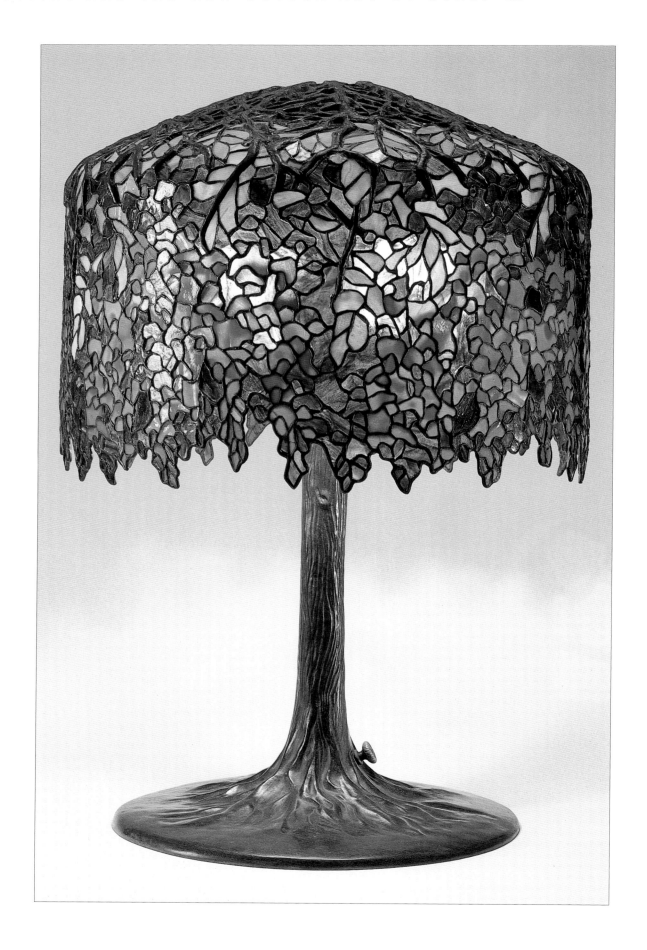

ers, not even considered collectors at the time, had their interest piqued by the products of the Tiffany Studios and, most particularly, Tiffany's leaded glass lamp shades and bronze lamp bases. One such curiosity seeker was Dr. Egon Neustadt, who, along with his wife, Hildegard, began what would become the world's most important private collection of Tiffany lamps by purchasing what they described as a "strange, old-fashioned lamp" spied in a small New York shop. The Neustadt collection would later become hundreds of lamps strong

and ultimately result in the publication of a monumental catalog of the collection, *The Lamps of Tiffany*, by Dr. Neustadt, first published in 1971.

Neustadt, although a prominent and prolific collector through the 1950s, was not alone. New York antiques dealer Lillian Nassau began bringing Tiffany lamps into her shop to the delight and interest of others who found the "curiosity" of a Tiffany lamp tempting enough to purchase. Other authors also found the Tiffany legacy ready for the literary nod. Robert Koch's *Louis C. Tiffany:*

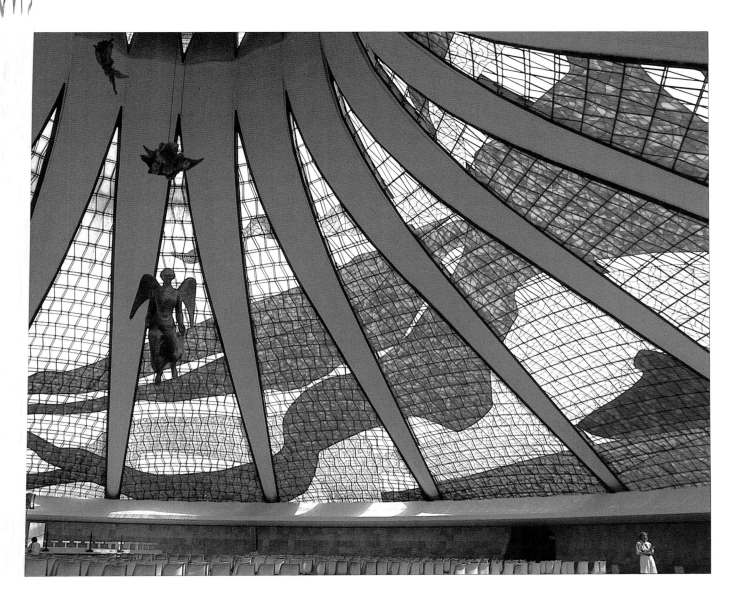

Rebel in Glass, first published in 1964, seven years ahead of Neustadt's book, offered a full history of the firm. His second book, *Louis C. Tiffany—Glass, Bronzes and Lamps*, followed in 1971 with a more focused study of the products of the studio. In the years to come, British writer Alastair Duncan would go on to become the most published author and authority on the subject of Tiffany, with books such as *Tiffany At Auction*, *The Lamps of Tiffany Studios*, *Tiffany Windows*, and *Masterworks of Tiffany*.

THE FIRST TIFFANY RETROSPECTIVE

In 1958, the Museum of Contemporary Crafts in New York mounted the first retrospective exhibition of Tiffany's work. It was the first time since the studio closed in 1932 that the objects of Tiffany's workforce were plucked from oblivion and elevated onto the altar of public display. The exhibit kicked off a period of interest, scholarship, and discussion that continues today. In a few years, works by the Tiffany Studios began to show up at important auctions of nineteenth- and twentieth-century decorative arts; higher and higher prices were fetched as fine examples of work that had remained in private hands for two generations were offered for sale. By the 1990s, the finest examples of Tiffany glass were valued at over $1 million.

THIS WINDOW FROM THE NATIONAL PALACE OF GUATEMALA IN GUATEMALA CITY FEATURES MAYAN-INSPIRED STAINED GLASS WORK. IN THE TWENTIETH-CENTURY, GLASS HAS BECOME AN INTERNATIONAL ART FORM WITH EXPRESSIONS FAR BEYOND THE CHURCHES OF WESTERN EUROPE.

The Rediscovery of the Art of Stained Glass

The 1960s fostered lifestyle changes on an almost daily basis. Every aspect of life—mass culture, communications, the arts, society, government, and the like—was being challenged; the rules were being rewritten. In the world of crafts, young people with a desire to get "back to the earth" rediscovered the rewards of hand crafting. Developing skill and creativity with a wide variety of hands-on materials evolved from curiosity, through fascination, to obsession. A massive and influential generation, the "baby boomers" of the 1940s and the 1950s were investigating crafts in a big way. Stained glass was ripe for rediscovery.

THE BIRTH OF THE MODERN GLASS STUDIO

To rediscover stained glass was to rediscover Tiffany. For better or worse, Tiffany would inspire a whole new generation of glass artists and craftspeople eager to realize and re-create the beauty and spectacle of the master's glass, with one important exception. Instead of relying on a team of people to create their works, they wanted to be able to do it alone in what would become the modern glass studio. To a new generation of glass craftspeople, the fascination with Tiffany was not merely the object, but the glass itself. How was it made? What made it so different from other types of glass? What magic did his artisans perform on the base ingredients of glassmaking to give it such life, depth, and painterly qualities?

The 1960s philosophy, or idealism, was that individual effort could make a world of difference. Anything was possible if you put your mind to it; challenge and experimentation made life worthwhile. Most of all, being creative was akin to being blessed. These three elements—challenge, experimentation, and creativity—became the stock in trade of the new glass community.

By the late sixties and early seventies, a handful of glass craftspeople had taken it on their own to study Tiffany's glass, analyze its components, and, in what can best be described as an exercise in trial and error, reproduce Tiffany's magic in hopes of manufacturing enough of the new glass to satisfy what they foresaw as a growing demand for colored art glass. In time they would succeed, pioneering what could be called a revival within a revival.

FOSTERING FUTURE GLASS ARTISTS

The new breed of stained glass artists shared all the passion and skill of their forebears. But they added one more important element to their repertoire of talents, one that would distinguish them as new and far removed from those who came before, namely, the ability and desire to teach. To rediscover the magic and rewards of creating with stained glass without sharing the experience for others to enjoy seemed to the majority only half the prize. For the first time in the long history of stained glass, communication became its lifeblood, a means to an end, a skill that would reap benefits beyond the creation of an object. Communication would spread the word, share the feeling, create excitement. The more people doing stained glass, the bet-

ter. The more people knew about stained glass, how it was made and how it could be used in the home, the better chance glass artists could make a living doing what they loved. Communication was good, it was smart, it became part of being a glass artist of the seventies and eighties.

More of today's craftspeople and artists found their way to glass in the early 1970s than in any other recent period. Whatever special conditions existed during those few years remains a mystery. To those eager to find a meaningful pursuit in their lives, glass offered great potential. It was an arena brimming with opportunities, not all of them financially rewarding, but opportunities nonetheless. Here was a craft and art rich in history, gaining in popularity, and free from the conventions of the real world. For those seeking an alternative lifestyle, the crafts and glass in our discussion offered prime ground floor openings.

CRAFT VERSUS ART

Much to the dismay of those seeking more from their glass efforts than the joys of skill building, the world of fine art was not ready to embrace much of the new glass being created. Stained glass in particular was held at bay long before it would be considered anything more than a "craft." Because much of the energy behind the rediscovery of stained glass came under the banner of "craft," it was an image and perception that proved hard, and sometimes impossible, to shake. The emphasis on handiwork, technique, materials, and the "oooh-aaaah" of beautiful glass left patrons, critics, and publishers of the fine arts like painting and sculpture cold.

Outside their own creative community, glass artists of all disciplines—stained glass, blown glass, and others—were considered second-class citizens of the arts. Their works were judged interesting but too lacking in content and meaning for any serious consideration.

The new "Studio" glass movement became an unspoken crusade for its members to gain the acceptance of the "real" art world. Despite the fact that much of what was being created, as is the case in all of the arts, was not art, the attitude that any of the crafts seeking art status were stepping out of line, attempting to rise above their station, so to speak, was unacceptable. This argument would be vehemently fought by both sides for years to come. By the mid-1990s, however, the controversy had all but disappeared, largely through the efforts of a handful of artists who through persistence, vision, and hard work made inroads into the fine arts community. More galleries featured glass in their offerings, museums such as the Metropolitan Museum of Art in New York began to access glass for their collections, and individuals began to amass important collections throughout the world. Maybe most important, the prices for contemporary glass rose to the levels of fine art.

A New Generation of Artists

In Great Britain and North America, stained glass artists encountered the post-war German school of stained glass. Through books, magazines, and a nascent lecture and seminar circuit, the works of artists such as Ludwig Schaffrath, Jochem Poensgen, Johannes Schreiter, Wilhelm Buschulte, and their contemporaries were influencing the perception of what stained glass could accomplish. As a perfect foil to the Tiffany-esque tendency toward spectacle, German glass was sophisticated and expressive, clean and contemporary. It reeked of art. The concepts of architectural relationships and abstracted geometries found willing support in many young stained glass artists. In a field where everything old had become new again, here were new heroes speaking in new tongues, the language of contemporary glass. Slowly, the names of stained glass artists who had been quietly creating successful contemporary works came to the forefront—names like Albinas Elskus and Robert Sowers in the United States and Patrick Reytiens and John Piper in the United Kingdom.

Among those eager to distinguish themselves in the new age of stained glass were Great Britain's Brian Clarke; American artists Narcissus Quagliata, Kenneth vonRoenn, Ed Carpenter, James Carpenter, Richard Millard, Paul Marioni, Peter Mollica, and Ray King; and Canadian artist Lutz Haufschild.

Some, like Clarke, vonRoenn, and Haufschild, used the German influence as a springboard for their own interpretation of architectural glass art. Others, like Quagliata, Millard, the Carpenters, Marioni, and King, imposed more of a signature style on their projects, whether they were institutional or residential commissions, sometimes tying their efforts to the architecture, and other times setting their work apart in a more autonomous way.

BRIAN CLARKE

Brian Clarke is by today's definition a multimedia artist. Primarily a painter, his early works in stained glass were exceptional in their unique absorption of the German style without resorting to mimicry. Clarke adopts the strong grid of geometry as the backdrop for his subtle use of irregular and whimsical forms scattered throughout his composition. Matisse-like in their simplicity, these casual shapes contribute to a unique handling of light space and Clarke's selective use of bold color. Clarke's stained glass employs a very catholic method of construction, executed by the Franz Mayer factory in Munich, Germany. He relies mainly on the lead came method, and makes ingenious use of the technique of pointing off his leadlines so that they extend into linear space, defying the logic of the conventional leadline and adding to the whimsical nature of his interruptive shapes.

Clarke's works are some of the largest of contemporary commissions. Take, for instance, the ceiling of stained glass he created over an entire Victorian street in Leeds, London: eleven thousand, five hundred square feet (3505 m) of vintage Brian Clarke; a powerful grid-ridden design with Matisse-like interruptions throughout. It is one thing that an artist conceive such a massive work; it is another completely that the administrative and financial machinery needed to realize such a project would come together and allow it to happen.

NARCISSUS QUAGLIATA

In the stained glass of Narcissus Quagliata, the drawn image takes center stage. Quagliata is an artist well versed in the concepts of architectural art, but his most memorable works are autonomous in nature and command the space and light they occupy. They draw their strength from their visual power unencumbered by the distractions of archi-

Below and right: ENGLAND'S BRIAN CLARKE HAS HAD GREAT IMPACT IN THE GLASS COMMUNITY. HIS GLASS ROOF OVER THE VICTORIAN QUARTER IN LEEDS, IN LONDON, ENGLAND, REMAINS ONE OF THE MOST SPECTACULAR OF STAINED GLASS INSTALLATIONS, RUNNING OVER 400 FEET (122M) OF QUEEN VICTORIA STREET. CLARKE'S CHECKERBOARD GEOMETRY WITH ITS INTRUDING ABSTRACT SHAPES HAVE BECOME A SIGNATURE STYLE FOR THIS INNOVATIVE ARTIST.

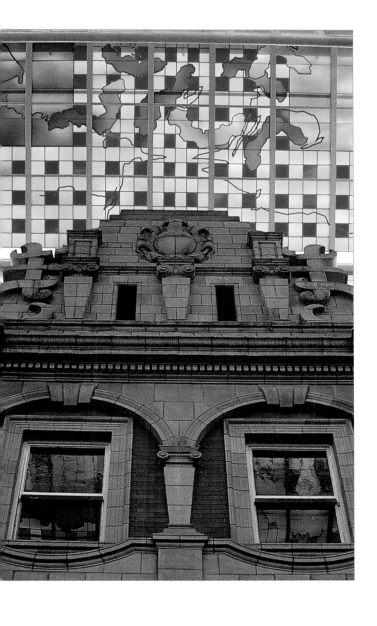

IN HIS WORK, NARCISSUS QUAGLIATA HAS ALWAYS
CHALLENGED THE PHYSICAL AND GRAPHIC LIMITATIONS OF
HIS MATERIALS. HIS *BURNING HEAD* JOINS TRADITIONAL
STAINED GLASS TECHNIQUES WITH THOSE OF GLASS CASTING
AND KILN WORK TO ENHANCE HIS DRAFTING SKILLS.

IN HIS WORK, NARCISSUS QUAGLIATA HAS ALWAYS
CHALLENGED THE PHYSICAL AND GRAPHIC LIMITATIONS OF
HIS MATERIALS. HIS *BURNING HEAD* JOINS TRADITIONAL
STAINED GLASS TECHNIQUES WITH THOSE OF GLASS CASTING
AND KILN WORK TO ENHANCE HIS DRAFTING SKILLS.

tecture. It is interesting to note how Quagliata seems to have two distinct styles and working methodologies at his disposal. When working within the confines and dictates of architecture, he channels his efforts into the expressive limits of color and line divorced from the representational image, as in his *Oracle* installation at the parking garage of Yerba Buena Center in San Francisco. But in his image-rich works, most notably *Porca Misera*, *The Prisoner*, and *Suzuki Roshi* (now in the collection of the Metropolitan Museum of Art in New York), Quagliata casts off the responsibility of merging with any surroundings whatsoever and gives his expressive instincts full reign.

KENNETH vonROENN

In the work of Kenneth vonRoenn, we find a strong commitment to glass as an adjunct to architecture. The name of vonRoenn's firm, Architectural Glass Art, in Louisville, Kentucky, states its intent. VonRoenn draws from the post-war German language and spices it with an American flair akin to the style of Frank Lloyd Wright. Where he veers from their directives is in his choice and mixture of glassworking techniques. Beveled, laminated (layered sections of glass), and sandblasted or etched glass join in more traditional glazing techniques to bring a new expressiveness to his geometric composi-

INTEGRATING GLASS DESIGN AND ITS ARCHITECTURAL SETTING IS FOREMOST IN THE EFFORTS OF KENNETH VONROENN OF LOUISVILLE, KENTUCKY. THIS WORK, THE MARY, QUEEN OF THE UNIVERSE SHRINE AT THE DAILY CHAPEL IN ORLANDO, FLORIDA, STANDS OUT AS ONE OF THE MOST VISUALLY COMPLEX OF THE ARTIST'S DESIGNS. HERE, HE FOREGOES HIS USUAL SPARE GEOMETRY IN FAVOR OF A MULTIPATTERNED EXPLOSION OF LIGHT AND COLOR.

tions. For example, vonRoenn's Lambert Airport Chapel in St. Louis, Missouri, super-imposes a taste of German influence over that of Frank Lloyd Wright geometry to create a unique and functional window that enhances its architectural setting and creates privacy, by means of the opaque glass used in its lower sections, in the hustle and bustle of a busy airport.

In his Mary, Queen of the Universe Shrine at the Daily Chapel in Orlando, Florida, vonRoenn calls upon his evocative powers and sophisticated use of sandblasting, beveled, leaded, and flashed glass to create both the image of outer space and the special effect of a starlit sky. A thoroughly modern stained glass artist, vonRoenn goes beyond the conventional techniques of the craft and embraces any that will service his designs and vision.

In his laminated, sandblasted, beveled, and dichroic (glass that changes color in shifting light) panels for the Prizant residence in Louisville, his architectural style is scaled down, but his preference for state of the art stained glass in a linear style is strongly evident. Here, vonRoenn established his grid pattern using square, beveled glass pieces. He then accented the composition

with square "pinchbacks"—tiles of glass with a surface texture that looks like it's been pinched—of dichroic glass that change their surface color as the viewer changes position in front of the window. Finally, he lightened the strict geometry with calligraphic sweeps of thin beveled glass. It is a totally nonrepresentational image with all the fascination of pictorial glass.

Lastly, in the massive installation of stained glass vonRoenn created for the Mountain View, California, City Hall, a recurring geometric theme unites the large expanse of glass within a large expanse of rigid, sleek architecture.

JAMES CARPENTER AND ED CARPENTER

Ed Carpenter and James Carpenter share last names and the medium of glass, but each makes his own contribution to the field in his singular use and manipulation of the concept of stained glass. Since the late nineteenth century, artists have seen fit to gradually reduce their chosen medium to its essential elements, as the Impressionists, Pointillists, and Cubist painters did at the turn of the century, and as the Abstract Expressionists, color field painters, and Minimalists continued to do later. James Carpenter and Ed Carpenter likewise honed their relationships with glass down to its essentials of space and light. With truly sculptural senses of how glass can physically exist in an environment, they have created some of the most stunning and pioneering works in this new age of glass.

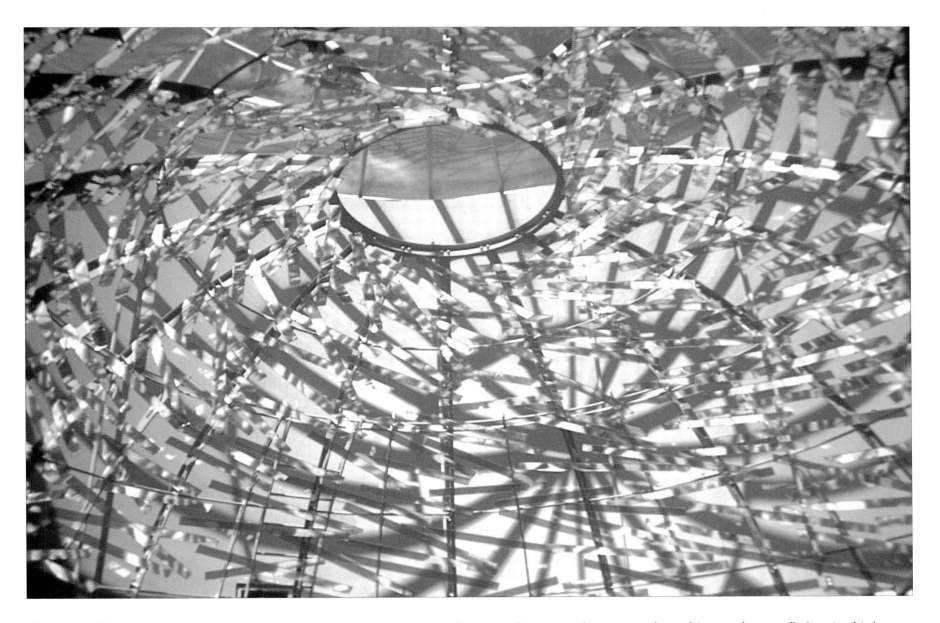

Opposite and above: JAMES CARPENTER'S *SPECTRAL LIGHT DOME*, BUILT FOR THE PORTLAND CENTER FOR THE PERFORMING ARTS IN PORTLAND, OREGON, IS BY NO MEANS A STAINED GLASS WINDOW. MORE SCULPTURE THAN ANYTHING ELSE, IT IS COMPRISED OF DICHROIC GLASS PANELS SUSPENDED TO CAPTURE THE EVER-CHANGING LIGHT OF THE DOME. DICHROIC GLASS CHANGES COLOR AS THE VIEWER'S POSITION AND THE AMBIENT LIGHT CHANGES. THIS QUALITY GIVES THE WORK MOVEMENT. IT ALSO MEANS THAT THE *SPECTRAL DOME* NEVER LOOKS THE SAME TWICE.

Any remnants of post-war German and twentieth-century American stained glass are cast aside in the groundbreaking work of James Carpenter of New York City. For his *Spectral Light Dome* for the PCPA (Portland Center for the Performing Arts) in Portland, Oregon, Carpenter suspended hundreds of dichroic glass strips from the structural steel framing of the dome. In a work reminiscent of Calder's hanging mobiles, Carpenter brings movement and the spectral experience of the changing dichroic sections into the architectural space. *Refractive Light Spine*, created for the University City Science Center, in Philadelphia, Pennsylvania, is more a structure of dichroic glass and steel than anything else. Carpenter points to the future in the use of alternative joining methods, employing sophisticated corner and edge supports for his glass members. Gone is any semblance of traditional stained or architectural glass.

Ed Carpenter of Tilamook, Oregon, once said of his work, "I will have succeeded

completely if I create a work that utterly defies photography." This may not be a sentence to inspire publishers of Ed Carpenter's work, yet it gives a glimpse of what drives the artist in his quest for new definitions and applications for glass in environmental situations. In 1973 Ed Carpenter spent time studying German glass as part of a scholarship he received. While there as a delegate of the American glass community, he was personally introduced to the artists of the German school by none other than Ludwig Schaffrath. Carpenter also spent time as his student in 1975. As Schaffrath's student, Carpenter enjoyed a unique opportunity at the side of one of the primal forces in contemporary stained glass. What he gained from the experience is made manifest in his commissioned works.

As part of an environment's architectural ensemble, Ed Carpenter's works become architecture themselves in the way he sets his glass off from its surroundings rather than installing it into them. In the Portland International Airport, in Portland, Oregon, Carpenter's glass *is* the interior architecture. Fins of glass create a visual arc along the terminal's ticket lobby. Here we have work as far from conventional stained glass as a project can be, yet it comes from the basic idea of colored glass installed within an architectural setting, a tenet as old as the medium itself. The glass is so integrated with the interior of the terminal that it is difficult to photograph, just as Carpenter wished.

At the Human Resources Building in Salem, Oregon, stainless steel cables, custom hardware, glass, and prisms create hanging sculptural forms on the interior of the building. From the outside, the work could easily be mistaken as a conventional contemporary stained glass window. Ingenious in the conception and execution of his works, Ed Carpenter succeeds in creating glass works that assume two distinct identities depending upon whether they are viewed from the inside or the outside.

PAUL MARIONI

It is increasingly common to find artists switching camps and techniques in their search for expressiveness in glass. Although not the norm, many have achieved success in both. Such is the case with Paul Marioni, one of the most respected of the new generation of glass artists, who distinguishes himself in the fields of both stained glass and hot (or blown) glass. It is interesting to see how an artist's dialogue with dimensional concerns takes shape. Marioni, because he has experience in stained glass (two dimensions) and blown glass (three dimensions), shares his interactions between both.

If we take for example his 1974 panel, *The Conversationalist*, now in the collection of the Corning Museum of Glass, we are given a lesson in conventional stained glass techniques used to support unconventional ideas. In this work, the underlying image of a nine-panel window and paneled wood wall supports a number of unexpected attachments. In a bit of surrealistic whimsy, part of the blue sky in the lower middle pane of sky glass is actually slumping and pouring out toward the viewer. The wall paneling is leaded in a conventional sense with strips of came, and a thicker strip of leading surrounds a draping trompe l'oeil tablecloth created by silk-screening and enameling the glass. Lastly, a pair of eyeglasses sits casually attached to the tablecloth. In the pouring sky glass and the tablecloth with eyeglasses, Marioni tempts the viewer with objects in a third dimension. This is autonomous glass at its best.

In contrast, he assumes an architectural style in his *Waterwall*, created with Ann Troutner for a Pawling, New York, residence. In this 1990 installation, Marioni's feel for depth is confined to the profile and texture of the silvery glass.

RICHARD MILLARD AND ALBINAS ELSKUS

Richard Millard and Albinas Elskus share a rich history in the contemporary stained glass community. Both are glass painters. More than any other artists of their generation, they have instilled new energies into this centuries-old glassworking technique. Both are respected authors on the subject of glass as well as accomplished practitioners of the art. Elskus's landmark book, *The Art of Painting on Glass*, first published in 1980, is considered the standard reference on the technique and continues to inspire young artists who want more control of the surface color of their glass. Richard Millard served as the editor for an industry magazine. His articles on painting, stained glass in general, and other artists appear regularly in print.

Their works reinforce the link between the old and new. Elskus shows the link in his

Opposite: THE CONVERSATIONALIST, BY PAUL MARIONI, EXPLORES THE POSSIBILITIES OF ALTERNATIVE IMAGERY THAT CHARACTERIZED MUCH OF THE NEW GLASS WORKS OF THE 1970S. CONSIDERING AUTONOMOUS WORKS IN GLASS MUCH LIKE PAINTINGS, ARTISTS LIKE MARIONI ADDED MYSTERY TO THEIR WORK BY MEANS OF THEIR TITLES, IN THE SAME WAY A PAINTER MIGHT.

detailed depiction of imagery using silver stain and vitreous paints in his 1976 panel, *Three Apples*, now part of the Corning Museum's permanent collection. Millard creates a link in bringing contemporary concepts to religious and architectural glass installations, such as his window for the Oral Roberts University in Tulsa, Oklahoma, and his triangular-shaped window for the Nativity Church of Ohio.

For these two glass painters, their accomplishments as artists go hand in hand with their careers as instructors. They have found, like many others, that in sharing their knowledge with others, they not only contribute to the future of the field of glass but also gain better insights into the why and how of their own creative work.

Opposite: ONE OF THE FINEST GLASS PAINTERS OF THE CURRENT GENERATION OF ARTISTS, IN HIS STAINED GLASS WORK FOR ORAL ROBERTS UNIVERSITY IN TULSA, OKLAHOMA, RICHARD MILLARD USES ABSTRACTED PERSPECTIVE TO CARRY THE VIEWER BEYOND THE GLASS SURFACE. HERE WE SEE THE ORIGINAL CONCEPT OF THE EARLIEST STAINED GLASS—TO DRAW THE VIEWER FROM THE REAL WORLD INTO THAT OF MEDITATION AND REFLECTION—AT WORK IN THE HANDS OF A CONTEMPORARY GLASS ARTIST.

Right: THE EXQUISITE PAINTING STYLE OF ALBINAS ELSKUS IS UNMISTAKABLE. ELSKUS EMPLOYS IMPECCABLE TECHNIQUE AND SUBSTANTIAL DRAFTING ABILITIES TO ACHIEVE HIS SIGNATURE STYLE. HIS *THREE APPLES* IS BY FAR HIS MOST FAMOUS WORK AND HAS BECOME AN ICON FOR CONTEMPORARY PAINTED GLASS.

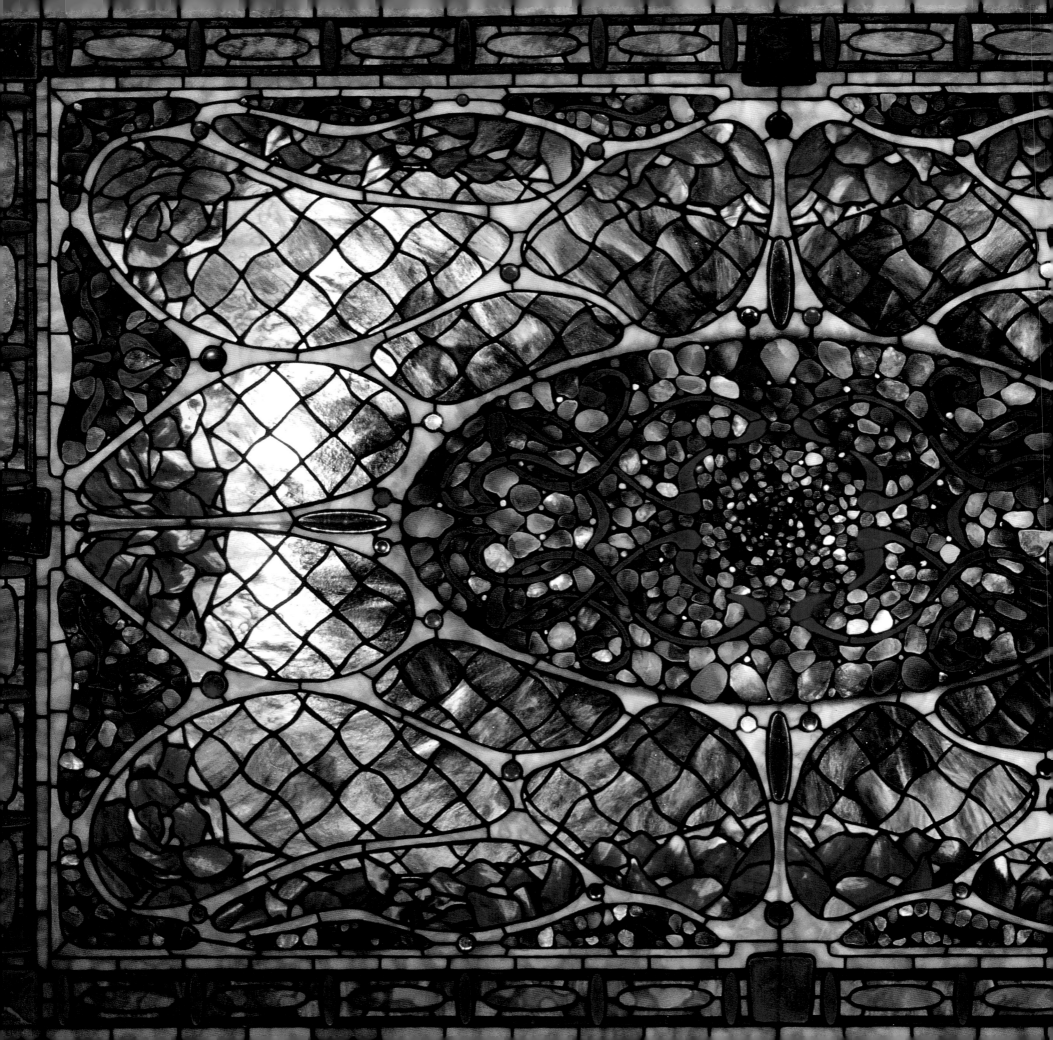

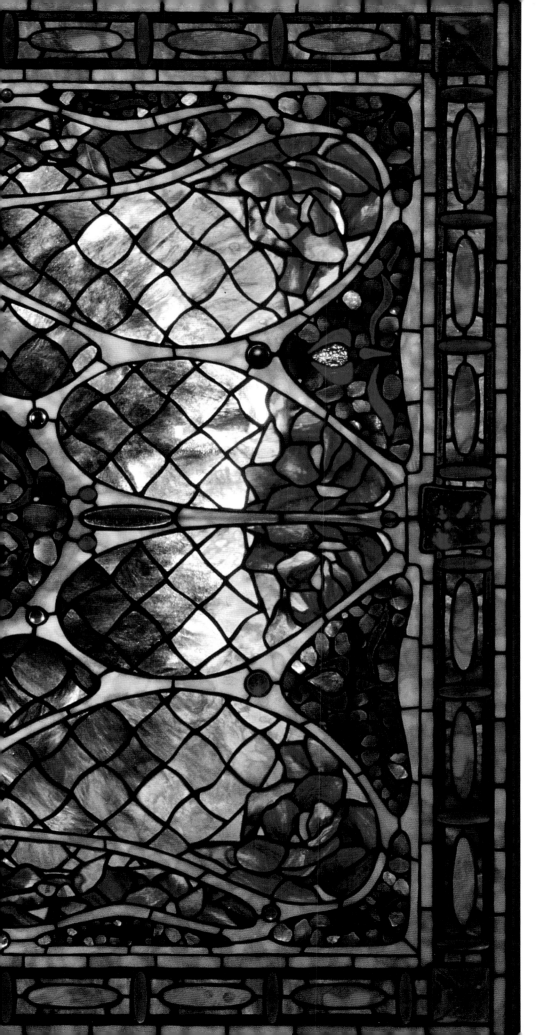

REFLECTING ON THE FUTURE

Stained glass is on television, on the Internet, and everywhere its artists, supporters, and lovers can spread the word. The instinct to communicate has proven to be the most powerful glassworking technique of all, opening doors for the medium where they formerly did not exist.

In his 1993 work *Oriental Carpet II*, contemporary stained glass artist Ken Phillips translates the carpet's intricate beauty into glass by way of meticulous craftsmanship and brilliant choice of transitional color sections, capturing the unique power of the Far Eastern style.

A Gallery of Excellence

A field once shrouded in secrecy and rivalry has given way to the free flow of information. The audience for glass has grown more in the last thirty years than in any other time in its long, illustrious history. Almost anywhere in the world today, anyone can learn to work with glass or enjoy it in their home.

Stained glass, sandblasted glass, beveled, fused, and blown glass have made their way from the architectural setting of their heritage to the homes of millions of people everywhere. It is becoming harder to find someone that hasn't been touched in some way by the glass movement than someone who has. At the forefront of this flurry of activity is a growing roster of exceptional artists, studios, and designers who are, while you are reading this, creating the glass masterpieces of tomorrow. Like their predecessors, they are constantly rewriting the history of glass and challenging any preconceived notions of what the medium is capable of.

To present a discussion of each of these contemporary artists would propose a project many times the size and breadth of this one, for the definition of contemporary glass has been modified to include all types of glass in all types of applications. Today's glass artists effortlessly travel from one technique to another. The trend in which artists incorporate traditional stained glass, sandblasting, etching, and painting, and any combination of additional techniques in a single work is par for the course for many working glass professionals. As you will see in the following select profiles, the sky's the limit, rules are made to be broken, and the future of glass is here, now.

LUTZ HAUFSCHILD

The only glass artist to win the coveted Saidye Bronfman Award for Excellence in the Crafts, Canadian Lutz Haufschild has produced an enviable body of work for someone who discovered working with stained glass in 1970. Trained as an architectural artist, Haufschild thinks in terms of the larger scales of architectural glass. The works of the German school may have served as his model, but he was quick to develop an expressive style of his own.

In his *Islamic Ornamentation*, in Burnaby Jamatkhana in Burnaby, British

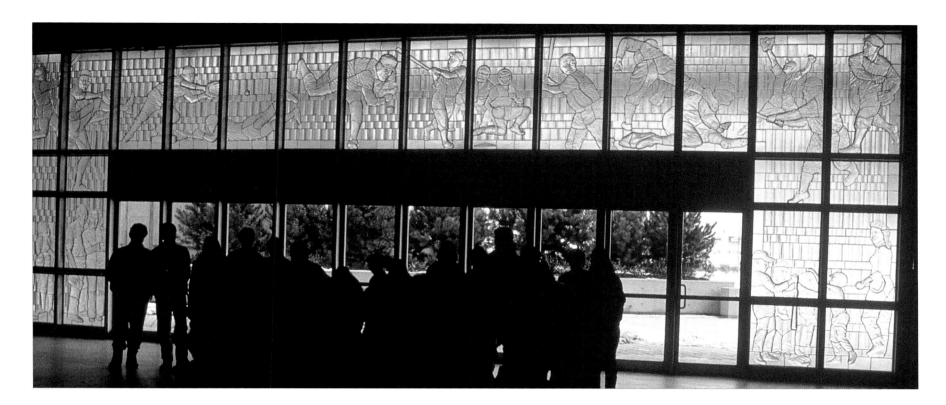

Columbia, a pair of cast-glass, three-dimensional windows show Haufschild's ability to shift gears from the purely coloristic to a textbook "architectural" style. Other works include windows for Robson Court, in Vancouver, British Columbia; *The Great Wave*, at Vancouver Airport's international

❧

Opposite and above: CANADIAN ARTIST, WRITER, AND PAINTER LUTZ HAUFSCHILD NOW RESIDES IN SWITZERLAND. HIS 1989 INSTALLATION AT THE SKYDOME STADIUM IN TORONTO, *TRIBUTE TO BASEBALL*, INCORPORATES SCULPTED, CAST-GLASS PANELS AND TRADITIONAL LEADING TECHNIQUES. THIS DETAIL SHOWS BASEBALL PLAYER BABE RUTH.

Right: HAUFSCHILD EXPLORED THE POST-WAR GERMAN INFLUENCE ON STAINED GLASS IN HIS 1989 TRINITY WINDOWS FOR SAINT ANDREW'S IN TORONTO. IN THE STYLE OF POENSGEN AND SCHREITER, HAUFSCHILD BUILT HIS DESIGN USING THE STRICT GEOMETRY OF THE WINDOW OPENING AGAINST THE ENERGETIC DIAGONALS CREATED BY HIS LEADLINES AND COLORED GLASS PIECES.

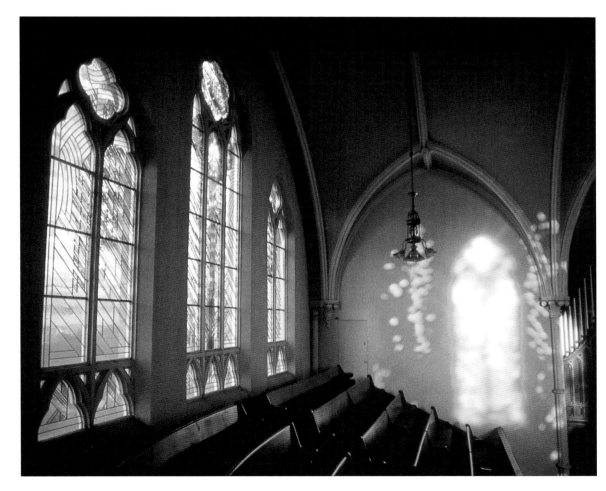

arrivals and departures terminal; the *Spectra Veil* in the Bata Shoe Museum in Toronto; the *Four Seasons* at St. Mary's Parish Church in Vancouver; and probably his most popular work by virtue of its location, *Tribute to Baseball* at the east and west entrances of the Skydome Stadium in Toronto.

PATRICK REYNTIENS

Patrick Reyntiens is a student and collaborator of legendary British painter John Piper. His work with Piper includes some of the most important in modern British glass.

∞

PATRICK REYTIENS HAS DISTINGUISHED HIMSELF AS A GLASS HISTORIAN AS WELL AS AN INFLUENTIAL GLASS ARTIST AND PAINTER. HIS BOOK *THE BEAUTY OF STAINED GLASS*, PUBLISHED IN 1990, WAS WELL RECEIVED BY THE GLASS COMMUNITY. PICTURED ARE DETAILS FROM HIS *REMINISCENCE OF JUSTE DE JUSTE (below and right)* AND HIS *LABORS OF HERCULES (opposite)*. *LABORS OF HERCULES* IS A SUITE OF WORKS THAT FOCUSES ON THE ARTIST'S EXPRESSIVE GLASS-PAINTING STYLE. THE VARYING WEIGHT OF THE LEADLINES ADDS MOVEMENT AND SUPPORT TO HIS ACTIVE BRUSHSTROKE METHOD OF PAINTING ON GLASS.

Reyntiens also ran a glass school during the 1970s at Burlieghfield in England. But it is his painted works that step outside of the Piper school and carve out a niche of their own. Reyntiens's mosaic of glass and lead is his blank canvas. Although it looks as if he disregards the positions of his leadlines and paints over them, his acute sense of structure is apparent in the way he avoids any clumsy interactions among his materials and images. His 1986 window *Fool's Paradise* is pure Reyntiens: symbolic, mystical, lyrical, irreverent, but most important of all, beautifully designed and masterfully executed.

∞

GRAHAM JONES

Graham Jones belongs to the newest generation of British glass artists. Like Reyntiens, he subscribes to a painterly tradition, one that conjures the romanticism of medieval glass. But his coloring is amorphous, creating painted areas whose colors tear into each other. The dual windows he created for Poet's Corner in Westminster Abbey are prime examples of his use of form, pattern, and color. In Graham Jones, we see the continuation of the bloodline that runs from Piper and Reyntiens.

PETER McGRAIN

Many of his peers would agree that the most gifted artist working in stained glass today is Peter McGrain. A self-taught artist, Peter McGrain stunned the audience at the 1990 Glass Craft Expo with his award-winning panel *Shrimping the Spring Tide*, a tour de force of ingenious glass design and technical

∞

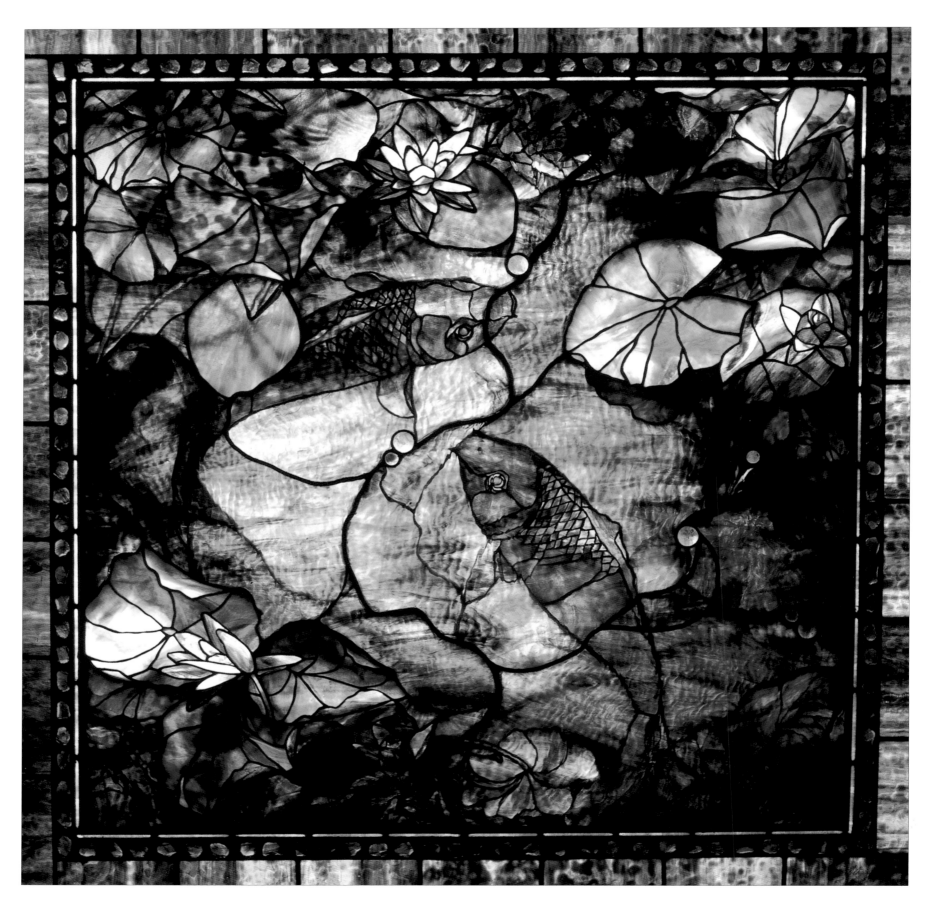

Opposite: STEVEN STELZ IS PROBABLY THIS GENERATION'S BEST PROPONENT OF THE AMERICAN STYLE OF STAINED GLASS MADE POPULAR BY TIFFANY AND LAFARGE. HIS *KOI WITH WATER LILIES* IS PAINTING WITH GLASS AT ITS BEST. STELZ USES A TECHNIQUE CALLED "PLATING" IN THIS WORK. PLATING EMPLOYS SUCCESSIVE LAYERS OF GLASS TO CREATE EXCITING COLORS AND COLOR PATTERNS, AS WELL AS TO ADD DEPTH TO THE VISUAL EXPERIENCE. *Below:* INNOVATOR DAVID RUTH SEEKS ALTERNATIVE TECHNIQUES AND NEW APPLICATIONS FOR HIS CREATIONS IN THE MEDIUM. HIS *SUALOCIN TABLE* IS CONSTRUCTED OF CAST GLASS AND METAL.

∽

wizardry. He went on to distinguish himself as an author, instructor, and graphic artist while gaining the respect and admiration of a whole new generation of glass enthusiasts.

His latest works include a monumental installation at the Rochester Airport in Rochester, New York.

STEVEN STELZ

Steven Stelz's work is rooted in the American School of stained glass, that of Tiffany and LaFarge. Stelz continues in this representational tradition and adds his own innovations to the mix by creating much of his own glass and extending his abilities to the medium of glass mosaic. Stelz's *Wisteria with Wrought Iron Gate* of 1993 is a direct descendant of the best of early twentieth-century American glass. His 1996 *Rhododendron* window, a masterpiece of layered, painted,

and copper-foiled glass, created for the Kokomo Opalescent Glass Company to showcase their glass, is one of the finest contemporary examples of the American School of Tiffany and LaFarge.

DAVID RUTH

Artist David Ruth has a long history in contemporary stained glass. Once a glassmaker himself, he then emerged as an important member of the team of technicians involved in Narcissus Quagliata's light paintings of 1994. Today, he applies his technical expertise to his own works, creating monumental glass sculptures and cast-glass objects. Take for instance his eleven-foot (3.4m) *Gomesia*

sculpture, or his cast glass *Sualocin* and *Borealis* tables. David Ruth pushes his materials to their limits and finds expressive new ways to instill them with excitement.

KEN PHILLIPS

Pittsburgh stained glass artist Ken Phillips's *Oriental Carpet II* (pages 118–119) shows the beauty of opalescent glass as few works can. Its ability to dramatically go from one area of color to another gives the work the "magic" so often attributed to stained glass.

But it is not magic. It is the skill of the glass artist that deserves the credit. Phillips's *Landscape and Stone Columns*, like the work of Steven Stelz, draws from the American School of stained glass, while bringing to mind the work of illustrator Maxfield Parrish with its dreamlike character and rich color.

DAVID WILSON

Geometry and the logic of architectural lines are David Wilson's point of departure. From there, he lightens his strict adherence to the concept of grid work by introducing beveled glass; edged, painted areas of free-flowing and/or spot color; and diagonal borders. In his huge Merck and Company installation at their Readington, New Jersey, offices, his works envelop entire walls, surrounding the viewer with glass.

ARCHITECTURAL GLASS ON A GRAND SCALE IS WHAT ARTIST DAVID WILSON ACHIEVED IN HIS INSTALLATIONS FOR MERCK AND COMPANY IN READINGTON, NEW JERSEY.

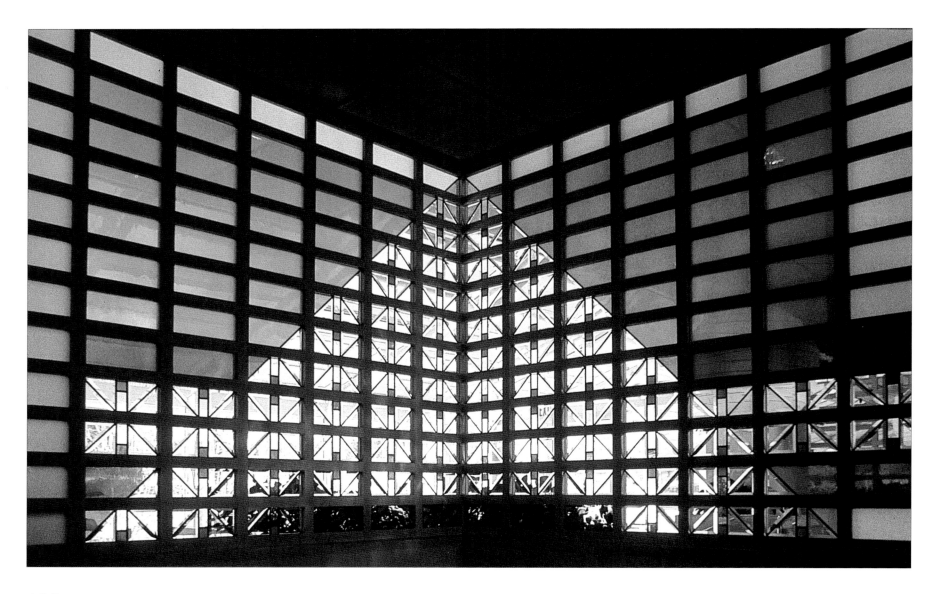

McMow Art Glass

Domestic glass commissions can sometimes limit the creativity and technical freedom of a designer or artist. Homeowners usually have a specific style or purpose for their stained glass. Sharon and Phillip Materio, owners and designers of McMow Art Glass of Boca Raton, Florida, seem to suffer no such restriction in much of their residential commissions. Their Atlantis, Florida, and Admiral's Cove entryways are excellent examples of sophisticated glass design and architectural embellishment. Suggesting the graceful lines of Art Nouveau in the former and a German/Deco influence in the latter, the Materios' work is proof that domestic installations can provide great opportunities for contemporary stained glass.

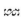

INVENTIVE DOMESTIC INSTALLATIONS THAT INCORPORATE THE BEST OF ARCHITECTURAL GLASS CONCERNS ARE EXEMPLIFIED BY THIS ADMIRAL'S COVE ENTRYWAY IN A FLORIDA RESIDENCE BY THE McMOW ART GLASS STUDIOS OF LAKE WORTH, FLORIDA.

THE SAVOY STUDIOS

In the tradition of the finest stained glass studios, Savoy of Portland, Oregon, has built their reputation on striking design work, masterful execution, and imagination. The studio has been fortunate in being awarded a number of commissions from the casinos of Las Vegas, Nevada, and similar high-profile institutions. Take, for instance, their fantastic *Lady and the Lion* panel created for the Tavern on the Green Restaurant in New York City, or their mammoth wall of glass at Church Street Station in Orlando, Florida. It is no wonder they are constantly in demand for large-scale works that are spectacles in and of themselves.

PHOTOREALISM COMES TO CONTEMPORARY STAINED GLASS BY WAY OF THE SAVOY STUDIOS IN PORTLAND, OREGON. THIS 1988 WORK, *THE GLADES*, IS IN A PRIVATE COLLECTION. SAVOY ALSO HAS TO THEIR CREDIT MANY IMPORTANT COMMISSIONS FROM MAJOR LAS VEGAS HOTELS AND CASINOS.

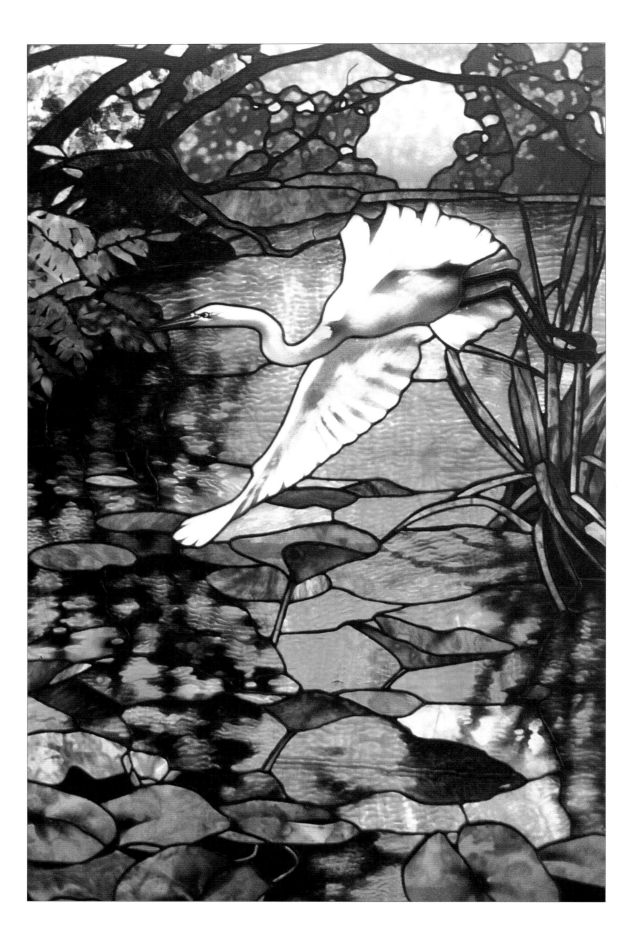

NOEL AND JANENE HILLIARD

Despite its small and relatively recent role in the history of stained glass, the leaded glass lamp (or Tiffany-style lamp) is a major catalyst for inspiring many to a career in glass. Although the name Tiffany (however incorrectly) has become the generic descriptive for stained glass lighting objects, much in the same way Kleenex represents any tissues and Xeroxes denote paper copies, it has never stifled Noel and Janene Hilliard from applying their innovative sense of design and construction to their works. The lamps they create can trace their lineage to Tiffany and his lamp-making contemporaries, yet their bold, original designs are far removed from those of their predecessors.

∞

THE LEADED GLASS LAMP, MADE FAMOUS BY THE TIFFANY STUDIOS, IS REINVENTED EVERY TIME NOEL AND JANENE HILLIARD OF THE HILLIARD STUDIOS OF ARCATA, CALIFORNIA, JOIN FORCES. THEIR IMPERIAL KYOTO *(below)* AND IVORY TOWER *(right)* LAMPS ARE JUST TWO EXAMPLES OF THEIR IMAGINATIVE DESIGNS AND IMPECCABLE CRAFTSMANSHIP. THE HILLIARDS TAKE THE MOSAIC CONCEPT OF THE LEADED GLASS LAMP TO NEW, EXCITING HEIGHTS BY THEIR CAREFUL AND INTELLIGENT USE OF REPETITIVE PATTERNS.

MARC GRUNSEIT

Australian Marc Grunseit left a medical career to become a stained glass artist. Fascinated by the material and its possibilities, he used the discipline and high regard for what he calls a "privileged body of knowledge" that he accumulated as a medical student and applied it to his art. In his striking *Tao of Medicine*, created for the Hospital Foyer at Wolper Jewish Hospital in Sydney, Australia, he was able to incorporate a number of running themes throughout the work, citing the thread that unites the ten panels as the double helix of DNA. It was an unconventional source of inspiration for an unconventional yet exceptional set of windows.

Left: AUSTRALIA'S MARC GRUNSEIT USED KILN-CRAFTED GLASS IN HIS *GENESIS: THE FIRST DREAMING* SERIES. KILN-CRAFTED GLASS FUSES LAYERS OR ELEMENTS OF GLASS TO EACH OTHER TO CREATE ONE NEW PIECE. AS SEEN HERE, GRUNSEIT EXPLORES A SIMILAR STYLE OF IMAGERY IN HIS AUTONOMOUS WORKS AS HE DOES IN HIS SITE-SPECIFIC GLASS. *Opposite:* GRUNSEIT'S 1993 *TAO OF MEDICINE* SERIES USES TRADITIONAL IMAGERY SET AGAINST STRICT CONTEMPORARY GEOMETRY.

ELLEN MANDELBAUM

The autonomous and architectural works of Ellen Mandelbaum sing with the freedom of painted works and prosper by the added dimension of the glass material. Her painting style is reminiscent of the Abstract Expressionists without the wild colors and indiscernible subject matter. Ellen Mandelbaum is one of a growing number of female artists making substantial contributions to the recent history of stained glass. Like many of her contemporaries, Mandelbaum is also an instructor and author on the subject of glass. Her works grace the interiors of numerous institutions and private homes, and her autonomous works are common features at exhibits of cutting-edge stained glass.

Opposite: ELLEN MANDELBAUM'S ENERGETIC BRUSHSTROKE STYLE AND SOPHISTICATED COLOR SENSE SPEAK WITH A PAINTER'S ACCENT, AS IN HER 1993 WORK *WALES WATERFALL,* CASTING GLASS BETWEEN TWO-DIMENSIONAL AND TRANSLUCENT ART. *Above right:* CATHERINE "CAPPY" THOMPSON BRINGS STAINED GLASS-STYLED IMAGERY TO A THREE DIMENSIONAL OBJECT IN HER 1997 WORK ENTITLED, *I WAS DREAMING OF SPIRIT ANIMALS,* NOW IN THE COLLECTION OF THE CHRYSLER MUSEUM OF ART IN NORFOLK, VIRGINIA.

CATHERINE "CAPPY" THOMPSON

Catherine "Cappy" Thompson, who has been working since the 1970s, is best-known for her transparent enameled vessels, which are blown and then painted. Her *I Was Dreaming of Spirit Animals* is based on a clear glass bowl made to her specifications by glass blower Benjamin Moore and then painted with enamel by Thompson, requiring repeated firings. The imagery of the piece derives from a series of dreams the artist had in her twenties, in which she was floating over Olympia, Washington, and was kissed by a celestial bear. This fanciful example of her richly multicolored work resembles children's book illustration. Although her work is contemporary, Thompson's style ultimately derives from medieval stained glass window painting. The artist's work is represented in permanent collections in the United States, Australia, and Japan, and has been exhibited around the world.

JUDITH SCHAECHTER

No artist can claim a more identifiable style than that of Philadelphia's Judith Schaechter. No stained glass artist's work is more controversial, more victim to verbal abuse, and, consequently, more and more valued by serious collectors and critics of the art. Unique from the start, it was as if her work blurted onto the glass scene overnight, full blown. Her style did not develop while her audience watched. When it "arrived" in the late 1980s, most prominently on the cover of the magazine *Professional Stained Glass*, it was every bit as engaging as it is today. Her panels are crafted to perfection using any of a number of techniques. Judith Schaechter's vision and use of glass, regardless of criticism, is unique. Always was, probably always will be.

Opposite and left: PROBABLY THE MOST IDENTIFIABLE ARTIST WORKING IN GLASS TODAY, JUDITH SCHAECHTER HAS HAD HER WORKS DESCRIBED AS BOTH BEAUTIFUL AND ALARMING. NOT ONE TO AVOID CONTROVERSIAL IMAGERY, SCHAECHTER CHALLENGES THE VIEWER'S EXPECTATIONS AND PRECONCEPTIONS ABOUT GLASS ART. MOST OF HER WORKS ARE AUTONOMOUS AND MEANT TO BE HUNG LIKE PAINTINGS. IT'S ANYONE'S GUESS WHAT HER CROWDED IMAGERY MIGHT MEAN. INDEED, THAT HAS ALWAYS BEEN PART OF THE FASCINATION WITH THIS ARTIST'S WORK. HER 1994 WORK *BAD NIGHT WITH INSOMNIA* IS OPPOSITE, AND HER 1995 *SELF-PORTRAIT* IS TO THE LEFT.

THE "FOUND ART"

The years 1975 through 1990 witnessed the coming of age of the modern glass artist and the supporting glass community as well. Beginning with the sparks of interest felt during the crafts revival of the sixties, in the short period of thirty years, an entire industry of glass emerged, one replete with books and magazines on glass; accredited college courses on the subject; glass museums, galleries, and collectors; retail shops selling glass and teaching the craft; new tools to simplify glass construction; new technologies of making and manipulating glass; and a growing awareness of glass, stained and otherwise, as a decorative and architectural embellishment. The long history of glass as a minor art exploded during one of the most vibrant creative periods in the history of the crafts and arts. The "Studio" movement had put glass on the cultural map. The term "lost art" became lost itself.

ONE OF THE MOST IMPRESSIVE ATTRIBUTES OF STAINED GLASS IS ITS NEAR-PERMANENCE; AS LONG AS IT IS NOT DESTROYED, WORKS IN GLASS HAVE THE POTENTIAL TO LAST MUCH LONGER THAN SOME OTHER ARTISTIC MEDIA, WHICH CAN FADE OR WEAR OVER TIME. THIS WINDOW FROM THE ANNUNCIATION CATHEDRAL, A GREEK ORTHODOX HOUSE OF WORSHIP IN SAN FRANCISCO, CALIFORNIA, SHOWS TWELVE YEAR OLD JESUS WITH TWO ELDERS OF THE JEWISH TEMPLE—A TIMELESS RELIGIOUS PIECE THAT SHOULD LAST FOR CENTURIES.

For Further Reading

Adams, Henry et al. *John LaFarge*. New York: Abbeville Press, 1987.

Brisac, Catherine. *A Thousand Years of Stained Glass*. Edison: Chartwell Books, 1984.

The Corning Museum of Glass. A *Short History of Glass*. Corning, NY: Corning Museum, 1980.

Cowen, Painton. *Rose Windows*. San Francisco: Chronicle Books, 1979.

Duncan, Alastair. *Louis Comfort Tiffany*. New York: Harry N. Abrams, 1992.

_____. *Tiffany Windows*. New York: Simon & Schuster, 1980.

Duncan, Alastair and William Feldstein, Jr. *The Lamps of Tiffany Studios*. New York: Harry N. Abrams, 1983.

Heinz, Thomas A. *Frank Lloyd Wright Art*. Paris: Academy Editions, 1994.

Hill, Hill & Halberstadt. *Stained Glass: Music for the Eye*. Oakland, CA: The Scrimshaw Press, 1976

Kehlman, Robert. *20th Century Stained Glass: A New Definition*. Kyoto, Japan: Kyoto Shoin, 1992.

Koch, Robert. *Louis C. Tiffany's Glass, Bronzes, Lamps*. New York: Crown Publishers, 1971.

_____. Louis C. Tiffany, *Rebel in Glass*. New York: Crown Publishers, 1964.

Neustadt, Egon. *The Lamps of Tiffany*. New York: The Fairfield Press, 1970.

Reytiens, Patrick. *The Beauty of Stained Glass*. Boston: Little, Brown & Co., 1990.

Schreiter, Johannes. *Verlag Das Beispiel*. Darmstadt, Germany: GmbH Darmstadt, 1988.

Sowers, Robert. *Stained Glass/An Architectural Art*. Secaucas: Universe Books, 1965

_____. *The Language of Stained Glass*. Portland: Timber Press, 1981.

_____. *Rethinking the Forms of Visual Expression*. Berkeley: The University of California Press, 1990.

Index

PHOTOGRAPHY CREDITS

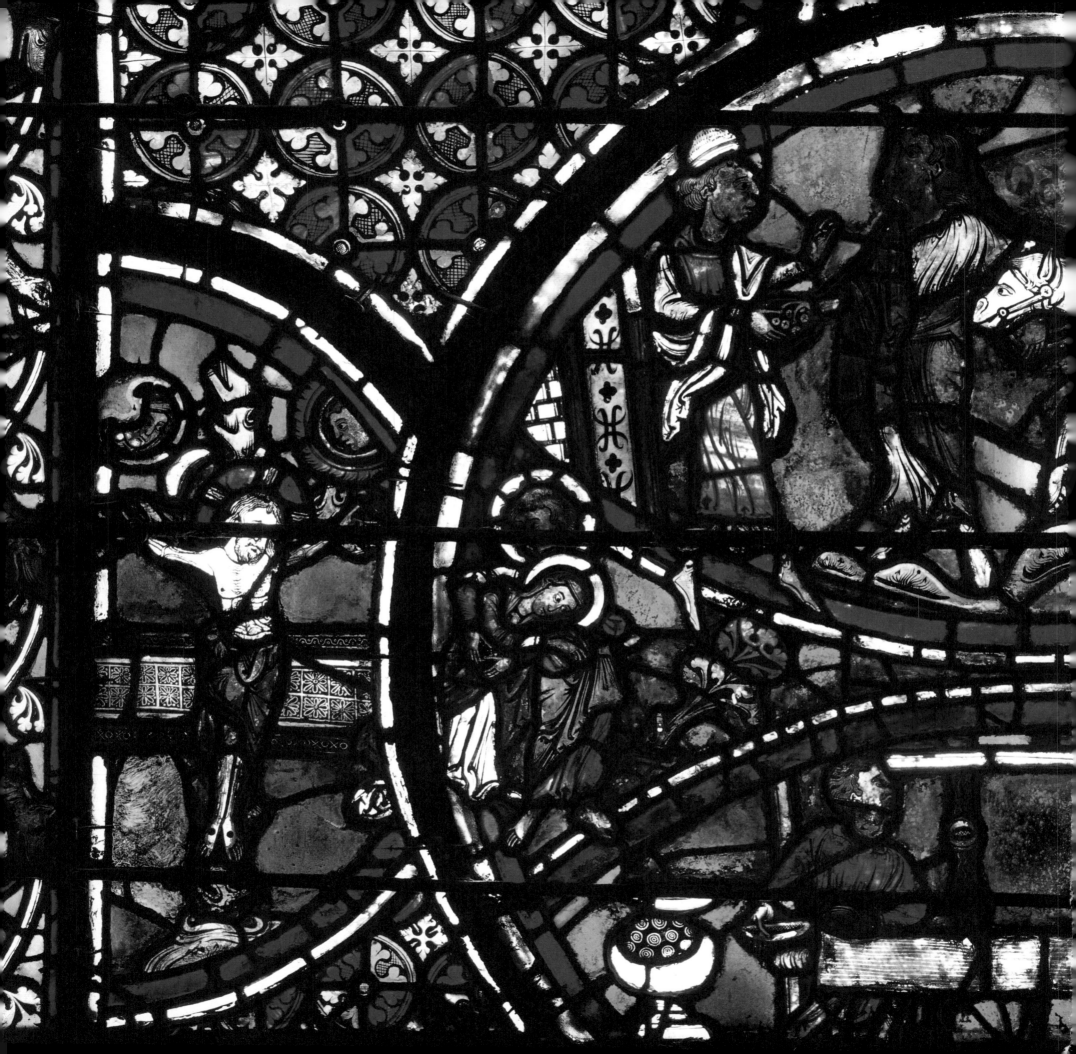